Regarding Ingres

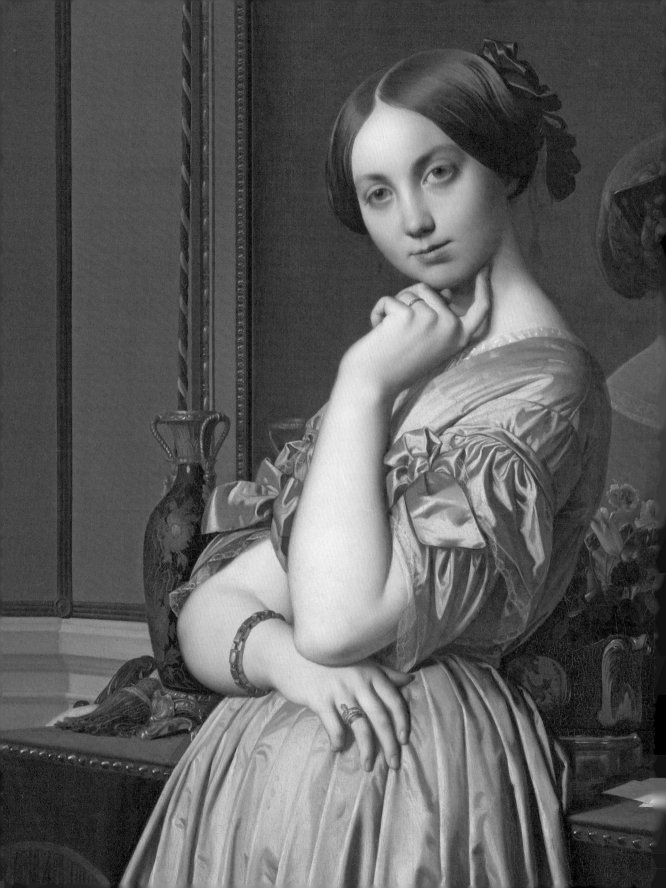

Regarding Ingres

FOURTEEN SHORT STORIES

INTRODUCTION BY DARIN STRAUSS

WITH STORIES BY

Mathis Clément, Najee Fareed, Nina Ferraz, Omer Friedlander,
Amir Hall, Anushka Joshi, Christopher Linnix,
Madeline McFarland, Jonathan Perry, Isabelle Philippe, Eric Rubeo,
Erin Townsend, Devon Walker-Figueroa, Alanna Weissman

Rizzoli **Electa**

in association with

THE FRICK COLLECTION

Contents

Preface

One early October evening in 2021—in the relative lull before the COVID-19 Omicron surge—Darin Strauss and the fourteen New York University (NYU) graduate students in his Craft of Fiction class arrived at Frick Madison (our temporary home during the museum's renovation) to commune with Ingres's celebrated portrait of the Comtesse d'Haussonville and to listen to a presentation by Frick Curator Aimee Ng. The students' assignment was to write a short story prompted by the painting for a book to be published by the Frick. The project was conceived as something of a follow-up to *The Sleeve Should Be Illegal and Other Reflections on Art at the Frick*, published by the Frick and DelMonico/D.A.P. in early 2021. An anthology of texts by cultural figures writing about a Frick artwork that has personal significance for them, *Sleeve* presents a rich range of observations in a variety of styles, with the joy of looking at art threading through them all. I thought an anthology of fiction inspired by a Frick artwork had the potential to be every bit as engaging. Frank O'Hara's love poem "Having a Coke with You" alludes to the Frick's *Polish Rider* by Rembrandt. Susanna Kaysen's literary memoir *Girl, Interrupted* was inspired by the Frick's *Girl Interrupted at Her Music* by Vermeer. For the musical version of the Kaysen book, Aimee Mann wrote the haunting song "At the Frick Museum [*sic*]." The Frick mansion is central to Fiona Davis's captivating novel *The Magnolia Palace*. Why not Ingres's exquisite *Comtesse d'Haussonville* as a prompt for short stories?

In talking to my husband over breakfast one day about how one might approach such a project, he had the terrific idea—for which I am very grateful—of partnering with a writing program. Very soon after, I contacted Deborah Landau, Professor and Director of NYU's Creative Writing Program, with my proposal that we team up, and she was on board right away. We are extremely grateful to Deborah for her enthusiasm and of course to Darin for his willingness to take on this project as part of his class, for his work with the students on their stories, and for his introduction for this book.

For the keen support that they always provide, I would like to thank Ian Wardropper, the Anna-Maria and Stephen Kellen Director of the Frick, and Xavier F. Salomon, Deputy Director and Peter Jay Sharp Chief Curator. Thanks also go to Aimee Ng for the energizing presentation she gave the students; to Christopher Snow Hopkins, Assistant Editor, for his invaluable assistance with the copyediting of the stories; and to Rizzoli Senior Editor Philip Reeser, with whom it is always a pleasure to work. Most of all, thanks go to the students, who threw themselves into the project with heart and soul.

As Aimee spoke on that October evening, one could sense the group's growing enthusiasm. As the students left, one sweetly said to me, "I hope we don't disappoint you." The stories were submitted the following January. And they do not disappoint.

MICHAELYN MITCHELL
Editor in Chief
The Frick Collection

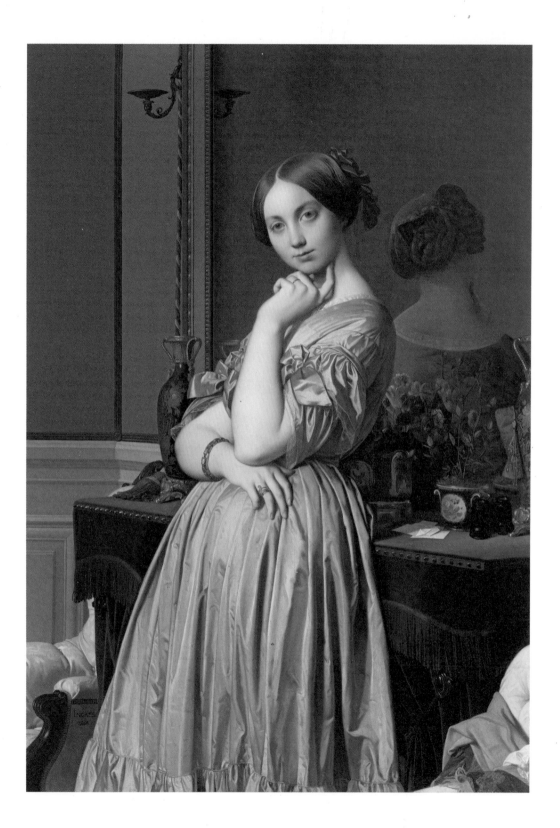

Introduction

DARIN STRAUSS

Certain projects throw you back on first principles. This one did so twice.

When a museum clears its throat, you listen. The Frick asked: would my NYU writing class take on—for publication—a famous portrait by a famous portraitist? Student fictions, all strung around a single work, a guarantee of perdurable print, what d'you think? This brought a buzz of modest enthusiasm, like a sip of Earl Grey. Working with the Frick, which I visited in high school. Plus, it would be good, you know, for the kids.

The artist on whose painting my class would riff was Jean-Auguste-Dominique Ingres (French, b. *unfashionably long ago,* d. *still really long ago*). The painting, *Louise, Princesse de Broglie, Later the Comtesse d'Haussonville* (1845), that chaste blue hub of the collection. Forget the students, who were almost uniformly young; in 2022, would *I* pick up on the work's signal? An antiquated, realist portrait? The wheel of revolving taste has surely turned many degrees from Ingres, with his silky pomp. A comtesse smiling amid her bygone privilege—what inspiration was there to be drawn from her? A quick Google search, and I found myself eyeing something frivolous: so outdated, so Marie Antoinette.

But then I actually stood before the portrait.

To be precise, the class and I got to view the Ingres, after hours, with the Frick's Editor in Chief Michaelyn Mitchell and Curator Aimee Ng. Ng's expertise served almost as a set of bifocals. Ah, *that*'s what I'm looking at.

And this is where first principles come in.

Ingres is both a strict realist and a tweaker of realism. He saw himself as a bulwark. Safeguarding the orthodoxies of the past, resisting the popular style of the day. But, conversely, like some foretaste of Matisse or Picasso, he wasn't averse to guiding his brush into odd places, distorting his subjects and the spaces they occupied. The effect was subtle but not *that* subtle. Elongating this body part, displacing that one. Still, I wouldn't have noticed any of this. It was Ng—her lecture, crisped by keen interest, opened these secrets to us.

And yet, even before I was initiated, the painting more than impressed me; somehow the art of an innovator conveys that s/he is innovating. In person, the comtesse is

overwhelming. For one thing, the work is an anthology—a greatest-hits compilation—of blues. The subject's dress is hypnotic, bright wrinkles, 3D undulations, thirty-one flavors of shadow. And there's her teasing face. I pictured the comtesse (as one of my students would soon do) transferred into the modern world: sarcastic, an eye-roller in torturous pumps, and slurping a Marlboro Ultra in front of Nobu or somewhere. But, mostly, what stands out is her physiognomy.

The comtesse's right arm doesn't issue from the shoulder, as does yours and mine and everyone's you know. *Her* arm juts from her mid-torso, an unnaturally elongated limb, sinuous, physically impossible. This is a painterly stroke of wild adventurousness—and near hubris. In a picture of otherwise Polaroid-quality exactitude, Ingres threw reality aside; he thought he could improve, aesthetically, on what God created. (And he was right.)

Ingres made similar alterations in his other great masterpiece, *Grande Odalisque*, which critics bashed; some, evidently, thought he'd mistakenly given his subject's back too many vertebrae. But no; there, again, he was rebelling. Which is—if I can be so audacious as to put myself in the same essay as Ingres, in resolve if certainly not quality—what I have tried to do in my own art. Hemingway saw an analogue to his own writing style—and inspiration—in Cézanne's apples and pears. Ever since I learned that, I've been inspired to look for my own non-writer writing mentors. The adventurousness, the subtle deviations from realism, even the way Ingres seems to leaven his daring by working within the ostensibly conventional—this all brought me to thoughts of my own goals. (And, in my own untutored way, had me reflecting on Klimt, another favorite—though I have no idea if more knowledgeable opinion would link these two disparate masters.)

Not that my finding surprising inspiration from Ingres should count as a check mark (or a demerit) for such a major artist. It just was one more reminder of an admonition—especially useful to artists of all kinds, I think—from C. S. Lewis. He advised to avoid "chronological snobbery," or "the uncritical acceptance of the intellectual climate common to our own age and the assumption that whatever has gone out of date is on that account discredited."

———————◆———————

At the risk of seeming even more untutored, I will mention here that, to me, one of the most powerful exemplars of creativity—and itself a kind of representation of creativity—can

be found in *The Simpsons*. I don't mean the main show itself, though I think that prime-time stalwart is pretty great. No, I'm talking about the opening sequence.

Each episode starts the same way: the camera swoops through clouds to the street; from there, it shadows members of the Simpson family on their way home, and into their house, where they settle onto their couch to watch television. That's it. And yet, in each episode, Bart writes a different phrase on the chalkboard, Lisa plays a different solo on her saxophone, and—the most impressive—a different visual joke marks the family's descent onto their love seat. At this point, the show is closing in on a thousand episodes—or, a thousand variations on that silly problem: how to find a different silent joke around a family sitting down together. How many options are there? How far afield can the writers go and still have it make sense, or fit the basic premise? It's a rather inspiring thought experiment. The answer, it turns out, is near infinite. This book is a humble literary version of that Simpsonic idea.

Each student given the same brief—write about this painting, with utter freedom, while prompted by some of its details—the young writers here went *everywhere*. And so, in offering up a bouquet of very different stories, what they really have given us is a look at the scope of human creativity. And so, that's the second return to first principles. I'd forgotten my belief in the genius of the form.

Mathis Clément wrote an elegant fantasy that, in great style, makes the mystical both convincing and poignant. Something about his story seems classic already.

Najee Fareed somehow managed to follow the assignment and still write a romp that takes place in a newly mythologized afterlife—and that looks at race and history and morality.

Nina Ferraz examines, in her story, personal history and public works. (One of the interesting things about Nina, who had a whole other career in Latin America before coming to writing and America, is that she's a late bloomer. Ah, but what a bloom!)

Omer Friedlander writes about grave robbing and musical genius and the power of obligation. His work is somehow both wild and tightly controlled at once.

Amir Hall found a way to use this European painting to launch a profound and beautiful meditation on a flood that hit his home country of Trinidad and Tobago. Its lyricism is breathtaking.

Anushka Joshi went perhaps furthest afield here—beyond the confines of the normal fictional short story and examining with an angry eye the origins of the painting itself (and its milieu).

Like a number of his confreres, Christopher Linnix used Ingres as a jumping-off point. His story is a heartsick cry, taking on racism and cruelty, and I found it unbearably moving.

Madeline McFarland wrote a work of deep feeling and verisimilitude about portraiture and what it means, inevitably, for the subject: imagining a modern heroine right into the comtesse's seat. It really works.

Jonathan Perry wrote a wild, sad, funny story that is not only entertaining as hell but kind of sui generis.

Isabelle Philippe has written a gothic historical epic in fifteen pages. I kind of don't know how she pulled it off.

Eric Rubeo used the painting to tell a ghost story—or did he?

Erin Townsend, like Madeline McFarland, chose to look, from a modern perspective, at the relationship between artist and model. And yet—in yet another testament to the variety of the human imagination—it's utterly different. In tone, in style, in intent. I read it numerous times in admiration.

Devon Walker-Figueroa is a writer with a Proustian mind for literary comparison. She hunts out likenesses in unlike things. Her story here is visionary and a gift for those who like fiction to be both ontology and music.

Alanna Weissman, in a very limited amount of real estate, gives us, expertly, a look at sisterhood, at the patriarchy, and at the effects of grief on psychology. It packs quite a punch.

It's hard to be up against a masterpiece. But I do think that, like the painting itself, these stories mix realism and abstraction in ways that both thrill and provoke. And I hope, like me, your reaction—no matter what it was to start—is more potent than a sip of Earl Grey. Because this is stronger stuff. ⚘

Her Eyes, Because They Are Mine

MATHIS CLÉMENT

If a man could pass thro' Paradise in a Dream, and have a flower presented to him as a pledge that his Soul had really been there, and found that flower in his hand when he awoke—Aye? and what then? —SAMUEL TAYLOR COLERIDGE

The week I met Axion Warburg I found out I was dying. The cancer, banished half a decade ago at the price of my prostate and with it any late-hoped-for satyric renaissance, had reemerged in both lungs. Dr. Edberg assured me from behind the desk of his comfortable Beaumont Street office that three months was what I had to get my affairs in order. Chemotherapy might extend that to six, but the cancer's proliferation was too far advanced for either of us to reasonably expect longer.

What would you do with that bald reality, the end of everything served up on a platter?

I asserted my will: no treatment. Dr. Edberg nodded complicitly, other patients had made the same decision before me, and handed me a leaflet entitled "Dignity in Dying." I dropped it into the first bin outside his office.

I never had children. My parents passed away long before my first round with cancer, father from a tick bite (Lyme disease), mum from an aneurysm seven hundred and thirty days later. I haven't spoken to my wife or brother since they ran off together to Germany. So those who will miss me are few: Mark, my best man and friend since age seventeen; the Trinity College troika; Dr. Sullivan from the office opposite. In an email I laid out to them the facts, without embellishments or euphemism. Then I headed underground to the British Museum, to seek consolation from the ancients. They did not hide us dying away behind hospitals, hospices, hearses, and headstones. The Egyptians expended the wealth of nations on their dead. Tutankhamun was all the more gloried because he died at eighteen. Is that wisdom? The impassive Nubian sphinx did not answer.

From behind me, a voice asked if I wanted to solve a riddle. Did I know the story of Homer's death? I did not. My specialty, to which I have devoted forty-six years of

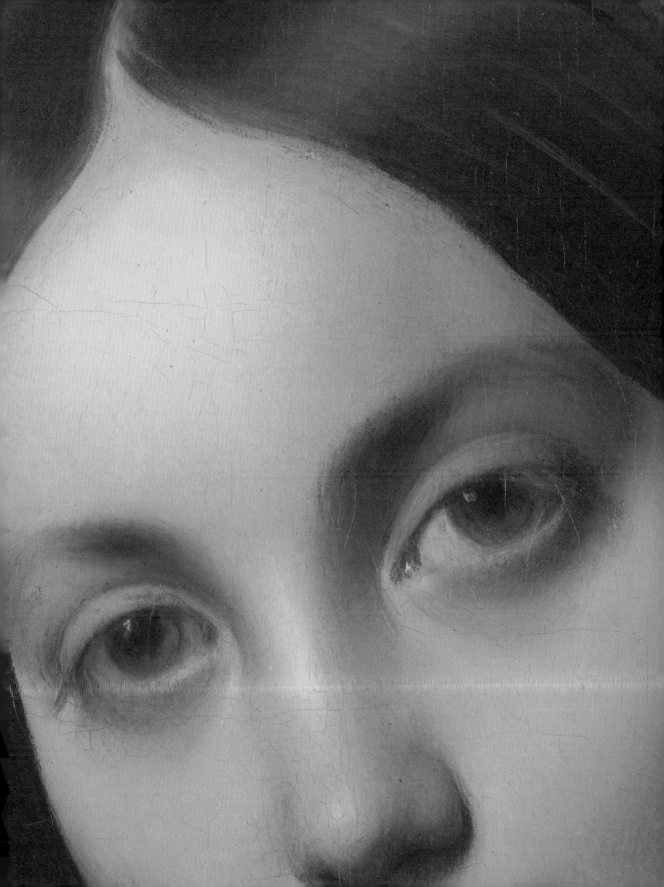

a moderately successful academic career, is early modern science. Of later and earlier periods I am shamefully ignorant. Well, explained the voice (emerging from repaired cleft lip, accompanied by darting eyes and a hand constantly adjusting jaw-length yellowing hair), the story goes that the poet, by now frail and sick as well as blind, landed on an island intending a short rejuvenating stay. Not long after his arrival, he got talking to two fishermen. They recognized not Homer, but simply an old man with time to spare. So they set him to solve the following riddle: *What we caught, we threw away; what we didn't catch, we kept.* Homer fell to thinking. Seasickness? Stowaways? Memories? No, no, no. When his guide came to ferry him back to the mainland, Homer refused, determined to outwit the fishermen. Each night he would turn the riddle over in his mind and each morning he would offer his solutions and be rejected. The frustration wore away at the blind poet until, one morning, he did not return to the docks. He was dead.

Axion, I was to learn, collects stories like he collects antiques. In both he seeks out the esoteric, the grotesque, and the incomplete. (The answer, by the way, is lice.) On learning as we passed the clay Gilgamesh tablets that I was the author of the paper in *Annals of Science* that established Vermeer's use of a camera obscura (romantic critics deny every word of it), a paper he judged a paragon of research and argument, Axion insisted I come to see the collection he kept in a lockup on the lower story of a Kensington mews.

The street's silence implied emptiness, the very opposite of what you meet once Axion raises the garage door and flicks on the light. I've seen tidier junk shops. Not a single surface was free of some trinket or other, usually more than one. For a seat, Axion offered a Victorian traveling trunk as Meissen porcelain was spilled over the sofa. "I think you'll like this," he said, tongue darting over cleft lip and hand through hair. From a Chinese lacquer chest of drawers he drew a thirteenth-century astrolabe, scorched, he claimed, from the sack of Baghdad. A week earlier putting down £50,000 for it would have been a reckless extravagance, but now I could afford to spend like a millionaire. We celebrated like millionaires too, with Krug and Montecristos. Axion showed off a garter he claimed had been given to him by a Swedish princess. Perhaps it's because I believed him (I had no urge not to) that we became friends. Over the next fortnight, we met three more times, always in the Kensington mews where his supply of treasures only increased. A cupboard opened onto one of Antonie van Leeuwenhoek's microscopes (through which

Leeuwenhoek's became the first eyes to observe sperm); three Johannes Schöner globes occupied three corners of the converted garage; a crucified écorché by Fragonard (the body had belonged to a Lyonnais pickpocket) leered in the fourth.

"But what I'm holding in my hand is beyond any of them. All the treasures in all the world's museums fall short," he says to me over the phone in the impersonal, suppressed tone we use when looking over our shoulder. "How soon can you get here?"

I explain that I have been at my lawyer's all afternoon finalizing my will and am exhausted. But he continues to press, not taking no for an answer until I realize that agreeing is the only way I'll end up getting to sleep tonight.

He sends a taxi to pick me up. London is a picture-postcard June when I close my eyes. I awake and two seasons have passed: Kensington drenched in winter drizzle and dark. Axion opens the door a crack at first, peering with a bloodshot eye past me and down the street before hustling me inside, past hung coats and stacked shoes into the garage space, which to my surprise has been stripped almost totally bare. On every previous visit, the wall opposite the sofa had been obscured by dunes of junk. Today only a Maori canoe, posed vertically, leans against the undecorated bachelor eggshell.

"Coffee," Axion says, shoving a mug into my cupped hands: compensation for my tiredness. Then he scuttles out, the tails of his navy dressing gown lifting to reveal pinkish, wiry-haired calves. The coffee is lukewarm and gritty. Having forced myself to swallow half like the fish oil my mother spooned down my throat each morning before school, I set the rest among the detritus of the coffee table. Axion returns hauling a hard leather case, which he sets on the coffee table, having swept away mutilated paperbacks and fag butts. Then he checks the woolen curtains covering the rear windows, making sure that no light can enter or escape, before settling next to me on the cracked faux leather. "We don't live like most people, Jared, preoccupied by their gas bill, where their kids go to school, what there is on TV tonight. What I mean is, they care about the here and now, and the next five minutes if they're smart, whereas we live almost all our lives in the past. Reliving the strife between Guelphs and Ghibellines stirs me far more than Labour versus Tory. It's strange, I know that. What's the past in the except words on a page and knickknacks for the display cabinet? So I once thought."

With apish thumbs, Axion flips open the case's brass knobs. Inside, couched in tissue paper, lie three pouches: felt, leather, and velvet. Axion removes the velvet pouch, loosens its strings, and allows to fall into his palm a roughed-up pair of binoculars.

"I have never shown them to anyone else. After you, I do not intend to." His oily black eyes anticipate the question on my lips. "I am showing you, Jared, because you deserve to have one last miracle to take with you to the grave."

A pyramidal shadow extends across his cheek, its point at his nostril, the base at his jaw. His sphinxlike calm poses the question: Will you accept? I lift the binoculars from his hand. The brass casing is warm, and blurry with palm prints. On the underside, the manufacturer's monogram has almost completely faded, but I spot the first half of the date, 18 - -, and the initials *PA*.

"Nineteenth-century French. These wouldn't go for much."

"Take a look."

I laugh, saying it's too dim.

"You don't need light."

More of the unrefusable persistence. I bring the lenses to my eyes.

How can I describe what I saw? There was a leopard. There was a cage in which it circled, a crowd to whom it turned its back. There was smoke, roasting chestnuts, an organ grinder. There was a dwarf walking on his hands. There was a dog lapping an obelisk of ice. There were black cobbled streets swept by a girl-child without teeth. There was a boy's wool shirt waving from a flagpole. The gutters streamed with violet dye. There was a wooden emperor suspended over Europe on dancing strings. There were grenadiers in bearskin hats marching to a military band's stately, silent music. The trumpeter wore an eyepatch. The flautist looked drunk. And there was light, reflecting in an Ireland-shaped puddle a flock of arrowing cranes, light brighter by far than Axion's dingy mews.

"So you see."

But what do I see? "I don't—" My lips catch on air.

"It's a window. More accurately it's a pair of eyes. From what I've gathered, belonging to a woman, early nineteenth century, French. She's an aristocrat; what her title is I don't know but I believe her family has been recently elevated by Napoleon. She is young, unmarried, although suitors frequently leave visiting cards. Her home is in Paris, a family apartment on the Left Bank. She lives with her parents and sick brother, spends a great deal of time by his bedside."

Axion indicates the felt and leather pouches. "In here I have the eyes of an Ottoman spice trader, here those of an Iroquoian matriarch. You don't believe me?"

I must look incredulous. Having gazed through her eyes my face must no longer reflect my own thoughts. I believe Axion, believe him absolutely. What's gripping me is not incredulity but insatiable curiosity. Questions fly into my head without hierarchy, too fast for words. I reach for something solid and my hand is suddenly wet. Coffee. Finally manage to stutter, "Why these people? What's their significance?"

"What is mine? What is yours? Yet we have received this gift." Axion clasps my juddering hands. His pupils scintillate like boiling tar. "There are three universes here. I cannot live in them all. But I have no right to lock a universe away. So I offer you the French woman's eyes. Do what you want with them—write an article, a short biography perhaps. You will be criticized for inaccuracy. Or simply watch. And when you reach the end, you will not be alone."

I nod, afraid that words will break the spell.

"Take her. She's yours."

———◆———

Over the days to come, I watch the woman inside the binoculars devour books about Native Americans and the Aboriginals of the raw new continent in the Pacific. I watch as she strolls the Seine, leans out her window overlooking the morning street vendors, steadies her tremors before knocking on her brother's door. I read her journal before seeing her face. She scrawls her thoughts in ragged cursive, then locks them away in a drawer of her vanity. Whenever I catch her at it I open the recording app in my phone to narrate what I'm able to make out (my French is good enough even with her antique handwriting) and, once she has gone to sleep, transcribe it in the sodium halo of my Anglepoise.

4 March 1807

How Paris bores me! All day Maman has spent [illegible] the number of forks for tonight's reception. As for the piano, she only plays when we have visitors, as a feeble [illegible]. [illegible] hatred of all things German since the war. Edmond is on another doctor and still in terrible pain. In one of his fugues he was repeating "Let me die." [Illegible] better if he'd passed away that first time. But we keep him alive in pain, not for his sake, but for the health of our own consciences. In the New World, they are free of such

hypocrisy. Perhaps there I would be happy. Oh, to know the names of plants and to navigate by starlight and live with the sun on one's back!

6 March 1807
Edmond was coughing blood this morning. Maman went shopping. She turns her back to reality. It is why she gives me Papa's letters to read first, so that she can avoid the shock of bad news. There has been nothing in three weeks and she acts happier than when we were tracing our army's [illegible] on the map. Without his word, it is as if Papa does not exist so cannot be harmed. What will we do if he dies?

All this I hear in my own voice. Her crushing entrapment and countervailing romance of escape remind me of my young self, stuck in a Richmond semi with a choice between parents whose highest expectation was that I become a plumber and the universe of books. Because she disdains the mirror, all I have seen of her are her hands, plump and raw-knuckled. The rest of her I am left to imagine. Yesterday, while she was out picking lilies, I gave her the obstinate Morel nose, the distinguishing feature of the women on my mother's side. For three hours, she had a blonde bob, until I noticed her pick a stray red strand from her sleeve. Her eyes, because they are mine, have always been blue.

————◆————

Her name comes to me over a half of grapefruit: Aurélie. The surname begins with a *Y* or *W* or *S*. I know both without thinking, like I know the position of my hands. Axion calls, hungry for everything. I tell him that she intends to marry the hussar her mother hates, that her brother lives, that she yearns for the sea. I do not give up her name; nor that, in the better world she imagines for herself, her brother and mother are dead; nor her naked body. That I caught before bed (my endurance has dwindled: I no longer hold up long after eight) in a gilt Italian floor-to-ceiling mirror. She had spent the day as a wild-eyed flush-cheeked Romantic, hair cascading behind her as she galloped on the back of a retired warhorse. As for that picture, like near-on all the others, I couldn't have got it more wrong if I'd had her as an eight-year-old Maori boy paddling Axion's canoe. Her face is skeletal: pronounced cheekbones under a gaze that is her only soft feature. A Boudican whorl wrestled down to her skull implies a talent for self-suppression. When the bath is full she unties her petticoat and for a moment I look away. I'm embarrassed seeing her, thin and naked, pinch the flesh

on her arms and examine under her breasts before she gets in. I used to fantasize about watching my neighbors when I overheard them fucking. But seeing her as she sees herself strips away all eroticism. Reality (hers) douses libido (mine).

Axion boasts of seeing the Venice of the doges and meeting Titian, of witnessing the preparation of fir leaf infusions and the slumber of eighteen families on the floorboards of a longhouse. He tells me he is pregnant.

"I'm praying I make it through. I figure if I focus on the Christian God and the Iroquois pray to the Great Spirit we'll have covered both bases."

I ask what happens if she dies.

"I suppose I'll become the first person to glimpse the afterlife and return."

———————◆———————

I miss Aurélie for two days because in Hyde Park I started hacking up blood. It began with a soft tickling at the back of my throat, the same as when I eat peaches (something in their pollen). At the end of a single, stabbing cough came a kidney-shaped clot, which a pair of mallards nipped at curiously. Dr. Edberg prescribes two sets of pills to treat the pain in my throat. I hide the swelling under my right nipple, newly puffed and tender as a pubescent girl's. It would only provoke another of Edberg's infuriatingly calm and rational recriminations. I wonder who will make it, Edmond or I, and what our siblings will do when we are gone. Aurélie will be in bits, despite her wish to be rid of him and her mother. Henry will receive the news too late to earn my forgiveness. I have his email address from the Caltech engineering faculty website. When things are nearing their end I'll write, make him fly over and leave him with an image of his brother no number of good deeds will expiate. The only vengeance available to the dead: to stick around.

One evening, Aurélie dines at Lapérouse. Its navy facade is lighter than I remember from visits with the Sorbonne classics PhD who explained that one reason it had stayed in business for over three hundred years was the discretion of its private dining rooms, where *ancien régime* aristocrats had entertained courtesans. A tradition she eagerly took her place in. One night she made me rent a hotel room and leave one thousand euros by the kettle so she could "feel like a real whore."

Aurélie has come to Lapérouse with her hussar. Oak paneling muffles the candlelight, which builds shadows into the tablecloth and the valleys of the hussar's forehead. I can see why her mother disapproves. She is magnetized by those Byronic eyes, despite their

promise of betrayal. He is no Henry or Edie, no deceiver: when he finds another woman, Aurélie will be the first to know it. If she wails and claws at him, he will simply reaffirm a man's right to a mistress. I'm shouting at her to read what his scoundrel's moustache and rogue's sharp brows so clearly say but Aurélie is entranced. Between soup and blanquette de veau, he spreads a sketchbook on the table. Showing his sensitive side. A crooked olive tree, a starling chick in its rough plumage, burnt Italian hills and stark Czech plains, distractions from five years' campaigning preserved in quick charcoal slashes, caught during rests between marches. Aurélie lingers on the landscapes. The binoculars' rims are cold but her gaze is warm, fanned by the glamour of elsewhere.

30 June 1807

Alphonse says we will live in Naples. He is confident Papa will approve the marriage. "He will not reject a comrade veteran," is his refrain. I have not yet received Papa's reply [illegible]. Maman collapsed in tears yesterday when I read aloud his most recent letter, which delivered the news before the bulletins: Tsar Alexander has at last sued for peace. It is strange that we no longer have to live with the uncertainty [illegible]. For two years we have cohabited with a ghost. The longer we heard nothing, the more the ghost faded. But then at one stroke, a new letter would revive him, flesh, blood, bone, all. And it would turn out that he was more distant than ever, traveling inexorably farther east toward the end of Europe. Now, finally, he is returning. Perhaps this new certainty will bring an end to my recurring dream. It happens the same way every night: I hear whispering; I rise from my bed; the whispering grows louder like the mistral rushing through leaves as I approach my vanity; in the mirror a man faces away from me, unmoving; I only ever see the back of his head, I reach out; for some reason, I think I can touch him; suddenly he turns and I wake up.

Two months gone and my brogues no longer fit. You could slip a tealight in before my toes and see its glow through the perforations. My watch is loose on my wrist. I have had to punch another hole in my belt. When I decline into the wicker chair opposite Mark, his shock at seeing me so transformed is unmistakable despite his flustered pretense at optimism. I tell him plainly, the same as when I asked him to be my best man, "I'm leaving for Paris tomorrow. This is probably the last time you'll see me."

His fork considers a shred of lettuce. "Does your brother know?"

"Edmond meurt depuis sept ans. Il n'y a rien qu'il ne sache pas sur le mort."

"Who is Edmond? You know I don't speak French. I'm talking about Henry."

"Yes, of course," I say, shaking my head of the fact that, for a moment, Edmond *was* my brother. Unsurprising perhaps, since this past week I've spent near on eight hours a day with Aurélie; how distant can she be from my thoughts? On Thursday, finally, I learned her address. Not ten minutes later I had a seat on the Eurostar and a hotel in the Latin Quarter, two streets away. When I return home from Mark sobbing into my shoulder while I reassured him that everything would be all right (tedious duty of the dying: consoling others for our own demise), the tabs are still open on my laptop and among them, my Gmail. "I can't tell him, Jared. He's your brother. That matters." I type quickly, my fingers a blur, and hit send before thinking begins: *You have three weeks to reconcile. Here is where I'll be staying. Don't imagine I'm expecting you.*

The Quarter. I search for Aurélie among its women. The hotel receptionist has her hands. One of the maids wears her sharp gull's nose. I find our eyes, sister, in a café perusing *Le Figaro*. But while her body has merely dispersed, her home has been demolished and replaced by a squat cream block. Instead of a glowering doorman, the ground floor is taken up by a bobo design shop. Brass magazine racks and tribal masks crowd the glass. Inside, the scent of oiled cedar. I ask the owner, a wily pensioner whose bald head is contoured like volcanic rock, whether he sells binoculars. He points out an alleyway of stacked chests. On top of one, upright like a lighthouse on a cliff, stands the shop's sole pair. Blood drums against my ears as I bring them to my face. But when I look through, all they magnify is my own blurred feet.

The apartment belonging to one of Alphonse's comrades, where Aurélie and the hussar meet out of sight of her mother, is now a wine bar. The cobbled alleyway she uses to slip out unseen occupied by a row of shops. The architecture of secrecy replaced by one of openness. But that doesn't make double lives any less enthralling; it's only the talent now required to live them requires a more consummate deception. Edie's mask was her professional success; promotion demanded travel and travel made easy the fulfilment of temptation. How long could it have continued if she and Henry hadn't both suggested the same Manchester hotel to me when I was visiting for a conference? Perhaps years longer than the agonizing months of spite and recrimination, the longest half year of my life, as brotherhood and marriage ripped each other apart. For perhaps only their secret was sustaining them; without it they separated after eighteen months.

Aurélie is spending the day in bed, hungover from last night's ball. I'm not feeling so good either, so I cut short my visits to her surviving haunts. The dingy restaurant in the Marais, the milliners in the twelfth arrondissement, the École des Beaux-Arts will have to wait. I am naked in the shower when I notice the latest symptom: a tingling in my groin at the juncture of penis and balls. It feels more concentrated than the impact of the water jetting from overhead and in fact the sensation is quite pleasant. However, when I bend to examine it, I nearly slip from the shock: my penis has changed color from tan to rose. Among the mass of pubic hair it juts out like a cold-chilled nose from a beard. Despite the heat raising a thick steam against the mirror, it has also shrunk. Likewise, my thighs, whereas the new shooting pain in my hips, which began in the Channel tunnel, seems to have expanded them. My body is a Judas. Five years ago, it made me into an unwilling monk. I took revenge with a shard of glass to my thigh. The Shias who thrash their backs to a bloody pulp proclaim they act out of devotion, but their true instinct is one of despair: the flesh unequal to the spirit. Until cancer, I would never have considered hurting myself. Now, if I did not have Aurélie, I would have added to the jagged scar.

Three snowy lathers fail to wash out the rose. What can I do but accept it? It's not like I have a use for my cock anyway, not as long as the only woman I want lives inside my binoculars. No use for anything but my eyes. Just as long as I am left those. I am cinching my dressing gown when the bedside phone trills.

"Mr. Andrews? This is reception. Your brother says he's here to see you. He asks if you will allow him up."

Ice freezes in my veins. The phone with its confused tail sits dumbly in my hand. "My brother?"

"Yes sir, that's what he says."

"Which room are you calling?"

A pause. "Your room, sir, number thirty-one. Should I send him up?" The ice has turned to tar: thick, simmering. I want to scream.

"I'll tell him to wait in the lobby." The tone: accommodating yet authoritative, like Dr. Edberg. I can picture Henry on the other side of the desk, every inch the quiet professional: tortoiseshell glasses, tidy haircut, crisp ironed shirt; nothing to imply that here stands a man who has done more to destroy his family than Claudius. All that propriety the most effective disguise for the demon beneath. Why did I tell him I was here? Why did I invite my killer to gloat over my corpse? I might have had children to comfort me

now, a girl and boy perched on the foot of my sickbed playing tic-tac-toe and Edie apply-
ing a cold press to my forehead. Because of Henry, I will die alone. Alone but for you,
Aurélie: Axion's gift, the weight of a human hand but will stay in mine as long as I want
without the false promise of a ring. I'm crying as I put her to my eyes.

All is blurry, brackish. Then she looks up from the water to Alphonse offering what
should be my arm, my firm support. Languidly, she turns her head to look back across
the Seine and my blood jumps: it *can* be my arm. Because on the opposite bank stands
the Palais du Louvre, fifteen minutes by foot from my armchair. Forget Henry. Forget
solitude. Aurélie is within reach. Down the emergency staircase, avoid the lobby; I'm
sprinting along the bank, my oversized shoes rattling against my toes and rubbing my
heels. Skip past a pack of drunks who hoot after me. My steps echo off the banking and
my panting off my skull. Running after a two-hundred-year-old woman was not one of
the palliatives suggested by Dr. Edberg. To my relief, Aurélie and Alphonse soon stop
beneath the Pont Royal. Ten paces away, I catch my breath and then tuck my hair behind
my ears and with a wet thumb primp my eyebrows as if I'm going to introduce myself. My
heart thumps as I approach. As if nervous also, Aurélie looks down at her feet and shuffles
them so that her toes protrude over the fissure between the path's two central paving slabs.
Carefully I align my feet with hers and we are together, in the same spot, facing in the
same direction, overlapping as we never could if we shared the same reality. Behind my
ribcage her heart beats two inches below mine. Her Boudican hair falls below my shoulder.
As her mouth fixes on Alphonse's, his Italianate curls flicking and tickling her nose, the
building anticipation in her pelvis also stirs in mine. She is desperate, vague, hopeful, and
afraid. The mixture stirs in me like booze in an empty stomach.

What if he leaves me in Naples? It's been so quick, and I've promised so much, have
given so much already. What if I'm too desperate to leave? There might be another war,
his leg will have healed enough to ride, and I'll be stranded like Maman, dreading the
news. Or he might find another woman; he's had others before me. And the question
that makes me tremble: do I really love him? I want him; when he kisses me I burn. I love
when he touches me. But that can't be the sum of love, can it? When the poets speak of
love it is a foreign country, like Alphonse's sketches. I weep over Werther and Charlotte
like I never have over Alphonse and if he left me I would not do as Werther and take a
pistol to my head. What if he is just freedom more than love? Once we are in Naples, a
new country, yes, a new world might be the love I need. And if it isn't?

They come like her name, unbidden, clear, for the first time unadulterated: her thoughts. For a moment I am the infinity of another human being. And then, as I follow them to Alphonse's friend's apartment, they come again: her pity for a passing street urchin, her anxious seeking for anyone who could tell her parents, her excitement as the key twists in the lock. For minutes after the door closes, leaving me staring at a bemused wine bar sommelier, I lose my own name.

What is happening to me?

I can feel it all falling away. Everything except Aurélie. Standing with her, *in* her, was like running under a laundry line and a shirt attaching to you, wrapping itself over your eyes.

I tear the binoculars from my neck, heave them toward the first appearing stars (suddenly like lifting a breezeblock overhead). They crack, a skull on the cobblestones, conclusively. A double-jointed streak blinds the left lens. The right is loose in its casing. I stumble drunkenly toward the Seine. A party boat blares music from below. Axion's miracle pirouettes down, down, and under its trailing foam.

The last sight in those lenses, the terror that brought them crashing to the ground, was our journal, where on a new page she had written: *The man in my dream.* Below, unmistakable, stared back my dark and eager face.

———◆———

I wake in panic, something still clinging from my dreams. The darkness is a tomb. For a moment that gapes like eternity, an anchor sinks onto my chest, pinning me under. I sweat to throw it off until I am only battling with sheets. Now I am awake. I call Hortense to draw back the curtains and bring my morning brandy, but the expected creak on the landing and three sharp knocks on the door do not sound. Strange. I listen closer. Manou is usually shouting about carrots and apples by now, yet I can't hear a word. I stumble toward the window and go smack into a wall. I must have got out the wrong side. The carpet feels softer today, almost like sheep's wool. I bump my hand. A doorknob, which I twist before stepping onto the landing—but this is not the landing. It is dark and beneath my feet is cool stone not wood. Panic rises in my throat, I twist, elbow something and suddenly all is light. When I remove my hand from where I've thrown it up in front of my eyes, I start to scream.

There is a sink that is not my sink. There is a rimless mirror that spans a wall and it shows me in a man's striped underclothes and not my petticoat. There is a footless bath.

And this vicious sudden light is not the sun's nor a candle's; it emanates from four circles in the ceiling that do not flicker or weaken or change.

This is not my room. I call Hortense, Maman, dear sick Edmond. My knees are trembling so violently I can hardly approach the navy curtains, which the light from the bathroom has shown on the wrong side of the room. "Please, God, deliver me." A little prayer before I tear them open.

How can I describe what I see? There is a teeming crowd. There are horseless metal carriages. There are women in men's clothes. There are white buildings one after the other. There are great windows like I have seen only in churches, only colorless. In one opposite, there is a girl watching a black-framed painting on the wall in front of her, which moves. In the sky, a stiff bird progresses without flapping its wings, which stiffly trail white as if the sky were water.

I bite my knuckles, I splash myself with cold water, I pull a strand from my head to check it is still red: all the tricks I know to break out from a dream. Then I fall to my knees. "Oh, God, I know I am a sinner. I wished Edmond and Maman dead. Alphonse and I have lusted and I did not confess it. I swear to be honest, Lord, to obey the church, to follow your commandments if only you release me."

I reopen my eyes to the same room: cream carpet, blank walls, bed, wide transparent windows; nothing to root me or to recognize. Bewilderment. Until my eyes settle on a man's costume hung over the white closet door. Unbidden, I feel a twinge as if I have seen it somewhere before. But that is impossible; I would have remembered such bizarre attire: gray jacket without braiding or medals, black trousers without a stripe, plain white shirt. And yet, yes, tingles of recognition scald up and down my nerves. I reach out. The same sensation of sleeve against fingers I've felt a hundred times. The fabric's musk is exactly mine. The stain on the lining under the breast pocket: wine, I remember someone spilling it. He has a moustache, glasses, a rough voice full of humor. He gave a speech before knocking over the glass. The suit—I wore it the night before my wedding! And the man, Henry, that's his name. Wasn't he here to see me yesterday? But I'm not here anymore. I'm dead.

No. I rush back to the bathroom repeating like a chant, "My name is Aurélie Soult, my papa is Alexandre Soult, brother Edmond, Maman Elisabeth . . ." Thank God, it is I in the mirror: red hair, gull's nose, cheeks rouged to cover the jutting bones.

But not just you. Look at the eyes.

They burn blue like the root of a flame. My instinct is to pull away, to protect myself, but a question in them holds me: Who am I? And with the question, the answer: Not only yourself, not entirely another.

This is his room, these are his clothes, and nubs of his beard around the plughole. And this is my hand on the sink, my breath steaming the glass, my cheeks flushed with blood. And then a thought, his thought mine: Axion did not know his true gift—to have destroyed the cancer with a new body and to have made a lonely self plural.

Suddenly a violent trill erupts from the bedside table, shaking the machine with a spiral tail and numbers on its back. A telephone, that's its name. It brings voices from one place to another.

"This is reception for Mr. Andrews. Your brother is in the lobby. He says it's very important he speak to you."

Henry. The bastard.

"Tell him I'll be down in a moment." I do not know what I'm going to do. I'm confused and yet certain, spoiling for a fight and afraid of one. Aurélie and Jared. I test the suit jacket; it sits baggily on my shoulders and descends past my fingertips. I cannot go out like this, I need more suitable clothes. Yet going out is the only way to get them. If I want to eat I will have to go out; if I want to live.

The corridor is empty and lit by the same blazing ceiling discs as the bathroom. Past a man talking into his hand and through rippling glass into the lobby. At reception, I say I'm here for Mr. Andrews's brother. The concierge looks askance, probably expecting Jared's body to be in Jared's clothes, before pointing to my right.

"You the wife?" says a tan, bespectacled man who shares Jared's affable button nose and blunt chin. A frost round his ears is the only sign ten years have passed. Otherwise, he is the picture of health. Bastard.

"I'm not married. Your brother only ever had one wife."

His expression darkens. "That's . . . we're . . . not anymore." He lets out a short coughing laugh and quickly covers his mouth.

"What do you want, Henry?" Jared on his own could never have sustained such iron hostility.

"His email, it said he had three weeks to live. I've got so much to say . . . I realize I'm not saying it well." Henry reaches into his pressed corduroy jacket and when his hand emerges it is latched on to an unmarked white envelope. "Everything I need to tell him is

here. If he lets me see him, and please, mademoiselle, whatever he's said to you, I beg you, let me see him, if he lets me in, it's written so I won't forget a word."

His atonement. His plea for forgiveness, so close I could lean forward and inhale the crisp new envelope smell. I lean back.

"You're too late. He died last night."

The California tan seeps from Henry's face. His chin falls forward. His free hand motions as if trying to open a doorknob. He starts, "Did . . ." but can't assemble the rest of the question. He has time: it's the question he'll be asking the rest of his life. A turquoise armchair catches his collapse. In the buffed marble, I can see the reflection of hands covering his nose and eyes, the hands that caressed my wife and then embraced me, the hands that loaded her boxes and drove her away. Henceforward they will be stained with tears. I deposit the keycard on the armrest and as I turn Henry indicates feebly toward the staircase. I shake my head. I'm not going up there to Jared's life, to Aurélie's. My time begins anew. I turn toward the street. The city streams through revolving glass: sun, smoke, cacophony, argument, dust, exertion, liberty, life. My feet carry me out of two pasts into the world's great current. ❧

The After Party

NAJEE FAREED

Everyone is black in heaven, even the living. William Shakespeare? Nigga. Alfred Einstein? Nigga. Confucius? Nigga. Prophet Muhammad? Nigga. Cleopatra? Nigga. Beethoven? Nigga. Julius Caesar? Nigga. Marilyn Monroe? Nigga. Jesus Lavonte Christ? Nigga! Elvis Presley? He's still white and burning in hell for what he did to black people's music along with every US president, every Boston Celtic, and the first demented fucker who thought it would be a good idea to put pickles on a chicken sandwich.

I've seen God a few times since I've been here. Sometimes he's a man and other times she's a woman. There's only one God, at least the monotheists got that right. But nothing else. Not the white beard, the burning bush, the long white robes, and definitely not the white skin. God, the man, looks like Morris Chestnut circa 1999. God, the woman, looks like Angela Bassett. God breathes death into you the moment you pass to our side and then God never speaks to you again. Absent in life, a cold shoulder in death. Here's my first lesson: God does not care about you and sure as hell does not give a fuck about me.

Heaven ain't hard to find. It's in East Atlanta, right off Exit 68 & 5/6. The biggest lie in life is that if you do good deeds with good intentions and love God then you are going to heaven. That's not true. The truth, as uncomforting as it may be, is that heaven is indiscriminate between the good and the bad. We are selected at random and heaved into our eternity without much of a second thought. Unless you had the misfortune of being a Boston Celtic, a US president, or Elvis Presley. There are popes, prophets, nuns, saints, scholars, rabbis, philanthropists, and imams in hell. There are pedophiles, rapists, country music singers, murderers, pillagers, Jehovah's Witnesses, and thieves in heaven. The gates are wide open at this point, and there is still no space for you. And there is my second lesson: there is no nuance in the afterlife.

The afterlife is all black and white. Bad and good. Hot and cold. Stupid and smart. Life and death. Heaven is small, only about eight miles long and fifteen miles wide. There are no shadows, no contours, no outlines, and no highlights. The world lacks definition, everything has been smoothed into binary. Die and become an angel or die and be a devil. I'm Serena, an

angel. Tonight, three of my favorite angels and I are going to the after party at God's house.

"I came here while you were gone. I'll see you at the after party," Josephine says, holding up a thin slip of paper and waving it across my eyeline. She's one of my three angels and I'm one of hers. "That's all it says. There's no name on it."

We're standing in the bathroom. It's about ten square feet, white tile on the floor, shower with no tub, and a cramped toilet. A mirror stamped over the medicine cabinet. One of the hinges has corroded, giving the mirror a slight tilt.

Josephine's fingers are cloaked in tawdry gold jewelry and chipped scarlet acrylics set against her oak-colored skin. She's as tall and thick as a tree, her fingers wriggle in front of my face like branches. Her dress clings to her like an extra layer of floral-patterned sequin skin. Josephine's tiny wings can barely get her off the floor and sink into her girthy back. She grins with jumbled lipstick-stained teeth.

"What you smiling for?" I ask. I swipe the note from her hands and place it down on the bathroom sink.

"I think it's from Killa," Josephine surmises.

"You mean Aquil? I am not calling no grown-ass man by his street name," I laugh. "Fake ass hood nigga. Probably drew his teardrop tattoo with a Sharpie."

"Aquil, Killa, whatever. You know who I'm talking about," Josephine replies. She rolls her eyes. "Y'all soulmates."

"He ain't my problem no more. We're done," I scoff.

"I thought y'all was cool?"

I lean into the foggy mirror, close enough to give myself a kiss, and I press my falsie into my eyelash. I blink a few times and jostle it in place.

"We as cool as he wanna be."

"What did he do?"

"He be breathing and shit."

"Serena, you cannot be serious."

"Josephine, I won't be dating a living boy. Soulmates or not."

I back away from the mirror and shimmy my shoulders. My ivory wings spring from my back. My right wing is ruffled, but I clench my back and it straightens. My left wing is crooked. I bent it, trying to fly on my first day dead. God says we aren't supposed to fly for a week after we die but people told me God said I was going to hell my whole life and I ended up here instead so what does God know?

"You so difficult. We leaving in five. So hurry up," Josephine says. She stomps out of the bathroom into the living room. I wave her away.

And then I exhale.

My nose is bleeding. The blood has dried at the opening of my nostril, but more is gushing out. It streams down into my mouth. I lick it, sliding my tongue across my top lip. The blood tastes like syrup and mucus. I slurp the blood until it's all gone. I turn on the faucet and rinse out my mouth. Drink. Gargle. Spit. Drink. Gargle. Spit. Smile.

I turn off the water and tow my arm across my face. My body suddenly feels so heavy. My shoulders are locked into my back and my feet to the floor. I don't want to go to the after party but we have no choice. We were invited by God herself. I wave goodbye to myself in the mirror and saunter out into the living room.

Josephine stands at the door, taller than the frame, tapping her cumbersome foot against the floor. Simone stands next to her, but she's so short it looks like she's sitting, and her wings are so big they're always on the verge of tipping her over. With her gigantic nose looming over her tiny lips, her entire body is a juxtaposition of extremities. Knobby knees with big feet, giant tits and no ass, long arms and stubby legs, large ears and meager eyes. She ain't all that pretty. I love her though. She's probably the only one of the four of us who deserve to be here.

"Okay, I'm ready to go," I say.

"Finally," Josephine responds, ducking her head beneath the top of the doorway.

"I didn't mind waiting on you. You look very pretty," Simone says before tailing off behind Josephine.

She never minds anything. It's nice to have someone that nice around sometimes, but most of the time I just want to stab her in the eye and wait to see who will apologize first. Me for stabbing her in the eye or her for getting stabbed. My money's on her. She's such a people pleaser. It makes me sick. I love her though.

"Thanks Simone. You look pretty tonight, too," I say with a smile as I follow behind her. I could barely make out her hunched back from underneath her wings. I guess I'm a people pleaser too.

The fourth angel of our group is Cinnamon. He's the driver. I knew him a little bit when we was alive, I used to date him in middle school. That was before he knew he was gay. I don't know why I didn't see the signs before, ain't no straight man gonna call himself Cinnamon. He is beautiful though. I always asks if he changed his mind and decided

to be bisexual, and he always says if he could change his mind then he wouldn't choose me. He has the smoothest skin I've ever seen, and because heaven ain't got no shadows, his matte brown skin clings to everyone's eyes. Just like me, he never thought he'd be here. His momma always told him gay men ain't got no place in the kingdom of God. And now we about to go party at God's house.

We all load into Cinnamon's golden 1999 Toyota Camry. Josephine cramps into the backseat, and Simone files in behind her. They slam the door shut and disappear behind the five percent tinted windows. I flatten my wings against my back and get in the passenger seat. Cinnamon shifts the car into drive and pulls away from our house.

12:17 a.m., December 26th, Jesus Christ's birthday after party. Blinking Christmas lights, Santa Claus inflatables, and Rudolph the Red-Nosed Reindeer figurines sprinkle the yard of every passing house. Another thing they don't tell you about heaven is that it's here on earth. The dead, we live among them. Most of them can't see us. Only those who are either truly pure or truly corrupted have obfuscated themselves from the living enough to see us.

Life is a mix of the good and the bad. A lot of people are a lot of things. And somehow in the process of dying, we lose everything special about us. My heaven couldn't possibly be the same as Josephine's, Simone's, or Cinnamon's. Josephine's heaven would probably be filled with big-dick men, lemon pepper wings, and rivers of Hennessy. Simone is a bit harder to read. She is always feigning happiness, it's hard to decipher what doesn't work for her. I think in her heaven, she'd be beautiful. Cinnamon's heaven is new. He just got here. He's still enthusiastic about being in everyone's heaven that I can't imagine he took the time to dream of his own.

I have spent my entire death dreaming of a different heaven. In my heaven, it'd always be raining with the sun out. Rainbows galore. I'd fly whenever I want. I'd visit the moon or I'd eat a star or I'd murder someone or I'd listen to music or I'd have someone next to me who loved me only in perfect increments of time and never in the right place. I felt more free on earth. At least there I could be content with my dissatisfaction, knowing that life is not supposed to be perfect. But what use is an imperfect heaven? A heaven where I could bleed or be heartbroken or cry or feel pain. I never understood the things people said God liked and the things he didn't. I can't imagine any heaven of mine where hell exists. Elvis gotta go somewhere though, and it sure as hell should not be heaven. That's my next lesson: stop trying to understand shit.

"I was next to God the other day. I had the opportunity to see her face," Cinnamon says. "I decided not to look."

"Why not?" I ask.

"What if God had something in her teeth or something? You think I would have had the gall to tell her about it? And I can't meet God if she don't got her shit together. I'd be ashamed and embarrassed for her!" Cinnamon exclaims.

"You realize we going to God's house right now?" Josephine scoffs.

"Yeah, but I ain't got to see that nigga," Cinnamon replies.

"Why would God have food in their teeth?"

"God is black with a black son and he still let slavery happen. God is vindictive and loves to play with us. God sat in they house, ten minutes down the road from mine and watched my daddy lay his hands on my momma every day for three years and ain't do a damn thing to help her. I don't put nothing past that nigga. I love God, but God just as fucked up as the rest of us, chile," Cinnamon says.

I hope that's not true.

"That's not true," Josephine says. "Ain't no way God as fucked up as me."

"It is true. I was there. I lived through God's apathy and I died cuz of it too. I can't look God in the face after everything I been through," Cinnamon says.

The car falls silent.

We all have our own versions of hell too, although there is probably more overlap in hell than there would be in heaven. It's easier to hate something than it is to love something. That's the problem with the whole world. They tell us God hates a lot: greed, sex, love between the wrong people, murder, dishonesty, gluttony. But God only loves a few things. I know my own hell is being captured in the wrong light and being trapped in that frame. Like a painting, in a museum, I can see it now: white skin, blue puffy dress, red satin ribbon in my hair, disheveled and completely miscast. I shudder at the thought.

We turn the corner of God's street, and his house sits at the center of his cul-de-sac. On either side of him are two smaller houses. Nancy Reagan and Genghis Khan live on one side of God while Prophet Abraham and the Virgin Mary live on the other. I don't know why God would want to have a crack peddler, a genocidal conqueror, an attempted child murderer, and his baby momma as his neighbors, but I guess these are the mysterious ways of God working as advertised. None of them have any Christmas decorations on their houses. There is a lone, poorly illuminated sign in God's front yard that reads

HAPPY (NOT) BIRTHDAY JESUS in basic bold font with an accompanying portrait of him. If not for the hectic parking frenzy and litany of car headlights flooding the neighborhood, God's cul-de-sac in heaven would be the darkest place in the universe right now.

Cinnamon parks his gold Camry a few houses down from God's house. We get out of the car and saunter over to Jesus's birthday sign. Jesus looks nothing like the stories on earth say that he does. The biggest and perhaps most striking departure from the Cardinal Cesare Borgia is not the difference in the color of his skin. Jesus is bald. I was shocked the first time I saw him, but it began to make sense the longer my mind stayed on it. Jesus has always had long, nearly Samsonian hair in every depiction I had seen of him on earth. But it completely figures that a thirty-three-year-old Jewish man would not have a single hair on his head. He had inherited male pattern baldness from God himself. His head is gleaming in the picture of him on the banner. Without a hairline, his forehead looks like it just goes on forever until it rolls into the back of his head. He isn't especially attractive, or at least he's not my type. He's not ugly. Just goofy looking. I would not trust this man to leap over a five-inch-deep puddle, let alone walk on water. Nigga look like a Milk Dud.

Cinnamon snickers as we walk past the sign, but the others seem to barely acknowledge it all. I guess Jesus is commonplace here. No more special than the rest of us. We can thank God for that. We walk in a straight line of ascending height: Simone, me, Cinnamon, and Josephine. We clench each other's hands and sift through the crowd. It gets thicker and thicker until we arrive at God's front door.

His house is white with white shrubbery and golden foliage, golden shutters, and golden shingles. His oak door is wide with a golden doorknob. Simone grasps it in her tiny palm and opens the door. A sudden blow: the scent of marijuana fills the room and sits down in the back of my throat. I close my eyes and cough, cupping my elbow to my mouth. Simone seizes my hand and leads me through the smoky clouds. I keep my hold of Cinnamon and do the same for him. She's talking to me, but I can't hear her. "March Madness" by Future blares through the speakers. You can't hear it when you're outside but the moment you open the door, you can't hear anything else. God's entire house shakes. Everyone is singing along, but no voice can be made out distinctly. Soon it becomes so loud that I can't hear anything at all, not even the music. The inside of my head goes hollow. Simone sits me down on the living room couch and my body fills up again. A dead woman in God's living room.

Josephine and Cinnamon sit down on either side of me. Simone remains standing but she's eye level with me. I burrow my ass into the couch, rocking back and forth, unable to settle on the large scratchy cushion. Josephine speaks to me but I still can't hear her.

"What?" I scream.

"—" Josephine shouts.

"What? I can't hear you! This music is too fucking loud."

Josephine cuffs her hands around my ear and yells into it.

"Killa is here! He's walking over here right now!" Josephine screams. I carry my eyes from my lap to the doorway of the living room, and Aquil, the living boy, lumbers toward me.

Aquil looks more dead than I do, dark circles cloak his eyes and bags drag them into his cheekbones. A scruffy beard hides his perfect skin. His face is sullen, like a skull wrapped in skin and given lips. Aquil is tall and exudes confidence. His legs fly out from under him with every step, his massive feet slapping the ground in time with his long swaying arms. His eyes always look lost, searching over what he got and directly onto you.

He takes my hand in his and kisses it. His hand is covered in bandages. Bloodstains and dried blue paint spot his palms. He bends over and kisses me on my cheek, his beard scratchy and coarse. The song ends and he whispers in my ears.

"I came to your house while you were gone. I told you, I'd catch you here," Aquil says.

"I ain't come here to see you nigga," I hiss.

"Well, here I am and here you are," Aquil laughs. "I'm glad you're here. I needed to talk to you. Well I still need to talk to you. Do you want to talk to me?"

I roll my eyes.

"I don't understand what I did to you. We can't talk?"

Josephine nudges me and sucks her teeth.

"Of course she's gonna talk to you!" Josephine says. "Cinnamon and I was just finna go to the other room. Ain't that right Cinnamon?"

Josephine stands up and extends her hand to Cinnamon.

"I was about to sit my ass down right here. There are too many niggas in there, I do not feel like sweating," Cinnamon snaps.

"Yeah, there are too many niggas in there, and we about to go get you one. You lonely as fuck, that's why you always got an attitude," Josephine says. She snatches Cinnamon up from his seat and drags him away. Simone grabs his shirt and follows closely behind them. Aquil sits down next to me. "Pink + White" by Frank Ocean softly plays.

"What do you want, Aquil?" I ask.

"It's Killa. I told you that sweetie."

"Okay, Aquil. What you got to tell me?"

"Not here," Aquil says. He pulls a pack of Swisher Sweets, a grinder, and a dime bag of weed from his pocket. "I don't want nobody to hear me. We can go to the bathroom."

"What is going on?"

"I'm finna tell you. Just be patient."

Aquil does not look up at me. He places the buds in the grinder and churns it. He hands me the swisher and his car key.

"Gut that for me," he demands.

I run the jagged edge of his car key down the belly of the swisher, and the tobacco falls out onto my dress. I wipe the guts down to the floor and pass the swisher back to Aquil. He empties the grinder into the blunt and pearls it shut. He raises it to his lips and flips open his white lighter, then inhales before spraying the smoke into the air. It fills in thick above his head, trailing back down into his mouth. It swirls and dances, I stare at it. The smoke is mesmerizing, familiar in the way it sways in the breeze of the ceiling fan. Aquil looks at me and grins, showing off his flashy mall-kiosk grill. He fastens the blunt between his teeth and takes another drag.

"Smile baby girl," Aquil laughs.

"Excuse me?" I mutter.

"I'm just telling you to relax. You look hella tense," Aquil says. "You already dead, can't nobody hurt you here." He extends the blunt to me. Aquil's and my fingers touch, Michelangelo's *Creation of Adam* flashes through my mind before the blunt joins my lips. I suck on it, *inhale . . . exhale.* I pass it back to Aquil.

"How do y'all do this shit?" I laugh. I feel like my lungs are about to croak from my chest and flop onto the carpet. But instead, my wings just feel a slight tingle. Weed is better for me in heaven. I only smoked a few times when I was alive. It used to make me anxious. But here, I just feel a bit lower. Dead people love being grounded, makes us nostalgic for the times we were earthbound. It still hurts my throat though.

"Definitely a habit. It just eases that pain a little bit. That's all," Aquil notes.

"You can get a habit that doesn't start a campfire in the back of my throat. More pain don't help with pain," I say. But that's not true. Most of my pain could have benefited from being grander or more intense. Throughout my life, most of my pain has come

from inconveniences rather than tragedy, and I felt guilty for even feeling the pain at all. I haven't earned most of my sadness. I'm unhappy with the life God breathed into me. I wonder if God hates me for that. God just walked into his living room with a dead girl and a live boy sharing a blunt on his couch. So maybe I should just ask her.

"Has Jesus been in here?" God asks. God seems to shift between 1999 Morris Chestnut and Angela Bassett with every step. It's a bit disorienting.

"No Jesus here. Just me and my girl," Aquil says.

"I'm not your girl," I add.

"Tell me if Jesus comes in here. I have someone coming that I'd like him to meet," God demands. Every word hits my ear with a different vocal chord.

"Don't worry, this ain't the first time Jesus has went missing. I been searching for Jesus my whole life and I ain't found him yet," Aquil says. I don't know how he's able to be so bold. I can barely look at God without feeling apologetic. I look at God's mouth. There's nothing in their teeth. "I'm sure you'll see him before I do."

"Stop being cute," God says before pivoting and leaving the room. I bit my tongue. I am surprised I have any tongue left given the amount of things I have refused to disclose to God. But God should know what I'm thinking right? Then again, God can't find their own son at their own party. So what does God know?

"God don't know shit," Aquil laughs. "I don't know if I should be impressed or angry about that. You know how many times my grandma told me not to beat my meat cuz God was watching? That scared me off from masturbating for at least two years. Two years wasted."

"What do you want Aquil? You've been beating around the bush for long enough. Niggas got shit to do. I'm not finna sit around this party and talk about nothing with you for hours on end," I say. "I'm not getting back with you. So hurry and tell me what's going on before I go back with my girls."

"I don't wanna get back with you," Aquil retorts. He locks the blunt in his mouth with his lips and stands up. He extends his left hand to me. "Follow me."

I take his hand, and he leads me back into the crowd. "Zone 6" by Young Nudy is playing and the room is shaking, but I can still hear. My ears have adjusted to the volume. We snake through the crowd and emerge at the bathroom on the other side. Aquil knocks and no one answers. He opens the door and leads me into the bathroom without flicking on the light. He closes the door behind us and we stand in the darkness.

"You acting weird as shit," I say.

"You gonna get answers real soon," Aquil says. I can't see him, but the embers at the end of his blunt ebb and flow in the darkness.

"Can you turn on the light?"

"Not yet. Just stay still. This ain't gonna hurt much?"

"What won't?" I ask. I extend my arms out, ready to lunge at Aquil or to find the light switch, but I feel nothing but the air around my fingertips. "Aquil, stop fucking playing. What's going on? Aquil? Aquil? Aqu—"

Something cold and hard smashes against my head, and I fall to the bathroom floor. The side of my face is leaking blood. I think about standing up, but something tells me to stay on the ground whatever hit me was gonna hit me again. The light flashes on, and it hurts my eyes. I blink a few times before I see Aquil and Simone leering over me. So I try to keep blinking until I don't see them anymore. It doesn't work. Simone has a metal bat in her hand, nearly taller than she is. My eyes dart back and forth between them, utterly confused.

"Simone? What's going on? Why the fuck did you hit me with that bat?" I ask.

"For love," Simone replies.

"What? What the fuck are you talking about?" I shout.

"I am in love with Aquil. And he needs me to do something for him. So I'm doing it. It's nothing personal," Simone says. "I hate it had to be you."

"You hate what had to be me? Someone better give me an answer before one of y'all dies again and the other one of y'all dies for a second time." I say. "If this about Aquil, I don't want the nigga. You can have him."

"I wish it was that simple baby," Aquil says. "But I did something pretty bad, and I can't fix it without you. So I need you for it. I've been watching you for a while. You won't be missed. No one dead loves you. Not even your angels."

"That's not true," I contend. "Just because Simone is a fake ass dead bitch, that don't mean the rest of my group is fake. Whatever you planning on doing, it won't end well for you."

"That's the problem Serena, none of this shit ends at all. And it's tiring. My heaven is some rest. A bit of shut eye. None of this shit," Aquil holds. "And Simone, baby, show him that neat trick you got."

Simone collects a decorative towel from the rack and runs it under the faucet. She scrubs the wet towel on her cheek, and her skin turns from tan to pink. She grins at me and throws the towel to the side.

"You're . . ." I begin to say.

"I'm alive bitch!" Simone squeals.

"You're white? I thought you were just really fucking ugly this whole time."

"Oh shut up!" Aquil bellows as he kicks me in my side. I groan and grab my abdomen.

"Just hurry up and do whatever the fuck you want to do. You fucking psychos," I say.

"The worst thing you can do is kill an idea and I did that. Simone is actually an idea, a beautiful idea. She's the Comtesse d'Haussonville. Not the real one of course. But the idea of her, from the painting *Comtesse d'Haussonville* by Jean-Auguste-Dominique Ingres. And I killed her. By accident of course. I fell in love with this painting so hard that it came to love me back. And then it wasn't a painting anymore. Love can kill, but it can also create. I've spent the last few years re-creating her. And now she's ready. But it needs some of that good ole human spirit. And that's where you come in," Aquil explains. "I'm going to put you in the painting. You've already done us the honor of bleeding all over God's bathroom floor. Now hold still."

I have nothing more to say. Aquil places his foot on my neck and wipes his pointer and middle fingers across my open gash, gathering a glob of blood. Simone pulls back the shower curtain and reveals a large painting of a white woman bound with a big gold frame. Aquil rubs my blood onto the painting in the shape of a bow on her hair. As soon as he pulls his hand away from the canvas, I can feel myself begin to slip away. My body fades into nothing, my wings are the last thing to go. My final lesson: do not trust any ugly people because they may be white.

I am in my hell. 🦋

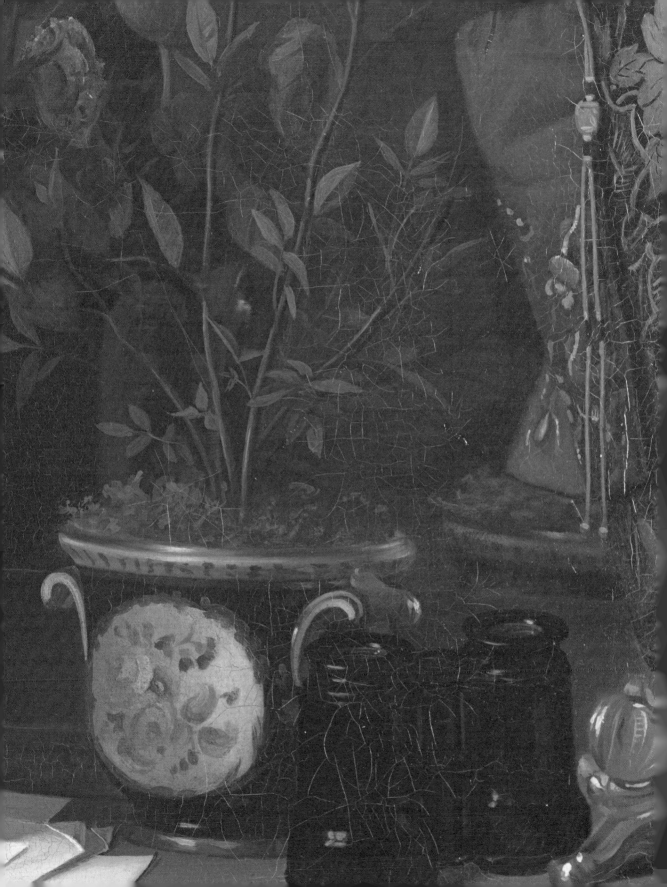

Submerged Islands

NINA FERRAZ

Dona Virgilia gave Helena the vase as though it was a message, the veins on her neck bulging, her two hands clasping her granddaughter's forearms, her whole presence fogged with old secrets. Helena melted into her grandmother's eyes, and the two women fell silent.

The vase was beautiful—light, delicate, perfectly polished, deep dark blue, richly adorned with details in white and gold on its edges and handles. The porcelain, fine and flawless, had a white medallion in its center, exquisitely ornate with flowers. What Dona Virgilia said was true: she, who had never left Pernambuco, had a vase that was practically identical to the one in the painting of the Comtesse d'Haussonville, by Ingres. Helena was looking at it right now, printed on the book bag she had brought from New York.

They were in New Petrolandia, in Dona Virgilia's bedroom, sitting side by side on the flowers of the bedcover. The room was dark, the wooden windows closed as always to avoid the sun and its merciless year-round heat. But they could see everything—the family pictures on the walls, the rocking chair by the bed, the old vanity with scars in the wood, the wobbly tarnished mirror. A delicate smell of Phebo soap in the air reminded Helena of love, intimacy, and storytelling—of the women in her family and how they all used to gather in Dona Virgilia's bedroom to talk about everything, anything, or nothing.

Helena was curious. What could that vase mean to her grandmother? What did it mean to her family? Dona Virgilia took the vase from her hands and started talking as if she had heard her unspoken questions.

"I love this vase. I loved it so much that one day I threw it away, out of the window, with all my strength, dead flowers and stale water flying everywhere. My first son had died the night before, here, in my arms. He was finally so still, no crying, no whimpering. His body was cooler, and I thought that the fever was receding. They had to take him out of my hands almost by force. I went to bed and slept for more than fifteen hours. When I woke up, I was mad and threw the flowers away."

Helena felt sad but also betrayed. Nobody had told her about the baby who died. Nobody had ever talked to her about death. Helena had grown up thinking that death was a rare calamity, something exceptional. And yet life and death are twins. The longer the life, the more you see its sister. Dona Virgilia kept staring at the vase.

"I couldn't bear to see the flowers wilt. I couldn't bear to see anything changing or fading away. I wanted to cast off, to desert all the beauty in my life. But the river saved me. The big alley beside my bedroom was flooded. The city was going through one of its worst floods that year, some streets transformed into Venetian canals. So the river was there, at the edge of my bedroom window. When the vase fell, the waters caught it. When it all receded, the vase was waiting, clinging to the mud. I love this vase, Helena. Maybe in all my madness, I knew the waters were going to catch it, to store it. And I knew that those waters would recede one day."

Dona Virgilia gently touched Helena's arms.

"You have to be careful, Helena. Don't throw things away. Some waters never recede."

Helena hesitated, and Dona Virgilia continued, her small eyes focusing somewhere in the distance.

"It is time to move forward."

Helena knew it was time. A few months ago, she had buried her father. It was all too recent; yet she knew it was time to move forward because it always is. For a second, she was sure her grandma was talking about her. The COVID quarantine, her work in the hospital, her losses: the last two years had been devastating. But maybe Dona Virgilia was thinking of herself, thinking of her Pedro. Though Helena had lost her father, Dona Virgilia had lost her son, which is even more disorienting. But then she said:

"It is time to go back to the Tower."

Back in the 1930s, Dona Virgilia's father had built a house so big, so splendid, so like a castle or a fortress that people called it "the Tower." But the house, Widow's Island, and all the other villages in the middle of the São Francisco River were now underwater.

Dona Virgilia was forgetting things. It was last year when they first noticed that she was going back and forth, sometimes floating in the present, sometimes submerging in the past. And she was in the past again. Helena would like to live there too, dwell in a time when she still had her family.

"We have to go back to the islands. Come with me, Helena dear, won't you?"

Helena felt a breeze of love on her face. Her solid grandmother, absorbed by those sentences, seemed to bend. For Helena, almost nothing changed when they moved from the island to New Petrolandia, a small town a few miles to the south. The houses were so similar that they overlapped in her memories—the same thick walls and small, dark rooms, the old furniture, the veranda all around, the chicken coop in the backyard. Helena could never remember what had happened in one house or another.

For Dona Virgilia, however, leaving the old house had changed everything. People say that moving is like being hit by a flood: no matter how much you prepare, something always gets damaged. And the Tower was her realm. When they moved, Aunt Leda was already a grown-up and took charge of their lives. Dona Virgilia became a guest in her own home, powerless, misplaced. She had left too much behind. Her house. Her past. The rest of her youth. Her brittle freedom. Her insulated pride. Suddenly, her world was underwater, invisible like submerged islands.

Helena gently brushed her gray hair and caressed her hands as if trying to flatten the veins and smooth all the wrinkles. Sometimes it is better to live in a lie. One day, Helena will just say, "I'll take you there tomorrow, Grandma." And she will surely forget everything, dams, islands, wishes, and promises. Maybe forgetting is what we all do. But, for now, Helena was clinging to the truth.

"Grandma, the islands are underwater, remember? Our house on the island is underwater. In the eighties, they built a dam, the Itaparica Dam. When the big wall was finished, they started collecting the water, filling up the reservoir, and we had to move. We had to leave our house, our town . . . that is why you and Aunt Leda live here now."

Dona Virgilia's expression didn't change, as if she knew where she was going.

She slid from under the bed an old kind of travel case, made of dark leather, heavy and stiff. Helena realized that she had never seen it or its contents before. She peeked inside, and Dona Virgilia nodded and handed her a manila envelope.

"This was for when I thought of leaving your grandpa."

Nobody had told Helena that either, but each one in the family had gulped down at least a sob of that pain. And Helena, as a woman, instinctively knew.

In our small world, every woman is a daughter of Eve, a sister of Emma Bovary. Back in that time, it was hard to be unmarried. And even harder to be unhappily married. Divorce was a preposterous idea. Freedom was a preposterous idea. Running away was the only option. Only the circus people or the Roma had a place for "those women," those

thirsty and dry women. Helena didn't know, but Dona Virgilia had almost become one of them. One of those women they used to talk about. Someone's daughter. Someone's wife. Always someone's.

It was in the streets of Serra Talhada. Helena was seven when she saw a Kale Romani for the first time. Her immense hair gave her a bird look. It cloaked her shoulders and waist, resembling huge wings full of jet-black feathers. The woman stopped on the other side of the street, studying Helena with her yellow eyes. She looked hungry and vulnerable but as if ready to fly.

Helena tried to find something of that black bird in Dona Virgilia, but it was impossible. For Helena, her grandma had always been only her grandma, old, tamed, grounded.

The papers inside the envelope were two tickets from Juazeiro to Pirapora, issued by one of those long-gone São Francisco River ship companies. Her grandmother had had someone else. She had had someone to make other plans with, someone to run away with.

"I bought this," Dona Virgilia said, touching the lid of the trunk, "and put all the things I thought I needed inside, including this vase. I was about to leave when your father woke up crying. It was a nightmare. He was four. He was terrified of the ghosts in his dream, and he held my hand the whole night. I felt guilty. I felt I was the ghost he had seen lurking in the corridors. He held me. And I let him be my anchor. I never asked him if that night he knew I was going to leave. That same month, I got pregnant with your Aunt Leda, and after that I never again had the courage to leave."

Dona Virgilia stashed the tickets in her apron pocket as if getting ready to go somewhere. As if, now that her son was dead, she could go back to that day and start all over.

Then Helena saw the pictures. The first showed Dona Virgilia in her wedding dress, covered in tulle and fake pearls, in front of the Old Petrolandia Cathedral. The church was tall. People said it was seven meters high from the floor to the tip of the cross. In her white gown, Dona Virgilia seemed sculpted over the church's white walls in high relief, monolithic, static, as Helena had always seen her. The other photo was more recent, probably from the 1990s, showing just the dome of the church, the tip of an iceberg as seen from a boat, in the middle of the lake. They were all proud that the weight of those waters didn't break their church or swallow it whole. The waters of the dam stopped rising just before engulfing the ceiling. Everything but the church—the whole city around was submerged, in ruins, a lost world, a meager Atlantis far beyond the Pillars of Hercules.

Today, oblivious people can drive their boats inside the church, crossing five or six meters above the nave, just beneath the dome, listening only to their own echoes. But the ones who lived before the flood can see the island underneath. From the dome, they can trace mental maps and revisit their old houses and their ghosts.

Helena realized she had her eyes closed when Dona Virgilia said, "Look, Helena. Keep looking."

Dona Virgilia gave Helena a picture that showed the Tower exactly as it was back in the eighties, before the waters. The yellow walls, the majestic garden, the hammocks, rocking chairs, and maidenhair ferns. Other photos showed other stories. The rising waters. A blond doll floating in the corner of an empty room. A rattlesnake swimming in front of the school. Some men navigating the main street in precarious boats, rescuing people and small animals.

"We know how to swim. We know how to drive a boat. We are from the islands. Life is a dam, Helena. A wall is built somewhere, the waters start rising, and you have to keep moving. If you don't move, Helena, this pain will drown you. That is why I am giving this vase to you. You have to save the beauty that is left."

Those words crashed into Helena like waves eroding sand, and she submerged again into her pain.

Her father had always been distant—silent and reserved. They were never close, but for her, he was a harbor, not a place to stay but a place to go back to. Ever since Helena left their small town to study in the city, they would talk for less than two minutes on the phone each time she called. "You are beautiful, Helena. I love you so much, you know that, right?" "Yes, Dad, I know. I took after you and I love you too." And that was it.

Helena's sister was in town that day. Her father called her, saying he was feeling sick and wanted to go to the hospital. She said "Okay, Dad, go. I will take a quick shower and meet you there." They never met. By the time she got there, he was already dead. Life is full of particulars, but death painstakingly follows customary storylines. And her father's story of chest pain and loving Hollywood cigarettes ended there, in cold sweat and nausea. Some scribbles on a slender strip of paper confirmed it: a heart attack. Helena had to wait until the next day to go from Recife to New Petrolandia. The road was dangerous. More than a day had passed since his death when Helena arrived, but the body was waiting for her in the morgue. He seemed to be sleeping. She touched his forehead, his cheeks. His face was his face: absent, cold, familiar.

The sisters embraced, no words needed. First came the man from the funerary services. He used their guilt to sell them his priciest casket. The girl from the flower shop also gave them some empty words meant as condolences and reassured them that chrysanthemums and carnations are the flowers for grief. With that heat, they needed a quilt of flowers.

They went back home, escorting the car that was bringing the body. They put the casket in the middle of the living room. People were coming from the towns nearby and also from Salvador and Recife. Someone put "*Il Silenzio*" by Nini Rosso on a speaker. They kept repeating the song the whole afternoon, just the instrumental version.

"Helena, it gets dark before five-thirty," someone said for the third time. She nodded, and the men gathered around the coffin. Everybody was waiting because they moved to the side without being asked and cleared a path to the front porch. They walked slowly the few streets to the cemetery, four men on each side, holding the casket handles. The sunset had a lot of red, but the evening had no other signs of pain. Somewhere, a rooster crowed for no reason, in no anticipation of dawn, fight, or hunt. A *vaqueiro*, the cowboy of those parts, passed by, tipped his hat, and rode toward the outskirts of the town. He was probably going to search for some lost cattle, his glossy black dog following him from a distance. In front of them, on top of a small hill, the cemetery was an improbable Constantinople, with its profile of small white houses adorned with flowers, crosses, and angels.

At the last minute, the fancy coffin disappeared inside a drawer-like hole in the north wall of the family grave. The two men cementing the grave were skilled and quick. Remembering this now, Helena could only see the glow of their sweat bathing their foreheads and arms.

To the right, a new marble plaque showed the names of her husband and son.

"Breathe, Helena! Breathe," Dona Virgilia said.

These days, whenever she thought about death, Helena held her breath and contorted her face, as if getting ready to be dragged by a huge wave. She had to dive. The voices inside her head were getting louder, but she was ready to hear them. She took a deep breath.

Helena blamed herself for the deaths of her husband and son. Her pride was to be blamed. She was an eye doctor. When the first cases of the new virus started happening in Recife, she was feeling safe. All her patients had to be free of flu symptoms and even test negative. And she said no to two requests to work as a first responder.

Helena said no, but she was ashamed. Her best friend was working twice a week in a hospital that treated all the suspected cases. Helena dreamt of being fearless, but she

wasn't. In her first years as a medical student, when she started working in the emergency room, she learned she would never be a real doctor, the way her father wanted. She almost fainted at her first leg amputation. She cried in the bathroom every time she had to face a horrible case.

And yet she thought that if she had lived in wartime, she would have worked on the front, and she almost believed it. She had a European view of war, where she would see herself hiding from bombs in metro stations, amputating legs of dirty and ragged blue-eyed men, using her language skills to comfort grateful soldiers in French and English and eventually in Spanish.

So, whenever she heard her friend's stories of selflessness and heroism, she felt bad, a coward. That was when she said yes. During her second week working at the flu emergency, she had mild symptoms, tested positive, was isolated, and soon felt better as if it were nothing. But her two men got infected. Their tragedy was so quick that Helena believed it was never going to sink in.

She kept working in the emergency room until the image of their dead bodies became adulterated with the anonymous bodies of her patients. She was afraid of being dragged down by these pangs of grief, these advancing waves of hard, dark waters. She would rather work all the time. She was afraid of going home alone, to that cold, to those menacing objects and the debris of memories floating all around.

"Breathe, Helena! Breathe!" Dona Virgilia interrupted her thoughts.

The two women embraced, their eyes flooded, the flowers of the bedcovers in disarray. Helena exhaled and stood up as if reemerging. She felt the air and drew another breath. She paced the room, holding on to the vase the way a drowning person would hold on to a floating object. She wasn't afraid of the current. She opened the windows and let the sun shine on her face for the first time in a year. Her body was alert. She sensed she could float and that was a good start. After all, some waters never stop rising. ❧

The Piano Teacher's Heart

OMER FRIEDLANDER

In the pleated folds of her dress, the Countess hid a crystal jar containing her piano teacher's preserved heart. The heart was floating in an expensive Gautier cognac. Holding her head high, she went past hoop-skirted women in puffy sleeves, men in ruffled cravats and stockings, navigating the vast marble Strasbourg Platform, under steel and glass. The coal-burning train hissed, coughing thick, ribbony steam. She took her seat opposite a thin man, severe and gaunt as a grasshopper. The crystal jar, hidden under the folds of her dress, was cold against her bare skin.

The Grasshopper withdrew a long pipe, stuffed it with tobacco, struck a match, and lit the end, puffing. Smoky haze filled the small compartment. The Grasshopper was staring at her. His voice barely above a whisper, he asked, "Is it safe?"

For a moment, the Countess thought the Grasshopper knew about the preserved heart. But he added, "It's my first time on board one of these death machines."

The Countess nodded. "Quite safe." But it wasn't. These new trains derailed all the time, caught fire, or were robbed at gunpoint.

The Grasshopper introduced himself, but the Countess soon forgot his name. He was traveling to Warsaw to purchase a very precious item for his cabinet of curiosities. He had been disappointed so many times before by cheating merchants. So many fake collectors were selling narwhal tusks as unicorn horns it was unbelievable. But this time, he believed the artifact was genuine.

"What is your business in Warsaw?" the Grasshopper asked.

"I stole someone's heart," said the Countess.

"Lucky man," said the Grasshopper.

The Grasshopper smoked his pipe. They sat in silence until the next stop. A disheveled young woman wearing a long overcoat, hoisting a large rucksack over her shoulder, sat next to the Countess. The woman's fingernails were dirty. Her unwashed hair hung in clumps from her head, but her eyes were unusually striking, the color of log moss. The Countess couldn't think of a good nickname for the young woman, until this urchin withdrew from her rucksack a raw turnip. Scraping the dirt off the bulbous

root, she bit into the purplish-white turnip with a sharp crack. She would be called Dirty Turnip.

That night, the Countess woke up to Dirty Turnip's hands in the folds of her dress. She was holding the crystal jar, staring at the preserved heart. It was dark, but the Countess saw Dirty Turnip's wide eyes. They stared at each other for a moment, then the Countess snatched back the jar and hid it back in her dress.

"What's inside the jar?" said Dirty Turnip. "Are you a Resurrection Man?"

"You're a thief," said the Countess.

"I was just curious. You're not hiding it very well."

"What's a Resurrection Man?" the Countess said.

Dirty Turnip laughed. "Body snatcher. They sell to medical schools for dissection organs, just like that, floating in a jar."

"I'm not selling the heart," said the Countess.

"My aunt was a body snatcher," said Dirty Turnip. "Best in all of Marseille."

This cast of bizarre characters could stage a play, the Countess thought. The Body Snatcher steals the Grasshopper's brain, and Dirty Turnip eats it.

"Whose heart is it?" said Dirty Turnip.

Stealing the piano teacher's heart had not been easy for the Countess. She had gone to Père Lachaise at night, sneaked into the cemetery in the dark. Above the piano teacher's tomb hovered a stone statue of Euterpe, the Muse of music, head bowed, clutching a lyre in her bone-white hands. By the gravestone, lilies and damask roses strewn on the ground, an extinguished candle, a few bright, polished pebbles. The only sound was the occasional clump-clump of falling chestnuts. The Countess daintily removed her silk gloves, stuck a shovel in the earth with a muted thump, and began digging, excavating the body of her beloved piano teacher.

The scent of wet soil, earthworms, and rotting leaves. It did not take long to reach the casket. Since the piano teacher was terrified of being buried alive, he requested the casket never be sealed shut. He left a note, a last will and testament. The Countess lit a gas lamp, its glow illuminating the misshapen teeth of gravestones, the clumps of grass like wild green hair. Inside the casket was a pale, emaciated corpse. The Countess was struck by the strange beauty of his ribs, sticking out like the ivory keys of a grand piano.

She withdrew a scalpel blade from her box of medical tools, and with a neat incision cut open the piano teacher's chest. He appeared very small, thin wrists almost

like a child's. On his deathbed, he had weighed about as much as a small dog. The stench was unbearable now, skin tinged blue. The Countess prepared the crystal jar filled with amber-colored cognac. She slipped her hands into the tent of the skin, as if she were rummaging in a sack, and then, slowly, carefully, retrieved the piano teacher's heart. The heart was abnormally large and covered in a thin layer of porous white tissue. It appeared diseased, not at all the way she imagined the heart of a great piano teacher.

———◆———

The journey to Imperial Russian–occupied Warsaw took several days. The Grasshopper smoked his pipe, and Dirty Turnip sometimes told the Countess midnight tales of her aunt, the Body Snatcher. The countryside blurred by, a monotony of brown fields, yellow wildflowers, and dense pine. The Countess ate disgusting, hurried meals at station stops in anonymous, decrepit little towns somewhere along the way to Poland. Sour boiled potatoes, meat swimming in beige gravy. A hunk of dark bread, sour cream, a sliver of herring. She nervously drank milky liquors, played with the folds of her dress, and glanced suspiciously at the other passengers. They were no longer perfumed Parisians, decked in lace and furs and slightly sneering. They were gray and weary eastern Europeans, worn threadbare, as if they were about to split at the seams. She was worried about the Russian inspectors at the border. If they found the heart, they would surely confiscate it. At night, with the bumping of the locomotive against the tracks and the crystal jar wedged uncomfortably against her hip bone, she found it difficult to sleep.

Her piano teacher had been a sleepwalker and an insomniac. *I have to lie in bed all day long*, he complained once in a letter. She imagined him lying awake in bed, on his side, eyes wide open, composing melodies in his head. Staring at the dilapidated wall of his bedroom, he could see the keyboard, and the giant shadows of his hands played and played. *My mouth and tonsils*, he wrote, *aching so much*. Now, his mouth was rotting in the grave, his teeth ground to dust.

To pass the time, the sleepless Countess imagined all kinds of people pursuing her and the heart. In one scenario, her pursuer was a detective. The detective patrolled the train platform, holding up a piece of parchment, questioning the passengers. When he reached her seat, he held up the paper, and she saw, instead of the face of a wanted criminal, a sketch of a heart. *Madame*, said the detective, *I'm terribly sorry to intrude. We are*

searching for a precious heart, stolen only yesterday. The Countess replied: *I would never steal a heart. I'm married.*

The train reached the Polish border. The passengers were awaiting inspection by Russian guards, stalking the dimly lit corridors of the train, sniffing out anything suspicious. If she were caught, she imagined she'd rot slowly in a damp cell, gnawing on chicken bones, drinking tepid, polluted water, and carving out the remainder of her days on the stone with her fingernails. Blood streaking down the walls, like spilled beetroot borscht. No one would remember her. No one would steal her heart from her chest and smuggle it across any borders.

Heavy boots, thump-thump-thump, and now here was the Russian border guard. His coat was lined with ermine fur, rings clacked on his fingers. He wore a saber across his leather belt, and his moustache was the color of fresh-fallen snow. He opened Dirty Turnip's rucksack, rummaging around the earthy root vegetables, then moved on to the Grasshopper's belongings, picking apart the tobacco pipe. Finally, he gestured toward the Countess's valise. She handed it to him, and he rummaged through her silk scarves and shawls, her velvet dresses and intricately embroidered hats decorated with flowers and birds. The border guard motioned for the Countess to rise to her feet, said something incomprehensible, but she did not get up. He spat a command at her in Russian, but she ignored him.

The Grasshopper jumped up. "Hold on."

The guard pushed him aside. Dirty Turnip stood up, her body between the Countess and the guard. She retrieved a bracelet of bright amber beads from the pocket of her large overcoat. The bracelet was surely stolen, pickpocketed from an unfortunate, sleeping passenger. She offered the guard the bracelet. "Take it. It's yours."

They stared at each other for a moment. The guard slipped the amber beads on his wrist. He showed it to another guard, and they both laughed. Then he left, walking with a slight limp toward the next passenger. For now, the heart was safe.

"Thank you," said the Countess.

"It's nothing," said Dirty Turnip.

The Countess wanted to ask her why she'd done it but felt it might be taken for an insult.

In Warsaw, the Countess found accommodation in Old Town under an assumed name. It was all very exciting; she felt like a spy. She had arranged to meet with an organist at the Church of the Holy Cross, to bury her piano teacher's heart. Tonight, she was

free to do with the heart as she wished, and all she wanted was to paint it. She set the crystal jar on the nightstand and lit a candle for illumination. She always carried with her paintbrushes, crumpled tubes of paint, a rolled-up canvas, several pieces of parchment paper, and charcoal. After making a preparatory sketch, she began painting, capturing the diseased white foam around the heart, the light reflecting in the crystal jar.

In the morning, she drew a bath. The tub was filthy, stained yellow and chipped in places. A few curly stray hairs clung to the rim. The wallpaper was covered in mildew, like creeping ivy. She was delighted with how disgusting everything was; it was liberating. Lying in an ugly bathtub, warm water bubbling all around her, in a decrepit hotel in Warsaw's Old Town. She tiptoed out of the bath, dripping on the pale stone tiles. She wrapped herself in a scratchy towel, embroidered with faded gold thread. To avoid attracting any attention, she dressed in a simple blue dress, tied her hair with a red velvet ribbon. It was time to meet the organist.

The organist was a stooped man, bent like a question mark. She followed him into the empty church, opposite the University of Warsaw campus. They walked down the dark wooden pews to the golden altar, lit with flickering candles, wax stumps dripping on the marble checkered floor.

"Show me the heart," said the organist.

The Countess withdrew the crystal jar from the folds of her dress and held it to the candlelight. Admiring the heart floating in amber cognac like some holy relic, the organist began counting his prayer beads, reciting a silent prayer. When he finished praying, he went to sit by the pipe organ.

"Can I tell you a story, Countess?" the organist said.

When he was a young man, he served as an organist at the Church of the Holy Sepulcher in Jerusalem. Under the "Status Quo" agreement, the holy site was shared among different Christian denominations. All of them celebrated Mass daily, praying and singing simultaneously in Arabic, Latin, Greek, and Aramaic, competing for vocal dominance in the small space of the tomb. The organist's task was to accompany the prayers of the worshippers, whose congregation gathered opposite the rotunda, in the crossing of the four arms of the cruciform church, a spot some believed to be the very center of the world.

The organ was in disrepair. Over the years, pigeons had flown into the pipes and defecated inside, ruining the sound. Still, the organist played, and the worshippers

prayed, louder and louder, trying to drown out the other denominations. One day, the organist went to the church very early in the morning. He walked through the souk as usual, passing merchants carrying pomegranates, perfumes, jewels, and sacks of colorful spices. He climbed the stone steps to the courtyard and found the church empty. The worshippers had not yet arrived, and for a moment, the organist closed his eyes and listened to the silence.

The organist was counting his prayer beads once more. His story was over, and now they were both silent in the empty church, staring at their hands. She remembered her piano teacher's hands so vividly. Reddish-blonde hair on his knuckles. Blue veins spidering across pale wrists. Long, thin fingers. Half-moon nails trimmed to the quick. As a girl, she had memorized everything about those hands. Whatever objects he touched gained significance. When he left her notes, little calling cards on the nightstand, she imagined the way he held the pen, the scratch of metal on paper. When he picked up the vase, brought it close to his large nose to smell the wildflowers, his fingers around the porcelain neck. When he ran his fingers over the tassels of her yellow silk shawl, spread on the armchair, after a night at the opera. Once, the piano teacher told her to place her small hands on his large ones, as he sped across the keys, and it was as if they were dancing together; as if she had placed her feet on his feet, and he had carried her, gliding across a great concert hall. ❧

Impossible Beauty

AMIR HALL

The floods came like humans in a hurry. No greeting and no goodbye. They leaped over our feeble fence. They rolled across our compound's yard onto the concrete platform that lined the house. Even the aloes got hit. The agave plants were lost forever. The snakes writhing in the brown waters looked like animated burglar-proofing.

I'd lived there about four months. This was the year after the world had almost ended, which could've been any year since Michael Jackson died. Nia, my roommate, gave us all discounted morning yoga classes. After, one of us would walk to the corner to pick up doubles or fried pies, which we ate at home.

I cannot remember if we had class that morning. Either way, I ended up stranded at the grocery store a block or two away because the rain had started falling. Ordinarily, I would've walked, but there was no road left, so I ordered a car. The car barely made it from the store to our compound.

I waded across the bridge that separated our compound from the main road. My feet were drenched by the time I got inside. Through the windows, I spotted Nia in the backyard, which ran parallel to the ravine. Crystal, who lived on the ground floor of the neighboring apartment, stood there too, on her verandah, visibly shaking.

"Hoss, what going onnnnn?" Crystal said.

"Tshh," Nia said. She shook her head.

"Wayss," I said. I felt a surprising calm.

"Where all that come out?" Crystal again. She had a point. None of us had seen the water in the ravine this high. The way the rain fell made a myth of the clear skies that preceded it.

We said other things, but everything sounded like silence in the rain. It was as if we had not been living on this land but that the land had been squatting on water all this time.

Crystal started pacing. "What going on? What going on?" she kept repeating. "This water just raising raising raising." Her hands moved from her head to the river. "And all

my appliances, my laptop—" She ran inside and came back a few moments later, falling to her knees, with her hands on her head, crying.

Nia took my hand and pulled me to where Crystal knelt. "Okay, alyuh," she said, holding my hand and rubbing Crystal's back. "This going and get bad."

She said it with certainty, as though she'd already seen it. Which made sense to me. They were all witches in my book. During my time there, I logged their abilities in an ongoing, mostly fictional narrative in my mind. Sometimes when Crystal spoke, it sounded like a psalm. Her wisdom was otherworldly. Nia, our resident healer, used her meditation practice to ease our aches and pains. Everything grew around Malaika, even people. She was our landlady, who lived upstairs with her daughter Jada and her sister Lily. The yard brimmed with plants of different kinds because of it. Lily, who managed the property with her, had the power of protection. Bad vibes ran away from her. With her, you felt safe.

"I get flood out before so I know," Nia continued. Crystal looked up at Nia. "Yeah, when I was younger, we get flood out in Maraval."

"How bad it going and get?" I asked. Fear crowded my body. Crystal's palms lay open in her lap as she knelt. We could all use Lily's presence, I thought. Just her aura would've calmed us down a bit.

"Doh beat up, doh beat up. However bad it get." And she nodded, looking out with watery eyes at something I couldn't see.

———◆———

In the beginning, Aunty Helen, our neighbor, had called Malaika panting and yelling, "MOVE THE CAR, MOVE THE CAR!" Aunty Helen was talking about Malaika's sedan, parked outside our gates. But Malaika was at work so she called a ride on the local rideshare app.

By the time Malaika got to St. Ann's Road, our street, the river had already reclaimed it, leaving no way to pass. She saw a friend of hers who lived nearby, Larry, stranded, looking upon his silver Nissan as the water passed through it. He clasped a few things he had managed to salvage, his phone and keys and a few documents in manila folders as the water hugged his knees.

"Is best I take it here," Malaika told the driver, and she tied her microbraids into as much of a bun as she could manage and wrapped all of it in an Egyptian-looking head

tie. She had recently achieved the length necessary for a bun and made the fact known regularly. As she opened the door, her lunch—some dry barbecued chicken breast, potato salad, and fried rice—let itself out of her body in vomit. She barely saw the contents before the river took them away too.

She and Larry would have embraced each other on a normal day. But on a day like that, one where you can't see the ground you walk on—eye contact goes a long way.

"Come by me and drink some water nah," Malaika said.

As they made their way through the ochre water, Malaika remembered her sedan. She looked up the road at the front of the compound which rose in a slight hillock, saving most of the sedan from submersion. She'd still be able to move the car uphill once she reached it.

The yard had already been invaded. Plants, some of Jada's toys, her little bicycle even, and some yard tools paraded around on the water's edge of their own accord. It was all muddy. She saw our apartment doors shut to keep as much of the water out as we could.

Later, she would joke that her first thought wasn't about the property or her own safety. She said she thought about us; she thought we were going to be pissed.

———————◆———————

"Nah nah nah nah nah nah nah," Lily said in another beginning. "Daz alrite man. It really coming down heavy—best you stay where you is right now and come down the road another day."

Lily opened her fridge and closed it. She heard the rain outside lashing everything.

"Yeah, yeah. All that good," she said.

She walked to her sprawling window, which looked over the ravine bordering the back-yard. Crystal hadn't sent the video of the ravine overflowing yet. So when she saw the river, she said, "Waysssss. Nah boy." The water had already covered the road parallel to their yard.

"What happen?" the voice on the other side said.

"This rain rell comin down but my man not here nah boy," she said, and they both laughed. Lily loved rain-time snuggles.

"You not easy."

"No but for real," Lily pulled her embroidered curtains aside. "The ravine by us—"

"It full?"

"Well it fulling up. Not full yet though."

She didn't think it would flood. The rain had been falling for such a short period of time that a flood seemed impossible.

Seeing the ravine bursting its banks had the effect of White Oak rum straight from the bottle; it woke her. After she hung up, she rushed downstairs to her tattoo studio, opposite Crystal's apartment, to pack away the books, paints, and paper she kept on low-lying shelves just in case. The waters were already gushing in when she got there. Thankfully, nothing remained on the floor, but Lily worried about the marks the waters would leave on her furniture, especially an antique cabinet left to her by her late mother. All thinking stopped. Instinct replaced it.

Crystal's door was open already, so she peeked in. "Crystal?"

"Yeah?" Crystal emerged from her living room carrying a drooping anthurium. Their eyes exchanged condolences.

"You need help?"

———◆———

Crystal's thoughts pursued her. She imagined the worst. Saw her furniture floating away, saw the mud she'd have to scrub from the ridges of her tiled floor and the walls she'd have to repaint. She saw the cost of repairing the damage as it kept rising with the water. But no water entered through the door to her living room. The ravine overflowed, but the incline of the yard to her place kept the waters at bay.

Relieved, she decided to roll one up to ease her spirits a bit. She turned around to go get her weed, which she kept in an old butter-cookie tin in her bedroom. When she got to the door, she discovered that the waters had made it there first. It had, apparently, entered through the front gate, proceeded through the driveway, let itself in under her door, and tiptoed into her bedroom and her bathroom while she was occupied with the living room. She called her mother and cried.

"Baby, baby?" her mother said.

"Yeah," Crystal said after regaining breath.

"Just breathe, breathe."

"Yeah."

"You'll get through."

"Yeah."

"You want me to come up the road?"

"No, Mummy, you—"

"Baby?"

"Yeah?"

"I right here."

She stood like that for a few minutes. When she got off the phone, she looked at her walls and the water and wondered how.

———◆———

We were monitoring the ravine from the backyard, so we didn't see the flood come through the gate and to our front doors on the other side of the apartment. Then we saw our welcome mat float past us. The first thing Nia did was unplug everything in the house, so I followed suit. Then she started stuffing blankets and towels into the crack at the bottom of the front door.

I wrapped all our curtains, the orange ones we got from Nia's mom, around the top of the burglar-proofing on the windows. At this point, the waters covered our ankles. And everything looked at us; the fridge, the sofa, the body pillow we left on the floor for the cats to lie on. Everything waited for us to save it.

Matthew, Nia's kind-of boyfriend who was visiting, started sweeping the water out toward the back door, where the waters weren't coming in. For a half hour or so, the waters kept rising, asking for nothing. And then, after a long time, they stopped rising and seemed to take a seat.

We could only wait. Matthew tried to continue sweeping. But the apartment became a shore. Our rooms chimed muddy water. We had leaned the beds against the walls and tried to create platforms for our mattresses. And the floods were not yet taller than a child.

You learn patience when you're in the flood. You want to see and feel your floors again. You worry about the books at the bottom of your shelves. You worry about lost things like the three plants you bought with the intention of raising them. You worry about your friends upstairs, the sisters, Lily and Malaika, and the little girl Malaika carried about on her hip. And you become thankful for all the ghosts you carry on your shoulders. They add to your company.

You are aware that this is a grace. That the waters, if it were written, could swallow the whole thing.

Outside, the rain fell like spite to the ground, and the clouds obscured the geography. I saw the whole road and ravine and yard become a river, and our compound, a shallow promontory. Whole trees performed backstrokes, whole fridges and cars made their way downtown.

I felt far away from myself, holding on to my body like a raft at sea, not aware of its sensations but aware that it was the only thing carrying me. Matthew and Nia were rafts for each other. I hugged my knees.

We found each other's faces in the flood. Nia, eyes as sharp as if they had just been drawn on paper. Matthew with his chest hair, sitting next to her. Me on the kitchen counter near the front door. All three of us clinging to a spliff Nia had rolled earlier that day.

"What the weather app saying?" Matthew asked. One of us opened a phone to see.

"Rain."

We laughed.

———◆———

Later, Crystal would say she saw a red ribbon stuck in the fence that lined the ravine earlier that morning. When she saw it, the wind took it, like a kite, beyond her field of vision. She could read circumstance, and she would say she should have known what was coming.

———◆———

When the floods receded and the waters in the ravine boiled down, the neighbors came in twos and threes, with their wheelbarrows and shovels and power washers. There were three houses in our cul-de-sac, but we were nearest the river and got the worst of its bite. With the people and the tools they brought, we sprayed out the remnants of mud. The mud on the street would take days to remove. The sun would refract in the hose water. Not today, the sun hid behind the rain clouds. The rain subsided but left its shadow.

"Somebody tell the Honorable Minister don't even bother to come," said Henry, one of our neighbors. Henry was burly and handsome in a way that could give the women he dates license to talk to anyone crazy. His mother volunteered him to do the things she wouldn't. "Let him come and help you wring out that cloth, let him spray down the yard, let him shovel that mud." Before the flood, and after, he haunted the neighborhood with his motorcycle at odd hours.

He was right, this was the custom here, the Honorable Minister came after disaster struck.

"They need to send some police for them people up in the hills. Is them who cutting down tree and throwing fridge and all kinda ting in the river."

"Is over twenty years it ain't flood here inno."

"And up to now I never see it flood so bad."

"Oh geed!" A child found a dog washed up, buried beneath the mud. A mother stepped in, pressed the child's face to her side. A man stepped in to take the body away. Men were useful in times like this.

Some of the neighbors pressed to help Nia and me further, asking if we needed the power washer inside the apartment. Nia said we didn't need them. It was amazing how she took charge. How Matthew and I followed her lead, unquestioning. I wondered if he knew these hours were open wounds for her. I wondered if she knew too.

I hadn't known she'd experienced a flood until that day. I saw it in her eyes though. She seemed to be seeing our flood in one eye and remembering hers in the other.

Now that the water had receded, we pressed our towels and blankets to the floor and pushed toward the doorways. Each time we wiped, we could see the terrazzo more clearly. We moved the furniture to one side and cleaned. Then we moved it to the other. We passed the spliff. The dead dog floated somewhere beneath all of us, spinning.

———————◆———————

As the water receded, Nia, Matthew, and I helped its movement with our brooms and blankets. From our windows, evening light poured in like it would on a regular day. The rains left no imprint in the sky. Only the mud on our floors.

Our house tabby cat, Leia, reemerged from wherever her hiding place had been and stalked the yard, avoiding the crowds of strangers who'd come to help. She was noticeably shaken. While we cleaned, she hunted snakes and lizards, probably to keep her mind occupied.

We were on our knees most of the time, pushing the mud out with our thick blankets. Then we took the blankets outside to wring them out until the water the fabric held released onto our feet and into the drain.

I looked into my room frequently, dreading the cleaning I'd have to do the following day. Taking the bed outside, spraying it down with water and bleach. The scary part

of disaster isn't the disaster itself, it's the repair. How, after months or years of being a normal thing, something as simple as the waters in the ravine you see every day could enter your house, rummage through your belongings, and rearrange your plans for days and weeks.

When we could see our floors through a more transparent glaze of mud, I went outside and started hosing where hosing was needed. Our wrought-iron gate acted like a strainer; it caught the debris floating in the water. I directed the nozzle of the hose at it. I went into the road. The women held hoses and sprayed the mud while the men shoveled the mud into wheelbarrows, which they took to the ravine. People like me did either. It reminded me of shoveling snow in the winter the few times I'd visited my family in New York.

I went back inside, and Nia and Matthew were smoking a new joint and sitting around talking. They asked if I wanted some, and I said no. I returned outside. I went back inside a few minutes later just to see if they were still there. Nia had started her blanket work again, but Matthew just sat there smoking.

"Matthew, you know it have thing to do outside still?" I said.

He looked at Nia, who looked back at him.

"Yeah, well, I just taking a smoke. I'll come out there just now, na."

And I left. I felt proud of myself. Matthew was an MMA fighter and trainer. He could have beaten my ass with flying colors. He came out a few minutes later and found me in the crowd to ask what there was to do. I said there might be shoveling or sweeping or hosing down. I looked around and saw that the work was dwindling. We were actually at the end. I could see this annoyed Matthew; I had hurried him and there was nothing to do outside, really. I pretended not to notice or feel bad about it.

He still took a shovel someone had left leaning on the gatepost and dug at mud that was barely there. He took over shoveling the portion of the drain I had been taking care of. I grabbed the hose and sprayed the mud to loosen it up for him.

Later, Nia would accuse me of gangsta-ing Matthew into slave labor. And I would laugh too, appreciative of the way he allowed himself to take direction from me. It made me feel a certain kind of power over him. Like a woman.

———◆———

Hours later, Crystal's toes were finally free of mud. Her room had been swept out. Her bed overturned. Her mother told her to use vinegar in the water she used to mop and to burn bay leaves to get rid of the drain-water smell.

Crystal couldn't help but stop and look at the sky, which had turned a startling Martian orange. Her skin seemed to glow gold from underneath. She had been cleaning, and the cleaning seemed like it would never end.

It was a spell, this peace. We met her there again. Lily and Malaika and her daughter joined. Even the ghosts must have stood in awe. We watched the sky as we would an approaching war.

"What going on?" She asked again.

"Tshh," Nia said again.

We were reading, all of us.

"It yawning," I said.

"Yeah," one or all of us said.

The sky yawning.

Crystal looked into the debris first. There were some snacks she had left on her floor, a few pillows and old clothes from her laundry basket. The flood had taken some of her kitchen utensils and pots. Among the debris in the yard you could see the wriggling of worms and snakes and dead or alive leaves.

A bright turquoise snake made its way from one end of the yard to the other. It would occasionally stop, lift its head, and taste the air.

"Look, Mommy!" Jada said. "Is a snake!" And by the way she said it, you would swear that none of this had really happened, that we were all in a screen next to Peppa Pig, and that all of it would end once the screen was turned off.

"Yes baby. And you know what we do when we see snakes?"

"Run!" the baby said, throwing its auburn hands in the air. We laughed. I would remember the snake months later, when, on a visit to New York, I saw one just like it in a painting. Except the snake would be a ring, poised on the finger of a French countess. When I saw it curled around the woman's finger, I imagined it was the same snake that had slithered through history and made its way to our yard.

We didn't run.

The snake threaded through the fence and back into familiar waters.

◆

"Allyuh wa take a drink awa?" Malaika said.

"Yeah," I said. "Might as well." I had gotten rum at the grocery store earlier that day

for other reasons. Our fridge was still in our living room. All the pots and books from our lower cupboards still sat on our chairs. I turned to Nia. She looked tired.

"Me and all," she said. "Better we whine it out in truth."

"Alright, we'll bathe and meet in a half hour up on the roof," Malaika said and went upstairs.

I went next door to check on Crystal. Matthew was helping her push the water out of her bedroom and bathroom.

"I good inno," she said, when I asked if she needed more help.

Honestly, I was relieved. I was tired of helping.

"Well Malaika and them say drinks by them on the roof when you done," I said.

"Drinks? Now?" Crystal said.

"Pick up yuh mouth," I told her. "Yes, drinks. So bathe and ting and come up when you ready."

She said, "Okay."

All I could hear were swishes of water, moving through broom bristles and leaping out of the buckets Matthew took and emptied.

The entire night returned to itself. All the usual crapauds and cicadas and other chorus members found their place somehow, so that this night sounded no different from the previous one.

I decided it was a blessing. Our apartment was washed with river water. The washing we would do after, with bleach and Fabuloso all-purpose cleaner, would add to the blessing. The blessing being, of course, not only that we survived but that floods had taken everything we could not otherwise wash away. Like grief, or worry, or the descent of friendships.

———◆———

"Residents of St. Ann's and Maraval are cleaning up after torrents or rains brought waves of mud into their homes. Both the St. Ann's and Maraval Rivers burst their banks on Tuesday, resulting in flashflooding in surrounding communities," the newscaster said in a rectangular way before the image of an older man with graying, irregular plaits came up on Malaika's phone screen. I knew this man. I had seen him in front of the shop we got bananas from when we ran out. Behind him was the bright brown of mud and bodies covered in mud sweeping and moving debris.

"I stand up on the side here. I notice but wait, the car moving, the car moving!" he

said. "When I went inside and get my keys now, time I come back outside, the river was pushing it, pushing it. When I turn, it went over the bridge and it was gone," he said, shrugging his whole upper body. "Couldn't do nothing about it."

Then Malaika came up on screen.

"Raaaaaaaaaaa," we said, and "Bloop bloop," among other silly things to big her up for making TV. The Malaika on the roof with us laughed in her flirtatious way, hiding the bottom half of her mischievous face.

"The last time this happened it was thirty years ago, when the woman passed away in the flood," on-screen Malaika said. "The wall collapsed about ten years ago, and the corporation came and fixed the retaining wall but they didn't fix the privacy wall." You'd never guess it was the same Malaika. The Malaika on screen, we all remember her. She was in her red jersey, hair tied up, coordinating the masses of neighbors who had come to help us and wearing her distress like it was a daily thing.

It was night. We had showered and poured our drinks and sloshed them around in our glasses so the rum mixed with the Coca-Cola or soda water and bitters. All the hills of St. Ann's shimmered in the night with optimism.

Present-time Malaika, in her light brown silk-looking nighty, steupsed. "I say more than that, and all I tell them the minister should stop paving the drains in the road and blocking the drainage. They cut that out though."

"Must cut that out. You feel them want people to hear that?" Nia said.

We tuned back in. The newscaster was saying that the parliamentary representative for the area, the Honorable Derek Ramsen, had come to get a firsthand look at the damage in the area.

"There is more extensive damage on the Cascade side." The member of parliament was also brown, with a fresh haircut and sharp shave. "This is all unfortunate," he said. "But I've been in touch with the Minister of Local Government and the Minister of Works and Transport, and they'll send people to monitor and look at some of the structural integrity of the bridge and any roads that may have been affected."

Someone in the back yelled, "Structural integrity? Wha bout your integrity minister?" The camera swiveled to the speaker, a bare-backed light red man leaning on his shovel. "You comin here to play jefe and watch and point? Yuh should be shame, look how long we contacting allyuh to come and clear this ravine. And how long we telling allyuh to redo them drains. Bout structural integrity."

The people around him had stopped their cleaning to nod and wait for the minister's response. But no response came. By the time the camera swiveled back, the minister had retreated behind what looked like his staff, talking very seriously, probably about the emails and calls our neighbor referenced.

The speaker kept talking inaudibly, and some people even started throwing mud at the Honorable's feet. The mud fell close enough that the Honorable retreated even farther down the street. Abruptly, the newscaster came back on. He said, "The inclement weather began at three p.m. and lasted for forty-five minutes. Due to speed flooding and high amounts of rubble, the areas of St. Ann's and Maraval are still largely impassable."

<hr />

The flood had left its hickey on our walls right around the house. Malaika hired a crew to repaint them the next day. All of us were engaged in mopping and sweeping the rooms that were affected. Nia had mopped inside by the time I got up, and I completed it outside in the driveway where she would have her yoga classes. Lily bought us KFC, and in the middle of the day, when the delivery came, we all ate on the red steps that led upstairs to Malaika's apartment. We ate like children at recess.

I think we all wanted to preserve our memory of things. Mornings doing yoga with Nia on the downstairs verandah, the afternoons when Crystal would come over for a smoke break from work, Lily's roof parties. That's what led us to defend our terrazzo and tiles from the mud, to bar the water from entry, and now to attempt to erase its mark. I would say we wanted to return to normal, but normal doesn't exist on that island. We wanted to return to regular magic.

But sitting there on those red steps, I felt that everything had changed. The way we spoke to each other softened. Lily, who doesn't really touch people other than her man, reached for my hand in that one day more than she had reached for it in the months I had lived there. The hammock was gone forever, stained by stubborn mud, so the days in which one of us would lie there and listen to the parrots at morning or the crapauds at night were gone too. We ate our chicken, and as our elbows touched, we were all acquainted with the individual sounds of each other's chewing.

The water that ravaged our compound was strong enough to bind us. And this was the magic, that we had found each other before the flood and had stayed with each other after it.

<hr />

The evening we had together after the flood had an impossible beauty; like a new day, or a woman in a painting, a turquoise snake in brown waters, a scarlet ribbon flying to oblivion. The glasses we filled with rum refracted amber streetlights. The occasional police cars and news crews bathed in those lights, and the hills receded into night. By our sweaty gyrating, you might never have guessed we were lost in this land on the banks of hungry rivers. You might have thought we were at home and in love. ❦

The Shawl

ANUSHKA JOSHI

In the corner of Ingres's painting of the French woman is a mustard-colored Kashmiri shawl, the kind made popular by Queen Victoria and by Empress Josephine, who they say owned four hundred of them. By Article 10 of the Treaty of Amritsar—named after that city where, much later, men, women, and children would be massacred by British guns, the wounded left to be eaten by dogs, their families forbidden from taking in their bodies—the Maharaja of Kashmir was obliged to send three shawls each year to the British government. It was a humiliation woven of the softest wool. In France, women were gifted these shawls upon marriage, but men wore them too. They wore these shawls like gossamer on their shoulders: the white man's so-called burden, so light, so bright. If I could, I would reach into the painting and take out the shawl, which does not belong there just as the sword of Tipu Sultan and the Koh-i-Noor do not belong in their museums. I would place it instead on the shoulders of my grandfather's friend, the one who fought for freedom building bombs and on whose bare back the British had placed heated slabs of iron railway tracks so that strips of flesh and skin peeled away in hunks as they asked him question after question, track after track. And they say they gave us trains, and so they did, those and the ones carrying the bodies through their Partition. I would place this shawl on those unbending, unanswering shoulders, as we do in our country to honor someone. But this shawl is trapped in a painting and he is long dead, and the freedom he fought for has curdled into another unfreedom in which Kashmir is silenced again.

If I could, too, I would stand still on the walkway that they have made for the Indians who pay to see the Koh-i-Noor in the Tower of London museum, a walkway built so that we will not stand there too long, marveling at this unknown ours, this foreigned own, this ungiven gift. If I could, I would stand still in its light: our stolen sun. ❅

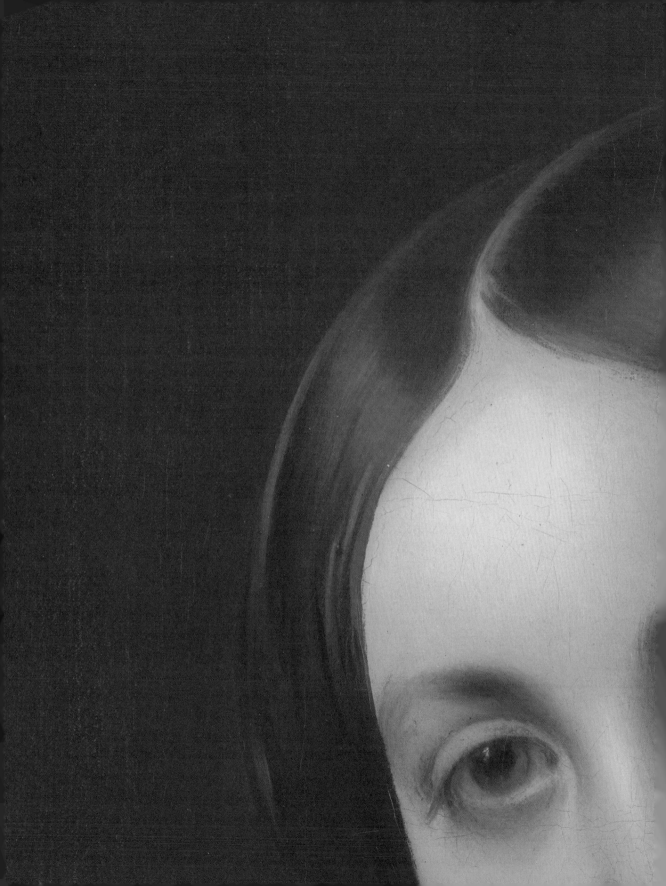

she was in my mind and I'm in your mind, still

CHRISTOPHER LINNIX

October 1, 2006

What came first, the chicken or the egg? My teacher asked us that today and I said the chicken. Because it just keeps happening. Over and over and over.

Before the chicken was a chicken, it was a bird whose beak had grown red fungus all around it. The bird saw the red fungus and got scared, which made its feathers turn all white. Then it laid some eggs, and all its babies grew up and had white feathers and red fungus on their beaks too. Chickens! It happened over and over and over, and every time the chicks would grow up to have white feathers and red fungus on their beaks.

That's why when I go back in time, I know I won't change anything in the now. Because the now is just the middle cycle of chicken egg, chicken egg. What's happened has already happened and keeps happening and that's that. Chicken egg, chicken egg. If a chicken in the middle of the cycle tries to change the color of its fungus and dyes the red fungus around its beak green, that won't do nothing for the egg it lays. Sure enough, the chick from the egg will grow up to have a red-fungused face. It is what it is.

———◆———

I told my daddy and he rolled his eyes. He doesn't believe. Mahmah believes though. Mahmah is the grandmother of my daddy's grandmother, that's why he calls her Granmah-Mah. I just call her Mahmah like everybody else.

When I told her I could travel through time, her eyes got wide and she said, "You stole them."

She didn't say it with words; she said it with her eyes. That's how Mahmah speaks, with her eyes. She kept saying, "You stole them," and I think she was talking about her little white cards. "But I didn't steal no cards, Mahmah," I said. "You're just jealous I can travel through time."

She didn't like that too much.

Mahmah doesn't usually come into my room, but last night she snuck in and started to choke me. She was on top, hands on my throat as spit dribbled from the side of her mouth that doesn't open all the way. I couldn't breathe. But I remembered that daddy had said that the Bible says to be nice to those who are mean. So I let her choke me, and eventually she stopped and fell asleep in my bed. When I told daddy about it in the morning, he yelled at me and told me to get away from him with all that kiddy talk. He didn't believe Mahmah could choke me.

October 2, 2006

I travel back in time in my dreams, but I can only go back to Mahmah's time, when she was a little girl. Little girl Mahmah lives in a place with no buildings and no paved roads, a smoky place where men wear vests and jackets and have bad teeth. There are no cars, and people travel on horses and carts and wide boats that puff puff puff. That's how I know it's a past that happened a long time ago.

Mahmah's a little girl whose mouth isn't old and hard and closed up on one side like it is now. I didn't know she was Mahmah at first, but her mouth voice sounds the same as Old Mahmah's eye voice. That's how I knew they were the same, because I been having Old Mahmah's voice in my head since forever.

I can only go back in time while I'm asleep. It doesn't happen every night, but I always prepare for it. I put on my daddy's watch and say my prayers and hope to go back in time.

Getting there is like waking up. Only I'm waking up in the middle of doing something. Like last time. I woke up and me and little girl Mahmah were playing hide-and-go-seek. We were in her backyard, and it was real cold and I was standing behind a tree when Mahmah jumped out next to me and screamed, "Found you!"

Little girl Mahmah never asked if I was from the future. And she never seemed surprised when I showed up out of nowhere. I never had to introduce myself to her. She just knew me. We were already friends, and I never had to explain how I got where I was.

When I checked my watch the hands were spinning fast, but the digital number said 11:30 a.m. Daddy likes having the watch with the hands on it, but I don't know why because he still has the little screen on the bottom with the time. Little girl Mahmah said, "What kind of watch is that?" and I said, "My kind," and laughed. But then I pulled my sleeve over it so she couldn't see it anymore.

Little girl Mahmah told me that her daddy was taking her on a steamboat the next

week. They were going to Cleveland to attend a convention and he wanted her to come with him. Mahmah's daddy was a big man and real important. That's what Mahmah was telling me, but I was acting like I didn't care because if he acts like I don't exist why should I act like he does?

Mahmah's daddy is mean. One time I was standing right in front of him and said hello nice and loud so he could hear me, and he acted like he couldn't hear me. Didn't say nothing back.

While she was going on about her daddy, little girl Mahmah was holding these white pearly index cards, rubbing the edges of each one into the middle of her hand. I said, "Why you holding them index cards?" She got mad that I called them index cards, and then said, "What's an index card?" I laughed because it was funny that she didn't know what an index card was. I said sorry for laughing and asked if I could hold one of the cards and she said, "No, no, no," and shoved the cards into the front of her dress.

I can only be in the past time for thirty minutes; then I wake up. That's why I bring daddy's watch—so I can know how long I got.

When I appear, I'm always dressed in the same outfit. A brown wool coat that goes down to my knees, gray wool pants, a gray vest, and a white shirt with buttons that match my dark brown shoes. It's like I'm wearing church clothes all the time, only I'm not in church.

When I wake up to the now time, it's the next day. I don't know why it works like that, I just don't want to mess up my superpowers by asking too many questions.

October 5, 2006

Old Mahmah is the only one who believes I can travel through time. Maybe she remembers me. She sleeps in my bed now and that's fine, I guess. Mahmah is tall. Her face is mean, but I think it only looks mean because her mouth is like that: one half being normal, while the other half is pursed together too tight.

Mahmah is real skinny and old and her brown skin looks gray. I made myself laugh one time because I was thinking, dang, Mahmah so ashy. But I don't do that no more because then she looked at me and it felt like she knew what I was thinking.

Old Mahmah has one last card. It's a small square card, bright white with sharp sharp corners, and she hugs it close to her chest. It looks like the same ones I saw little girl Mahmah holding.

Something's written on it, and I want to see what's written on it but I don't ask. I don't want her to choke me again because that hurt pretty bad.

Tonight, she woke up screaming. She was tossing and turning, then screaming.

"What's wrong, Mahmah?" I said.

She was lying next to me, and I rubbed her back and she stopped screaming and started groaning instead. She was hugging her card. Then I got scared because half her mouth was bleeding real bad. Did the card slice her mouth?

"What happened, Mahmah?"

But she kept tossing.

"I won't say nothin', I won't say nothin'! I won't," she groaned. Now I'm lying on the floor.

Those are the only words Mahmah knows how to say with her mouth. *I, won't, say,* and *nothin'*. Sometimes she mumbles mumbles, says, "I won't say nothin'," and keeps mumbling. She does most speaking with her eyes. When she looks me in the eye, I know what she's saying. It feels like she's pulling my head back and pouring what she wants to say from her eyes into my eyes until my head's all filled up. Sometimes it hurts, and that's why I try to not look her in the eye because she's always saying something mean. I'm glad little girl Mahmah isn't like that.

October 9, 2006

The deacon from my daddy's church came to our house and told daddy to start bringing me to the church again. Daddy stopped bringing me to church after I started talking about Mahmah. It's because I embarrassed him. The last time I went I told some of the church boys that I could travel in time. The boys laughed and told their mothers and their mothers told their fathers and their fathers asked my daddy why a boy as old as me is still talking like he's four years old. Someone told my daddy that I might be on a spectrum.

"Ain't nothing wrong with the boy," the deacon said. "He just needs the Lord. And so do you. You can't raise this boy alone, you know that."

Then the deacon and my daddy came and stood around me at the kitchen table.

"And it wouldn't hurt to talk a little bit about, uh, this Mahmah. Indulge the boy."

My daddy nodded as he grabbed the deacon's shoulder, and the deacon held my forehead with his palm and they prayed while I sat there trying to eat my Frosted Flakes. Before the deacon left, he pulled a big black Bible out of his coat and placed it on our kitchen table. Then daddy made me bring it up to my room and put it next to my bed.

October 13, 2006

My daddy told me that Mahmah was born free and then became a slave and then was free again. That's how old she is. Slave old.

Daddy chuckled when I showed surprise. "You're acting like she's still alive," he said, shaking his head.

———◆———

Daddy said, "My grandmother told me a long, long time ago that Granmah-Mah was a witch. At some point, she was obsessed with getting revenge on the men who captured her into slavery and killed her daddy. But instead of casting spells on them white men, she'd started casting spells on her own boys. They say that's how one of her sons went blind in one eye, because she squeezed some liquid in his eye, claiming it was some 'all-seeing' potion. Crazy talk. All it was was some salty water and who knows what kind of poison. It's sad. She was cursing the folks who loved her most. That's what slavery can do to the mind."

November 1, 2006

Daddy's been nice to me lately. That's probably because I haven't said anything about going back in time or embarrassed him at church. I heard him on the phone before, saying he'll never be able to be a deacon with a crazy son running around yappin' about time travel and ghosts.

I feel bad because I want daddy to be a deacon too so he can get one of those nice Cadillacs like the one the deacon has. I can imagine my daddy standing up on the pulpit, clapping and stomping his foot with all the other deacons. So now I just ask him questions about Mahmah to see what he knows about her past life. I haven't been back in time in a few weeks, but I really want to go back. I put daddy's watch on every night just in case.

———◆———

Today I watched Mahmah shuffle through the house, whispering to herself. Whispering like *spss spss spsspsspss*. She doesn't look like a ghost to me.

She's always holding that small pearly white card. She holds it with two hands, pressed close to her chest, and it looks like she's whispering into it. "What's that card,

Mahmah?" I said. "Lemme see it." I held out my hand. Her eyes got wide and mad-like, and she turned her body away. I felt bad and said sorry.

———◆———

Daddy went up to his room and pulled an old dusty box out from his closet and told me to sit down. "Since you're talking about her so much," he said. Daddy sat next to me and reached his hand into the box, pulling out the same white card that Mahmah was holding to her chest, only his was an old and bent, yellowy white card. Daddy was gentle with the card because it was so old and said that it was Mahmah's most cherished possession. Daddy said that Mahmah used to have a whole stack of those pearly white cards way way back in the day. Each one had a fancy design with a name scribbled in cursive through the middle, like the one he held in his hand.

It read "Mme Albertine," in gray scribbles that probably used to be silver. Daddy said his grandmother passed it to his mother, and his mother passed it to him. Now, he said he would pass it to me as long as I take good care of it.

Daddy said he was proud of me, that I took to caring about Mahmah. Daddy said, "Our family history begins with Mahmah. We know she had a daddy, but anything before that was, you know, erased. So whatever it may be, she was the one to scatter the new seed. The one to carry our family forward."

While he spoke, I cradled that nice yellowy white card in my hands like it was a baby. All I could think about was Mahmah and how she'll be jealous when she sees I have my own Mme Albertine card.

November 4, 2006

Last night I traveled to Mahmah's past in my dream but I forgot to put on daddy's watch. When I appeared in her past time I was on a steamboat, a big one that goes puff puff puff like how daddy looks when he smokes his cigar. I saw little girl Mahmah and her daddy boarding the boat. I was already on the boat somehow, but when they got on I ran over to them. Everyone on the boat looked excited to be there, and everyone who passed Mahmah's daddy kept saying "Top of the morning, sir. Top of the morning, sir." Maybe little girl Mahmah was right about her daddy being important.

When little girl Mahmah saw me, she asked, "How'd you get on this boat?"

"I don't know," I said. Then we were quiet, and I said, "Are you a witch?"

She must have thought I was calling her a witch because she looked like she was thinking of a comeback. Something like, "If I'm a witch then you're a . . . a ghost. Ghost face! You're not even here."

I said, "I'm just asking a question, sensitive."

Mahmah's daddy came between us and knelt down in front of Mahmah.

"Honey, I know you're excited about being on this boat, but how about you play with your imaginary friend later on? Maybe when we get to the room?"

Mahmah said, "Can we just play one game of hide-and-seek?"

He sighed and nodded, "Just one. Stay where I can see you. And, no conversations out loud, please."

Mahmah's daddy was tall like Old Mahmah. He was wearing his top hat and circle glasses and spoke real proper. It wasn't nice to call me imaginary when I was standing right in front of him.

Me and Mahmah went to play hide-and-go-seek again, and Mahmah couldn't find me. I wish we didn't do that though because we spent the whole thirty minutes doing that, and I woke up before she could find me. It's because I forgot the watch at home.

November 11, 2006

I asked daddy who the "Mme Albertine" scribbled on Mahmah's card was. Daddy said that back in the day Mahmah's daddy had taken her from their home in Buffalo to New York City to see the opera. The year was 1841 and she was eleven. It was Mahmah's first time in the city.

Daddy said that while they were walking to the opera place, Mahmah was looking up at all the buildings. While she was looking up, she accidentally bumped into this white lady who looked like a queen. She was visiting New York City from France and was also there for the opera. Mahmah's daddy was worried and was extra apologetic, but it turned out the French lady was kind, and her translator told them that she believed in the abolitionist cause.

Mahmah's daddy was an important man in Buffalo and was a part of an abolitionist group. As she was speaking with Mahmah's daddy, Mahmah must have seen those white pearly cards in her handbag because the French lady smiled and had her translator give her a whole stack. Daddy said that Mahmah loved them cards. She loved them cards so much she used to sleep with them.

That's probably how she cut her mouth up so bad, I thought.

I asked, "Where'd the other ones go?"

December 15, 2006

I was with little girl Mahmah again in my dream last night, but this time I had my watch. We were on the steamboat headed to Cleveland.

When I saw her and asked to see one of her pearly white cards, she said *no*. I said why? And she said, "Because you're not a real person and because they're mine and just because we played hide-and-go-seek doesn't mean you get to have my stuff." I can tell that she's mad because I disappeared on her last time without saying bye. I usually say bye. I told her it was because I didn't have my watch. She said, "What?" but then I said never mind. "Why do you keep saying I'm not a real person," I said. "I am real."

She didn't say nothing back, just stayed silent. We were walking on the main deck at the front of the boat, near Mahmah's daddy, who was huddled up with four other men, laughing and carrying on.

It was nighttime and I think she knew that I didn't have no room to go to. She said, "You can stay in our room if you want." I said okay. "But you'll have to sleep on the floor." I said okay.

It was cold outside and she felt sorry for me. I could tell what she was thinking because I know her eyes. She showed me where their room was, the last door at the end of the main cabin.

Before I could say thank you, I woke up. I was in my bed, and it was the middle of the night and the thirty minutes weren't up. I was confused, but then I saw that Old Mahmah was standing over me, naked, pressing a pearly white card between her long dark breasts.

Mahmah's breasts were black black and looked like eyes reaching down toward me. I didn't like how they looked at me. Her whole body was wrinkly, and she smelled musty and gray.

"Mahmah? Why are you naked? Put on some clothes." She was looking down at me and started crying silently, and I noticed the left side of her mouth. The thinned, hardened ridges that lined the tightly pursed lips began to swell and bleed. First a little, then more. "It was you," she said, with her teary eyes.

Then I got up and ran to daddy's room and got in his bed. That's where I am now. I want to tell daddy, but I don't want him to blame me for him not being a deacon. And I don't want him to think I'm crazy like Mahmah.

January 10, 2007

Today my daddy told me how Mahmah became a slave.

A few months after Mahmah's daddy took her to the opera, she begged him to take her with him to Cleveland, Ohio, for an anti-slavery society convention. She kept asking him, "Daddy, can I ride with you down to Ohio? Daddy, please let me come. Please?"

Mahmah's daddy convinced himself that it'd be good for her to see the world.

As my daddy told the story, I already knew some of it was wrong because little girl Mahmah told me that her daddy wanted her to come with him to Ohio, not the other way around.

Well, Mahmah's daddy took her down to Ohio with him. They woke up early in the morning and boarded the steamboat that would take them down Lake Erie to Cleveland. Daddy said he doesn't know all the details, but it was about a week's trip, and when they arrived and got off the boat three white men came and jumped on Mahmah's daddy and said he was a runaway slave.

Mahmah's daddy was an important man, my daddy told me. He organized many conventions for colored folks and was headed to Cleveland to organize something much bigger. White folks used to try to trick him into slavery all the time—used to try to get him drunk or kidnap him or catch him up without his papers. But he was always one step ahead. He always had friends nearby to keep watch for kidnappers. He never drank alcohol outside of his home. And, no matter what, he kept his papers on him at all times. Mahmah's daddy was smart.

Daddy says that the white men held up a drawing that looked just like Mahmah's daddy, but it couldn't have been him because he was born free. Mahmah was screaming as the men then wrestled her daddy to the floor, but then the sheriff came and said that they don't do that in Cleveland. The three men demanded that everyone be taken to the sheriff's department to sort it out because by law they had a right to take him back down.

Daddy said that Mahmah's daddy wasn't no fool though. He knew his rights and kept papers on himself at all times. A big crowd was formed around them. Had he taken out those papers everything would've been good. But Mahmah's daddy was out of his depth, my daddy said. He had never traveled to this area, and the friends he thought would be there to vouch for him were not there.

When Mahmah's daddy went to get his freedom papers from his suitcase, he couldn't find them. So they went to the sheriff's office and ... This is where daddy forgets the story.

All daddy knows is that they put Mahmah and her daddy in a stagecoach with metal bars and rode them all the way to Kentucky. They ended up killing Mahmah's daddy though. They never planned on keeping him alive. He was an example, and Mahmah, his only child, was the cherry on top.

So Mahmah had to be a slave for about twenty more years. Till Lincoln freed everybody that is, daddy said.

Then daddy said, "Oh," and remembered part of the story—that every few miles on the way down to Kentucky, Mahmah would reach into her blouse and pull out a Mme Albertine card and toss it from the stagecoach, hoping that a friend of the French lady might see it and call her and, maybe, she might come back to save them. She kept the last card for herself, kept it hidden somehow.

That's the one daddy gave me, the one that's in my pocket right now as I write this. He said his grandmother told him that story and that we should always be thankful for being where we are today.

"Is Mahmah really a witch?" I asked. "Is?" Daddy said, chuckling.

New journal—January 22, 2007

Daddy took me to see the deacon yesterday. The deacon made me sit under the cross of God while he palmed my forehead and asked God to heal my mind and cover me in the blood of Jesus. Daddy didn't say anything to me on the drive back. When we got home, he went up to his bedroom and shut the door.

Daddy found my last journal and read it, and now I have to hide my journals after I write in them. Daddy thinks the walls in his bedroom are thick, but they're not and I can hear what he says in there.

He said he did what the deacon told him, that whenever I asked about Mahmah he showed interest in my questions and validated me. He said that he always thought it was weird that a boy my age was asking questions about a woman who's been dead for decades.

But Mahmah's not dead, she's not. She's sitting next to me right now, mumbling mumbling, as I write this.

She's mad at me again. I can tell by the way she watches me, like she's almost squinting. Yesterday, when I tried to show her my Mme Albertine card that Daddy gave me, she bit my hand with the side of her mouth and snatched the card from me. I shouted and

held my hand to my chest while she held my card to her mouth, which was bleeding again from the middle to the left side. Blood drops got all on the card because she was holding it so close to her mouth. Now the card is ruined and gone, and daddy is mad because he said I lost the card and doesn't believe Mahmah took it from me.

He kept saying, "Mahmah's gone, boy, Mahmah's dead." He was shaking my shoulders saying, "What's wrong with you? What's wrong with you? Ain't no ghosts in this house, boy." Then he called me crazy and then said sorry, but I still cried.

January 25, 2007

Daddy came to my room and took his watch and said he needed it for work. But I know he didn't need it for work. I heard him say on the phone that he was going to take the watch to wean me off my ghost foolishness. He knows I need it because he read my journals.

I cried myself to sleep and woke up back in Mahmah's steamboat again. It was night-time, and everyone was asleep in their rooms.

Everyone is mad at me. Daddy is mad. Mahmah is mad. I wanted Mahmah to not be mad at me, so I had an idea: to go to her room on the steamboat and take little girl Mahmah's stack of white pearly cards. That way, when I wake up I could give them to Old Mahmah and she wouldn't be mad or naked or bloody no more. My plan was to find the room, sneak in, and quickly shove a few of the cards into my pockets before I woke up. I could give most of the cards to Old Mahmah and keep one to give to my daddy to show him that I can travel in time. Everyone would be happy.

———◆———

When I got to their room at the end of the main cabin, I thought the door would be locked but Mahmah must have left it open for me. The door creaked a lot when I opened it. There was one window straight ahead from the door but a cloud was blocking the moon, so the room was all black and I couldn't see well. I listened to them sleep-breathe and that's how I knew they were on opposite ends of the room. Mahmah's bed was on one side of the window, and her daddy's was on the other. We swayed side to side. I was nervous and scared so I just stood there. I didn't want to make noise. I got on my hands and knees and crawled through the room, feeling my way through until I saw a wide trunk. It was directly under the window and right between the two beds.

I crawled over to the trunk, but it took a long time because I was going slow. In the trunk, there were clothes and bundles of papers and cards that weren't Mahmah's cards, and I couldn't see what was what.

Then the cloud moved from in front of the moon and a big beam of blue moon came and hit the trunk and I looked at my hands and I was holding open a sheet of paper. On the paper were thin scribbles that filled space between black block letters. I couldn't read all the scribbles, but I could tell that the first scribble was Mahmah's daddy's name, William. I couldn't read his last name but there were block letters that came after that read "A FREE MAN OF COLOR."

I was holding Mahmah's daddy's freedom papers. They had his height and weight and the type of brown he was and everything. I was about to put them back in the trunk, but I looked to my left and saw that the blue moon had hit Mahmah right in the face, and she was watching me. Her eyes got wide when they saw my hands, and I looked and saw how the blue moon shined right through them. Her lips parted like she was about to say something, but before I could put the papers back I woke up.

January 28, 2007

When I woke up on Thursday, I had Mahmah's daddy's freedom papers in my hands. I started to shout and threw them on the floor. I didn't mean to take them. I didn't mean to bring them back to my time. I didn't even know I could do that.

If I had had the watch then, I would have known how much time I had left. It was my daddy's fault. It was little girl Mahmah's fault for being weird and staring at me.

The next night, I held the papers in my hands when I went to sleep. I was trying to wake up in Mahmah's time and give her daddy back the papers. But I didn't go back to Mahmah's time. I'm going to try again tonight, but I need to make sure Old Mahmah doesn't know I have the papers. I don't know what to do.

February 3, 2007

I didn't time travel tonight because I can't sleep. Mahmah was in my room, looking through my drawers. She knew I brought something back, but I wouldn't tell her. "Stop looking for something that's not there, Mahmah," I said. But she grunted and picked up the Bible that the deacon gave me.

"Mahmah, stop!" I said, and then before I could stop her, she opened it and saw that I cut the inside pages out. She saw her daddy's folded pages stuffed inside. She started screaming but with her eyes. Her mouth stayed shut on one side while the other side only parted a little bit. It was loud and I held my head because it hurt.

She threw the Bible across the room and cried into the freedom papers.

She turned to me slowly, and I could see then that it was true. She was a witch, a ghost, ugly and bent and her teeth were black, and she was mouthing words at me from the side of her mouth, but nothing was coming out of her mouth. Then the room darkened at the corners and began bending in toward me, so I ran out.

February 8, 2007
Mahmah won't leave me alone. I can't sleep because every time I try it keeps happening. Over and over and over. Living it and waking up and living it and waking up. Mahmah's in my mind and won't leave me alone.

———◆———

When Mahmah found me in my room, she was holding the Mme Albertine card that daddy gave me. She smiled and held it out, and I took it. I thought she was forgiving me because her eyes were nice, but when I took it, I saw the blacks in her eyes burst until her whole eyes were black. She kept smiling. The eyes were all black and swirly.

She reached and dug her nails into my scalp, tilting my head back so that I was looking up into her face. She looked down at me and bent to make her face close to mine. Then she tilted her head to the side and poured the blacks from her eyes into my eyes.

———◆———

When I woke up I was tied to a chair, leaned back, like I was at the dentist. I was in a dark basement, and a white man was standing over me.

Mahmah's daddy was knelt down in front of me and started to shout and fight, but there were three other white men by him who held him down and said, "No nigger, you have to watch."

I didn't know what they were talking about. I wanted to get up and leave, but the white man called me a bitch and told me to stay still.

The man said, "Now, y'all coming to Kentucky whether you like it or not. And you're going to do it because you want to. You're not going to shout, you're not going to complain. You're not going to start no shit. Hear?"

Mahmah's daddy said please stop, we'll come. And I agreed. "I won't say nothin', I won't say nothin'!" I shouted.

The man standing over me put on a pair of long black gloves, thick and worn, and smiled. "Oh, I know," he said, "I know you won't."

And then he brought out a needle threaded with a brown wire. He grabbed my jaw, and I was screaming, "I won't say nothin', I won't say nothin', I won't!"

Mahmah's daddy was screaming and shouting as if I was his own child. The man stuck the needle right into my top lip at the side of my mouth. He pushed the needle through the top lip and pulled it out through the bottom lip and looped it up and pushed it through the top again. He kept doing it and doing it and pulling hard to make the wire real tight. Over and over and over.

It took so long because I kept crying and shouting, and the wire would rip through my lip and he'd have to start again but he kept on. He kept on! There was blood dripping off my face to my neck and chest, and all I felt was pain. It was pain that took over my whole body, rushing as the wire went down through one lip, bending like a river and rushing back up through the other. Again and again, my mouth!

"Hold her still!" The man threading my lip shouted.

"Ha! She's a tough one," someone shouted back.

When they said "her" and "she," I didn't get it because I'm a boy. I twisted my head away. My eyes went over to the corner of the basement. A black boy was standing over there, hidden behind some large shelf, showing half his face.

Then the man snatched my face back toward him and kept threading.

"Almost done, baby," he whispered. I was so tired that my screaming stopped, and all I could do was lay there. Half my mouth was wired shut tight to where when I cried it sounded like I was hissing.

I knew he was finished once I heard him pat pat my face. I couldn't feel it but it sounded like a heartbeat in my head. When he turned away the other men began to lift Mahmah's daddy to his feet, but found that he'd fainted. As they slapped him awake the man began pulling off the black gloves, which then looked new-like coming off of his hands, all glazed and glimmery.

I rolled my face back to where the boy was. He'd moved from behind the shelf to the basement door. He cracked it open and was about to sneak out, but before he left he turned and looked me in my eye. Then I saw that the boy had my face. My same face. And he, me, was smiling. And his, my, mouth started moving like he was saying something to me, but there were no words.

I looked down at my own self and saw that I was wearing a dress and I felt sharp corners, those index cards hidden on my body, digging into my breasts and hips. When I looked back to the door the boy was gone.

"Now. If ya make a sound, and I mean a peep, on our ride down to Kentucky, we'll kill this little bitch before the law can reach for the cuffs. If ya happen to make a sound and we don't get caught? Oh boy, well. Well then you get to watch us wire the other half of this pretty mouth shut. Wouldn't be very nice to have a full mouth of wire would it, sughums? Wouldn't never be able to talk right," the man turned back to me and brought his face down real close to mine, showing his yellowed teeth, "Then again, a nigger woman ain't got much a need to speak no way." ✻

Self-Conscious

MADELINE McFARLAND

The idea came to Joey after another long talk about *confidence*. Louise couldn't be placated. They sat in the corner of an Italian restaurant near the apartment; though they had the nanny for four hours, they hadn't strayed far. Louise always worried, almost permanently fragile. She had given birth, but it was like she had really laid an egg—as if what awaited her back at the apartment was not a pudgy, hardy baby but a delicate chick barely protected by a thin white shell.

She had become just as disconnected from her own body. More so. It was claustrophobic, anxiety producing—she saw no way back. The evidence was incontrovertible in every reflection: blurry in dark windows on the street; sharper in the dim bathroom mirror; and staggering, nauseating in the bright lights of dressing rooms—new indents visible on her thighs, in her back and her ass, and across every centimeter of her swollen stomach, her widened hips.

Louise had always been thin before, lucky in that way, gifted carelessly by genetics. Puberty had ravaged her self-esteem, but in the years that followed she had gracefully lengthened and thinned without fat moving or appearing at all. Her brother Albert, in contrast, struggled with his weight throughout his life, with long periods of exercise regimens and new diets recommended by personal trainers in New York.

When she called Albert to complain, he snapped, "Louise, forgive me if I have a hard time talking you through your first time experiencing insecurity. You think of your body every time you see it in a mirror? I have to think about my body every time I walk."

It chastened her briefly, but self-loathing returned. After another month or two, just before the holidays, a fight between Louise and Joey about Christmas plans—a long flight to the Bay Area to see the mother-in-law who always derided Louise—ended in tears. Vulnerable, she admitted the depth of her general struggle.

"You're so beautiful," Joey had said, holding her hand. "It physically *hurts* me that you say this kind of negative stuff about your appearance."

"I *was* beautiful," she said. "You married a beautiful woman. But now you have me."

They were aging unjustly, she thought, as were many of her straight female friends and their partners. When Louise met Joey, she had been secretly proud of herself, knowing that she valued the *right things* about him because the attraction had certainly not been overwhelmingly physical. Raised to be thoughtful, to not be superficial or judgmental with boys, she told her friends what she liked about Joey in the manner of a waiter reading a list of orders back to a table: smart, funny, ambitious, liberal, mentally stable, wealthy, good with kids. Joey mentioned Louise's physical beauty the first time they met, again on the next dates, and then each time they slept together, as she expected he would and as men had before. Your eyes, your smile, your legs. Thank you, she said, you're so sweet, you're too kind.

She indulged Joey throughout their marriage, calling him handsome and usually meaning it, letting him think that he had always been as attractive as he secretly suspected and that she was the ultimate reward for a life of hard work and self-growth—a life well lived. But, now—he was either slowly aging into himself or simply rewarded by society for the maintenance of features once mediocre, though the reason hardly mattered when she moved with him in public, watching a mutual appreciation between him and a young woman. His wrinkles became him, his roughened cheeks and his graying hair dignified him. The change in the perception of them both began before the baby, but it was *pronounced* now, amplified in a way that threatened to rot her. It was, she thought, as if she grew anonymous at the same pace that he grew worthy of attention. Her eyes, her smile, her legs—they were different now: strained, uneven, ballooning with extra weight.

At the Italian restaurant, they continued the ongoing conversation about Louise's confidence for another half an hour until the photos occurred to Joey. His friend from prep school, August, was a famous photographer working in New York, a man with so notable a career in a social circle of such generally successful people that it had grown almost boring to his friends. They met at fourteen in a stone dorm nestled into mountains; Joey appreciated August's talent and faithfully attended his shows, drinking the wine the galleries provided, but August's work was mostly beside the point for him. And yet now he saw it as a salve, a potential lifeline for his young wife.

"What do you think about having August photograph you?" Joey asked her. "Just to remind you that you're beautiful. He'd do a great job, and you'd see what you really look like. No more dysmorphia! A photo won't lie."

Louise laughed. "August is way too busy to take a photo of *me*."

"Maybe, maybe not," Joey said. "I mean, I'd pay him, of course."

"Maybe," Louise echoed. "Maybe. We'll see."

They walked back to the apartment arm in arm, moving carefully and slowly, as if they were many years older, together over the sidewalk's dirty ice.

———◆———

The day of the photo shoot, Louise prepared her appearance carefully. She wore her best dress, a silky, flattering light blue gown, and tied her hair up behind her. She achieved the illusion of a fresh, makeup-less face with a series of makeup products and left it at that minimum, wanting to look natural, even dewy. Her eyebrows, strategically, had been recently sugared and her nails were manicured, painted pale pink.

It was a bright spring day, one of the first warm days of the season, and the city was quickly thawing, returning to life. She wore a light jacket, the kind originally designed for aristocratic hunting trips, and enjoyed the sharp feeling of the air for the first time in months. She considered walking to August's studio across the park, keeping away from the new mud in the grass and the paths, but ended up hailing a cab, waving a long arm up to flag it down. In an earlier period of her life, she would have smoked cigarettes with friends to christen the good weather. In her current life, she hurried the baby away from cigarette smoke when they passed smokers in the park or on the street; today, she had the nanny there for a full eight hours of daylight so she could go across town and remember she was beautiful.

"Where are you going looking like that?" a man passing by asked her as she entered the cab. Once, too, this would have been only disturbing, the casual audacity of the catcall. She was ashamed to admit as she sat down in the cab that she felt in her weakened state a certain pleasure in the comment, the return of the novelty that catcalls had held when she was twelve and thirteen.

August's studio occupied the top floor of a large, vaguely industrial building that reminded her more of Brooklyn than Manhattan, the nooks of warehouses where she used to get her hair cut in her twenties. The door was locked when she reached his floor, but he opened it quickly and ushered her in, waving his arms.

"Welcome, welcome," he said. He was shorter than she remembered or perhaps only looked smaller alone in the studio, humanized by context. She hadn't seen August since the wedding of one of his and Joey's friends two or three years before, and she realized as

she stood across from him now, they had never been alone together. He drank a can of lime-flavored seltzer water as he began to show her around the studio. "Do you want a seltzer?"

"No, that's all right, thank you," she said mechanically and smiled. He brought her to the corner space designated for the photo shoot, and she turned to eye the small, backless stool set up in front of the camera. She felt awkward, imagining the photos that would be taken, uneasy with the distribution of her body in the dress, the faint wrinkles around her eyes.

He followed her gaze. "Yeah, so," he said, "I never do portraits, really. Happy to do this one, but we're both going to be winging it a bit."

"No problem. Thank you for doing this today," she said, and smiled meaningfully so he would understand she meant it.

She shook her jacket off, uncomfortable in the somewhat stifling warmth of the studio, and hung it on a hook underneath a puffy red jacket, then slowly sat on the stool. Self-conscious, she wrung her hands. Then she clasped them together and looked at him expectantly.

"So, what do I do?" she asked August.

"Well, what's your vision for the portrait? I have ideas."

"I'm not sure," she said. "I think something natural—but with personality, you know? Something that reminds me of myself."

"Okay, let's try it out," he said, standing behind the camera. He fiddled with a series of buttons, shifting the camera's lens. His eyes, Louise noticed, were a bright, speckled green. She felt that she could sense the discomfort of the imposition that Joey had made on him, as conscious of his wasted time as her own—the hours gone to taking care of the baby, the missing hours of sleep each night. It wasn't worth thinking about what he *could* be doing instead of photographing her, she knew, but she did anyway, unable to not see herself as a burden, heavy both literally and emotionally. "Look at me and relax your face."

Louise looked at him tentatively. He began snapping photos and then issuing orders, slowly at first and then rapidly, fluidly—a flood of commands she didn't process before obeying them instinctively with her body, growing pleasantly, mindlessly complacent from the consistency of the movements required.

"Move a bit to the left," he said. "Can you tilt your chin up? Can you move your arm to your right side a bit? Actually, to the left, please. Wait, look at me. Good. Okay, move your whole body right."

Her mind wandered, like it did when she tried to meditate or wandered through the automatic things of life: the grocery store, the subway ride, the doctor's office waiting room. There was a growingly pleasant, light feeling in her body: the calm of having a task at hand, the joy of looking pretty in a pretty dress, and the satisfaction of being the center of someone's attention without the humiliation of effort.

Yet there was an inescapable lack that her mind always returned to: not necessarily emotional, not in the people in her life, but in the *everything else,* in what was supposed to balance her social life. Their friends, their friends of friends, their acquaintances, and everyone in between—they were uniformly interesting, charming, impressive. They had multiple friends like August, genuinely famous figures, and then they had other friends, less well known to the public, privately oiling and greasing the operations of the city and its most important industries. In a sense, in their world of restaurant meals, with conversation as currency, what everyone *did* was irrelevant. This kept Louise afloat and even allowed her, at times, to move into the center. But alone, it could feel like there was nothing there, that her time was free, but she was not.

She had worked, of course, before she married Joey. She majored in French and English literature in college, and after, she took a slew of underpaid jobs, oscillating back and forth between those realms: editorial assistant at a magazine; French teacher at a private school on the Upper East Side; college application essay tutor. But none had set her on a path, and as soon as she felt herself as part of some sort of superstructure, she panicked, sensing a problem without a solution, switching industries deftly before breaking down. When she met Joey, set up by savvy mutual friends, it had been almost immediately obvious that they would get married and equally clear that it could be the end of her grasp at a career. With that change, she had surrendered and started filling that space, that supposed busyness, with hobbies and projects of various levels of passion: crochet, book club, skillful cooking, then translating little-known children's books into French.

"You have an expressive face," August said, jolting her out of her thoughts. "It's actually really interesting."

"Thank you," she said and smiled, proud, though she wondered what had been flickering across her face. "Someone told me that in college, actually, but they said it was why I *didn't* photograph well. That people with more static faces are easier to capture."

"Yeah," August said, laughing. "But I'm an expert."

She laughed along with him. He kept taking photos, and her eye caught on the light coming through the far window, a fat, glistening rectangle projected on the studio floor. She watched it shimmer until August spoke again.

"You know what?" August said. "What if we took the photos at your apartment? I think it would be more authentic, more natural. You in your own space. This doesn't feel right."

"Sure!" she said, surprised by her own enthusiasm. She felt calmer now and ready for almost anything, the way she had been as a girl. "That sounds great."

They took a cab back across town, through the closest entrance of the park. In the car, they chatted about the weather, the baby, the latest events of their lives. Riding the high of her comfort, she began to tell him the amusing stories of the past few weeks, the kinds of anecdotes she shared with her brother Albert to coax him onto the phone before she unloaded her troubles.

"I always forget how charming you are," August said after she spoke, looking at her intently.

"My only skill in life," Louise said, and he laughed in a friendly, genuine way. She liked its sound: infectious, easily charismatic. "I'm serious! I always thought I was one of those people kind of designed for others to interact with."

"Hm," he said. "So that's why Joey thinks a photograph will cure you."

"Joey has lots of ideas," Louise said, surprised again by the tone of her own voice: now, suddenly, dismissive, even harsh. They didn't speak for the last few blocks.

The doorman waved to her as they walked into the building. As they entered the apartment, August stopped Louise in the foyer.

"I like the idea of a photo of you just after you've come inside," he said as she dropped her phone and wallet on the entry's table. He spoke faster as he went, as if overwhelmed and inspired. "It captures your energy a bit! A woman in transit—but still for the photo. I think that's your spirit—it'll be the right kind of authentic."

"Okay," she said. She took off her jacket, hung it, and went back to the spot next to the table, putting her hand on her hip. She laughed as she moved her arm, feeling dramatic. Posing felt different, more comfortable in her own, known space, and she felt how inherently strange August's studio had been and how much stranger it would have been if Joey and August had not played ice hockey together in high school a decade before. As she changed positions, she felt content and grateful for her position in life and for the way the

day had gone—the general propriety of August; the power he might have shown, or taken away, and yet had not.

"Cross your arms," he said, and she did. "Rest your head on your wrist. Great. Turn closer to me. Wait, the other way. No, come back."

She obeyed pliantly, shifting her body.

"Now purse your lips, like you're smiling a bit," he said. "And look at me like you know exactly what I'm doing."

Louise laughed. "I do know what you're doing," she said, and she made the face. As she did, she imagined the path that hovered between them but that neither would take, like the silvery racetrack of a video game she played as a child suspended in the air. Its existence threatened but also comforted her: she was young; there were still attractions to be managed.

———————◆———————

The doctor's office called the next morning to tell Louise she was due for her physical.

"I've been at the doctor's for the last six months," Louise said, barking into speakerphone as she held the baby, searching the kitchen for the banana purée. She wheeled around to find it behind her, on the silver island, next to the tiny spoon she used to feed the baby.

"Right, but for the baby, not for you," the receptionist said, and Louise could hear an impatience matching her own. "We need to check up on you, too."

"Okay," she said, backing down. "I can come in today."

She watched the call blink to end without touching her phone, still holding the baby in her arms. He looked up at her with a sweet, almost inquisitive expression, like he was actively waiting for whatever she'd say next. She looked back at him expressionless, wondering what a *real* mother would do now, what she should be saying or thinking but was not able to. The baby started to frown, stuck with her solemn face, then slowly to whine, and then to cry.

She went to the doctor's, feeling lethargic. It was downtown, a subway ride away. No one bothered her on the way, jeering or leering or even watching her at all. The summer after she graduated college, she remembered, she had once been asked out on the 1 train twice on the same day: once on the ride uptown and then again on the ride back down. She had rejected both men but politely and with fake confusion, so they wouldn't follow or hurt her. Louise texted Kara, a friend from college, before she left, and asked her to get

lunch. They agreed to meet after the appointment by Kara's office, where she worked as a media lawyer at a large firm.

"Stand on the scale, please," her doctor said.

"Oh, don't tell me what it says," Louise said, and she covered her eyes.

The doctor stared at her. She asked Louise the routine questions about her health and wellness, and then listed her medications.

"Celexa, 10 milligrams?" she asked Louise.

"Yes."

"Okay. I'm going to grab this form I need you to fill out, about how you're feeling," the doctor said. She left the room and returned with a questionnaire about depression, which scored symptoms based on regularity. Louise filled it out in pen on a clipboard.

The doctor looked at the questionnaire for a minute. "So, you scored moderately depressed," she said.

"Okay."

"Your medication is supposed to help those symptoms."

"Right."

"Moderately depressed is pretty high for someone already on SSRIs," the doctor said. "Maybe we should up the dosage."

"Okay," Louise said, shrugging. "Sure."

The doctor marked something down in pen and nodded.

At lunch, Kara talked to Louise for a long time about a problem at work. They both ordered salads with chicken added. Kara wore a lavender pantsuit and heels, and her hair fell in soft waves across her face. Louise looked at Kara's legs enviously, ignoring long parts of the story, though she understood there had been a dispute between Kara and a younger male associate.

"So, what do you think?" Kara asked her at the end of the story.

"I think, fuck the patriarchy," Louise improvised.

"Exactly," Kara said, pleased. She drank some of her water. "Have you been writing—translating—lately? Are you working on anything?"

"No," Louise said and sighed. "I feel like I have no time, but it might be that I just have no thoughts."

"What have you been up to?"

"Nothing, really," she said. "Well, August took some photos of me, actually, yesterday. Joey asked him to do a portrait—we're trying to work on my *self-esteem*."

"Can you fast-track self-esteem like that?" Kara asked. For a second, Louise saw the college version of Kara flash in her face: the bold, menacing expression she had worn on the lacrosse field or walking into a party first, opening the door for her friends behind her.

"Who knows?" Louise said. "I'll try anything."

Kara squinted at her and nodded, shifting her jaw.

"I should get back to the baby. I had to drag in my nanny at the last minute," Louise said during the lull that signaled the natural end of lunch. She took a cab back uptown, feeling beleaguered and rushed. In her reflection in the cab's rearview mirror, though, she saw herself looking otherwise, objectified for just a moment: a glimpse of an anonymous woman of unhurried elegance, someone radiant.

———◆———

The show opened in late spring, just as summer began to slip into the city. Louise had been surprised by the call from August informing her the photo would be shown; she assumed it would remain a separate, private project, disconnected from his other work. She was excited to finally see it, had pictured it constantly over the months, running through the memory, including the shining moments of positive feedback, but she was anxious now, too, that the final image would be publicly shown. She understood that she had given the photo too much space in her brain, that it had passed some point or threshold and become one of the few defining events of her life. But she couldn't stop the flow of her expectations once she began to wonder, overwhelmed by the farthest reaches of her vanity and hope.

He showed the photos in the same gallery where he often did, a prestigious one in Chelsea near the glassy event space where Louise and Joey had been married five years before. Back on that street, Louise felt both sturdier and nostalgic, remembering the sense of shaky potential that life had held then. She had left the baby with the nanny again but had committed to giving her the next two Saturdays off, resolving to mother more actively. She still felt that she only pretended to be a mother, like she was just trying it out for a little while, though she already didn't feel like an independent, childless woman, either. She was something suspended in between, a specter in the space between maternal feeling and a lack thereof.

Louise and Joey unintentionally both wore yellow to the opening: he in an old but fitted button-down work shirt and she in a flattering but slightly coarse summer dress that fell to her knees. They stood out in the crowd of people in the gallery dressed almost exclusively in black. Their coordination pleased her, though it didn't surprise her; she had married Joey because of this kind of subtle distinction from other men, the relentless confidence that carried him through the world. It had always buoyed her, and though she was nervous, she was slightly mollified by their renewed temporary unity, by the feeling— absent since the baby—that they were indeed *in it together*, not just on the same loosely affiliated team.

Kara and her husband, Hayes, holding glasses of wine, greeted them as soon as they walked inside the gallery. Hayes, a remarkably good-looking man, was always either fun or boorish, announcing his mood immediately each time he joined Kara's friends. He had been widely considered undeserving of Kara by them in the first years that they dated, but had outlasted the dislike and survived its slow transformation to bemused resignation.

"Louise!" Kara cried, reaching out for her. "The star of the show!"

She laughed and rolled her eyes. "Hardly!" She waved exaggeratedly in the ostensibly royal style she had been taught as a girl, cupping her fingers and rotating her wrist. "But I am here."

"It's an absolutely stunning show," Hayes said, after shaking Joey's hand. "I think Louise's is the only portrait, but when you walk around the whole thing it's so *cohesive*, you know, you can see how he tied the whole thing together thematically."

Louise nodded, scanning the photos visible above people's heads on the closest wall as Hayes, Kara, and Joey spoke.

"I'm going to go find August," Joey announced, shifting away from Hayes. He murmured pleasantries, then walked away from the group without pausing to wait for Louise.

"Louise," someone said, tapping her shoulder. She turned to find her brother Albert beside her. "Finally, you're here!"

"Al!" she said and embraced him, kissing his cheek. She thought he looked thinner and more vibrant, with a trimmed beard and new glasses. She complimented the changes immediately, and he smiled.

"Have you already seen the photo?" she asked her brother.

"Yes. It's in the very back room." He hesitated. "It's—*different* than I thought it would be. I don't know. I want to know what you think before I have too much of an opinion."

She looked visibly worried as he spoke, widening her eyes. "Oh, no, I mean—I don't want to scare you! It's good. Let's just go see it. Should we go there now?"

She nodded, and they immediately abandoned the photos in front of them. Albert led her around two corners, turning left then right into the farthest room of the gallery, a small room with just one piece on each of its three walls.

The photo of Louise was on the center wall, printed four feet high and three feet wide. It was a photo from the apartment foyer, her coat and keys visible beside her. She stood how August had instructed her to, leaning her face on her wrist and looking into the camera. Her gaze was both placid and arresting, the expression of a woman much wiser than she usually felt.

"There you are," Louise heard Joey say from behind her, and then felt his hand on her left elbow. "I was looking for you, and now here's double."

Joey knew as soon as he saw it that the photo was both of Louise and not of Louise, instantly recognizable as her and yet completely altered, an image of her body intimately familiar to him and as distant from him as from anyone else.

August had edited the photo extensively. Part of the edit was clearly cosmetic, what people called airbrushing, and so it was obvious to and almost expected by Joey: her skin flawless and even; her hair shiny and almost taut; the curves of her body shrunken and smoothed. The other part of the edit, though, that took some time for him to identify piece by piece, went beyond the cosmetic into the abstractly aesthetic, alterations not just of the reality of her appearance but of reality itself: her angles changed, the proportions of her body shifted and distorted, an arm hanging impossibly low; the reflection of her body in the background mirror tweaked to a reflection that must have come from another photo, one twisted by some degrees.

It was, as it had been for Albert, entirely different from what Joey had expected, an image that totally abandoned her as it elevated her, too. For one minute, he stood in shock, unable to register the image; his body, unused to shock as well as discomfort, was stricken by a double blow, and he felt something fuzzy spreading in his head, muting his thoughts.

"What did he *do*?" he asked.

"I don't know," Albert said, standing back.

It was both amazing and horrific to look at; lovely and cruel; inaccessible and yet, despite itself, inviting.

"Hm?" Louise said, though she did not turn herself away from the photo to address them.

"It's just—it's not, really, you know—I guess it's not what I really thought a photo—" Joey struggled to say, grasping at words like a child bobbing for apples in a barrel of water.

Louise, still looking ahead, walked toward the photo with the ordinary gracelessness of her body and, reaching out to it, fell in love with its irregular, extraordinary grace.

"It's gorgeous," she said quietly and fervently, like she recited a prayer. "It's gorgeous. It's me, it's me, it's me." ⚹

There Is a Light But Not for You

JONATHAN PERRY

I found the first note one morning in December. It was a visiting card, to be precise. There it was, on the cupboard in the dining room, underneath the cloudy mirror. I ripped the card into a billion pieces. From the front bay windows, I looked out at Cranberry Street. I looked east, past the Fenwicks' and the Andersons' houses, then west, past the Havemeyers' and the Schmidts'. I did not suspect any of them.

Late for work, I hurried outside, into the burning chill, snow crunching beneath my galoshes. There was neither footprint nor handprint nor cigarette butt around the perimeter of my old colonial home, absolutely no evidence suggesting authorship. There was only the blanket of fresh snow and the silent Lake Erie winter and this strange visiting card, the mysterious visiting card with a message scribbled frantically in red ink, like an EKG, like the results of that polygraph. It did, I must confess (though I would never quite understand it, even now), look like the handwriting of Julia, my late wife.

"Assholes," I muttered as I cruised the slushy interstate. "All of them." Admittedly, I did not know precisely who "all of them" referred to at the time. All of my meddlesome neighbors, I supposed. And all their mischievous, ill-bred children. I didn't get along with the neighbors, it's true. Some of them had implicated me in Julia's death, and forever kept their distance, even after the state had cleared my name. Perhaps, I thought, speeding past a salt-coated semitruck, the assholes were my colleagues at Smith Goldman & Doogins, where I worked as a partner in the Mergers and Acquisitions group, as you well know.

This was the very morning of our proposals, it's true. There were five of us contending to become what's called in the business a Named Partner—Berger, McGinty, Humphrey, Irving, and me. It followed that one of these soulless crooks, several of whom I'd suspected had, before her untimely passing, established relations with my Julia, would try and sabotage me, yes, on a week of such boundless importance. The neighbors and their children, my colleagues at the firm. Oh, all wretched scoundrels of this earth, I said to myself. Ha! Ha! as I sped past the corpse of a mangled fawn. All the wretched scoundrels of this earth. They have always been against me, in opposition to me, ever since my birth, it's true.

I strutted, yes, *strutted* into the office, and I did not greet anyone or return any of their phony greetings, except for that of my paralegal, Katherine, who was beautiful and genuine and not against me and who, upon Julia's death, provided me solace in a series of increasingly platonic ways.

"Morning, Mr. Bracegirdle," she said. "Nice weekend?"

"Not quite," I said. "Someone, it turns out, is harassing me. Stalking me."

"That's nice," she said, fumbling for some inconsequential manila folder or other. Her desk was disorganized, unprofessionally so. It was a conversation we'd had over and over and over. "Kyle took me to *The 39 Steps* Saturday? At Playhouse Square? I thought I would hate it because it's old or whatever, but it was so good, Mr. Bracegirdle. You should go, you should really go."

"Listen to me, will you? I found a note in my dining room this morning, Katherine. A note from Julia: *Best of luck and all my love*, it said. Katherine, are you listening?"

Katherine moved a stack of papers from the desk to a drawer. The both of us had spent our lives moving stacks of papers from desks to drawers, it's true.

"Aw, Mr. Bracegirdle, that is so sweet," she said. "You found an old note from Julia? That's beautiful. You should carry it around forever."

"It's not an *old* note, goddamn it. It's a new note. It's a new note. Brand new." I receded into a conspiratorial whisper. "Someone is trying to sabotage me. One of the partners here, I'm sure of it."

All around the gray room were attorneys and paralegals and interns shuffling about energetically, saying things like "pleading" and "service of process" and "judge so and so," transporting papers from one area of the office to another, slurping Keurig coffees, etcetera. "Pay attention, Katherine. It's the day of my proposal to the old guard. And then this?"

"That would be pretty devious, Mr. Bracegirdle," Katherine said. "But like, Occam's razor? Were you drinking again and found it somewhere and maybe brought it to the car?"

"No," I said.

"Okay then, maybe like a ghost? Maybe the house is haunted?"

There came an incredible silence between us. Katherine, it's true, had grown more and more *spiritual* as the ceaseless carriage of time dragged her limp through her thirties. She believed increasingly in ghosts and the astrological signs and the fuckery of Mercury. I was in no mood, and she wasn't helping, so I hurried away, finding refuge in my immense corner office.

Nothing happened for two hours, nothing at all. Then I began reviewing my *book of business* and ran through my *deal sheet* in preparation for the week's proposal, all the while contemplating suspects vis-à-vis the visiting card. When my thoughts started ending where they'd began, which was nowhere, absolutely nowhere, I scanned the *New York Times* on my computer. A plastic surgeon in China had completed the world's first successful head transplant. The beneficiary, who in my eyes was nothing but a doomed victim, had the appearance of Michael Myers from the Halloween movies. The head was simply too large for the victim's gaunt and sickly torso. Transformation, I concluded, was impossible, Detective Mann.

After preparing myself a caramel espresso from the Nespresso machine, I stood idly at the window for ten full minutes, in a meditative silence, contemplating which of these scoundrels had the boldness to author such a note. I looked out at the city of Cleveland. It is the most underrated city in America, you will agree. In my youth, I had always dreamt of becoming mayor of Cleveland, or maybe even governor of Ohio, but as happens to most Americans, my life became an increasingly insurmountable succession of financially onerous obligations and debts, which made the prospect of achieving anything interesting, challenging, or fulfilling completely unthinkable. And then my wife died—another expense—and there came that prolonged investigation, yielding nothing worth mentioning here, as I'm sure you remember. People talked, assumptions were made, accusations were levied, etcetera. Finishing my espresso, I fell asleep in the wing chair, curled up like a fetus, and had a baffling dream that Julia was trying to convince me to eat some sort of bran muffin, nagging at me from the grave. And just as I reached out my hand to destroy the muffin, there came three knocks on my door.

"Who is it?" I asked, rubbing my bleary eyes. The door swung open. It was Wendell Berger, smiling-assed Wendell Berger, the co-chair of the firm's Banking and Finance group, carrying a manila folder stuffed with financial documents.

"How goes it, Comandante?" Wendell said jovially. He was clean shaven as always, smiling unnaturally, reeking of the patchouli-scented cologne he usually over applied. He was excited about something. I'd worked alongside Wendell for thirty-seven years, and I could sniff out that he'd just settled a big case, on the morning of my damned proposal.

"The Jackson case settled," Wendell said, closing the door behind him. He went on spewing out details about the negotiations, his triumphant defeat of opposing counsel, and so on.

Was it Wendell? I thought to myself. Was it goddamned piece-of-shit Wendell? Wendell had always done right by me. Wendell had always done right by the good Lord. On more than one occasion, Wendell had led the firm in hours of pro-bono work, representing indigent clients all over the city in a wide variety of civil and criminal matters. In terms of philanthropy, Wendell was something of a legend. He was six foot four with a beautiful wife and two immaculate children, now at Brown and Harvard, respectively, and he had no problems whatsoever, had never once had a problem, any problem, whatsoever, ever, not once, I thought. Wendell would be the last person to do such a horrible thing. This I can see clearly now. Probably it was Wendell whose name would go up on the building because he was a brown-noser but also an extremely talented attorney. And a consummate gentleman. And extraordinarily kind, in a way that could border on creepy, depending on the context. Was it Wendell? It was too soon to say.

He was fucking my wife when she was alive, I suspected for a variety of reasons that the record will reflect.

"Let me see that folder," I said suddenly, pointing to the folder Wendell held underneath his muscular arm.

"What?" Wendell cried.

"I said, give me that goddamned folder you're carrying. Give it to me now." I reached across my desk and yanked the folder from Wendell's gentle grasp. Then I produced, calmly, a handful of shreds of the visiting card I'd stored in my breast pocket.

Indifferent to his protests, I analyzed a yellow sheet of legal paper whereupon Wendell had written the words MS. KATZ ENTITLED TO COMPENSATORY DAMAGES ALSO PUNITIVE??? and contrasted his eloquent handwriting with that of the mysterious visiting card.

Inconclusive, I concluded after a glance.

"Look, Wendell," I said, returning the folder. "Someone's fucking with me." I stared inquisitorially into his hazel eyes. His scleras were yellowing faintly with age.

"What is this?" Wendell said, vaguely guiltily.

"I said someone is *fucking* with me." I handed him the shreds of the visiting card and gauged his reaction, and the crow's feet around his eyes, the movements of his chapped pink lips. "I found a . . . menacing . . . in my dining room," I told him. "Just this morning. Sitting there on the cupboard. The day of my proposal and, well, I'm suspicious . . ."

"Suspicious of *me*?!" he squealed indignantly.

The very words of the note, stuck into my mind like gum on pavement, I recited to Wendell. He shook his head in genuine disbelief, and in sympathy for me, for his colleague, for his Comandante, who in Wendell's eyes, having so suddenly lost a wife had suffered enough tragedy for two or maybe even three upper-middle-class American lives.

"That is monstrously cruel," Wendell ventured, gazing into his lap, rubbing his hands together. "What an atrocious—Lord! I'm sorry, Lew. That's horrible."

"Yes," I said.

"Awful," he went on. "Callous," he said. "Just thoroughly callous!" he added for good measure. "I mean, the lowest of the low in terms of—"

"—Yes," I said. "Enough. Thank you. Now listen, listen to me." I leaned forward, took a deep breath, and whispered. "I suspect someone at the firm. One of those other bastards. Not you, Wendell. I'm sorry if I gave that impression just now. Wipe that look off your face, will you? The goddamned litigators, or maybe McGinty or Humphrey or even Irving."

"They wouldn't," Wendell said. "No. They wouldn't."

"Isn't it obvious? On the day of my proposal to the top brass? The day of this monumental decision? Perhaps the single most important week of each of our individual lives?"

"Not mine," injected Wendell. "Sure, it'd be nice, Lew, to have your name on the building in gigantic golden letters. But it's a little ego boost is all. It'll all be washed away some day. Everything good gets washed away." Was he remembering my Julia, I wondered. "What's important is friendship. And love. And the money, Lew? The money is just—"

"Out of all weeks I've worked at this—"

"And anyway, McGinty would never. Humphrey would never. Irving—"

"To suddenly receive a visiting card from my deceased wife? On the week of my proposal, to receive this visiting card from my dead wife?" I leapt from my chair and slammed my fist into the mahogany desk. "Bad faith. Subterfuge. You know it when you see it!"

Wendell too leapt from the wing chair and hurried over to me, his old friend, his Comandante. He embraced me out of sincere brotherly compassion and/or guilt and held me close for several moments until I peeled him off like a nagging scab and asked him to leave me be.

That afternoon, my mind running amok on account of the conspiracy, Mr. Goldman's paralegal summoned me to the Grand Conference Room. On my walk through the office,

I passed McGinty's office, and then Humphrey's, and then Irving's. It was, they knew, the hour of my proposal.

In the Grand Conference Room, as the managing partners had named it—for they enjoyed naming the rooms around the office, and the areas around the office, and the non-attorney staff of the office, whom they quietly considered chattel, like pets (did you know Julia's dog Ethan, may god rest his soul, was merely chattel under the common law?)—stood one hundred percent of the managing partners—that is Frank Smith, Mr. Goldman, and Marianne Doogins, an ashy, sinewy, decaying triptych of Limited Liability Partners against expansive glass windows. Mr. Goldman, that putrefying octogenarian, sat at the head of Grand Table. Frank Smith sat to Mr. Goldman's right because Frank Smith was afraid of Mr. Goldman, on account of his wealth, and because he thought of himself as Mr. Goldman's right-hand man, especially since Marianne Doogins was a woman. And Marianne Doogins sat to Mr. Goldman's left because, in terms of symmetry, which she appreciated as an aesthetic principle, it would not have been proper for her to sit anywhere else.

I strutted, yes, *strutted* through the frosted-glass doors, chest out in feigned confidence, carrying my deal sheet and my book of business and collated spreadsheets of my annual billable hours, all of this stuffed into a tattered manila folder. The grandfather clock in the corner, which had been placed there two decades ago by Mr. Goldman, the father of Mr. Goldman, click click clicked.

The old partners stood simultaneously. Extended three hands. I shook them all, without alacrity, looking zero of them in the eye, and found my place at the opposite end of the Grand Table. The room was cold, my hands quaked, and my knees trembled slightly.

"Have a seat, Lew," said Mr. Goldman, though I'd already taken a goddamned seat.

"Good to see you, Lew," said Frank Smith. "You look. You seem. You seem a little I dunno, what's the word? Verklempt, Lew," Frank Smith ventured. Frank Smith routinely spoke in ten-dollar words because he'd graduated from an abysmal law school, which, three years after Smith graduated, lost its accreditation and became a for-profit electronic music production college, an event that filled him with a terminal insecurity wherever he went. "You know there is nothing to worry about. We're all friends here."

"We're family," Mr. Goldman said.

"We're family here," said Frank Smith. "Mr. Goldman is right to say it."

"And this is well a family decision—whose name to add to our eminent partnership." Mr. Goldman cleared his throat and took a long sip of his milk.

"A tremendous decision. Truly monolithic."

Marianne Doogins sat quietly, nodding along. She didn't say much as of late. Rumor had it that Mr. Goldman and Frank Smith had only added her to the partnership on account of her gender. The rumor started when, at last year's Christmas party, Mr. Goldman said to a particularly useless male summer associate, "You know we only added Doogins to the name on account of her sex."

"For it is in monuments, like names etched into a limited liability partnership, that we escape the erasure of time."

"In monuments, we escape the erasure of time is exactly right," said Frank Smith.

Marianne Doogins suddenly sneezed loudly. Then, after a brief silence, she sneezed again, though less violently the second time. She was a great woman. Perhaps I should've married her, Detective Mann. I slid the tissue box in her general direction. Mr. Goldman and Frank Smith glanced at her gravely. She removed a tissue and wiped a glob of goo from her septum.

"In any case," Mr. Goldman said, slightly perturbed by the piercing sneeze. "We are gathered here to entertain your proposal. Walk us through your legal career at the Smith Goldman. Show us the numbers, as if we did not already know. Sell us on Bracegirdle in shining golden letters."

Before I raised the issue of the devious visiting card, which I fully intended to do, I began, in a sort of disassociated, economical manner, reciting the highlights of my legal career, as I'd prepared on a yellow legal pad. The crux of my proposal was a history of client acquisition, the success of the HeartMart merger, several efficacious summary judgments, and the larger part of this decade's gross profit, which had, I admitted to myself as I spoke, tapered off since Julia's death and the subsequent criminal investigation. I even went so far as to offer anecdotes of comradery that in my mind demonstrated a familial love for my colleagues, whom—it was no secret—I largely detested. The old guard, following my every word, nodded their heads approvingly. "But," I said, "considering this topic of comradery, there is an issue I would like to raise with you all before we proceed any further."

It was then, at the climax of their anticipation, that I relayed the story of the visiting card.

Without hesitating, I stated clearly the very same hypothesis I'd shared with Wendell—that someone within the firm—either McGinty, Humphrey, Irving, or perhaps

even Berger, I hadn't ruled it out—had forged the visiting card and planted it at my home the very morning of this proposal, with the aim of sabotaging me. I requested that Frank Smith, Mr. Goldman, and Marianne Doogins investigate this deception before coming to a decision. "Are these the types of individuals you'd like to immortalize on this building? Crooks? Villains?" I asked rhetorically.

Mr. Goldman and Frank Smith simultaneously shook their bald cashew heads in disapproval, disgust, even. The Grand Conference Room fell awfully silent. Marianne Doogins dragged the back of her hand across her stuffed nose.

"That is quite the accusation!" Mr. Goldman roared.

"What proof?" Frank Smith asked. "What evidence?"

"Intuition," I retorted bravely. "Inference. The same intuition and inference that has made me a lead attorney at this firm all these years!"

"These men are friends of mine!" Mr. Goldman roared louder. "To think McGinty or Humphrey or Irving—it's unthinkable!" he concluded decisively.

"Friends of his," Frank Smith said. "Of mine. Family, in fact."

"It's nonsense," Mr. Goldman said. "Mr. Bracegirdle, I would like to propose," Mr. Goldman said, "and I don't wish to belittle the tragedy you have suffered. But I would like to propose to you, Mr. Bracegirdle . . ." He stood, organizing some papers. "You have been unable to handle your grief, Mr. Bracegirdle. Just two years ago, you were accusing these same men of having relations with your late wife. And now, this note. It's been a year since her death and, quite frankly, your paranoia, and your drinking, Mr. Bracegirdle. You drink liquor in this office at all hours—oh, do you drink. We can smell it on your breath, you know. It is discussed. It is discussed. We can smell it on your breath right now."

"I can't," Marianne Doogins said.

"I can," Frank Smith said. He sniffed the cold, stale air. "Yeah, for sure. It smells like . . ." he sniffed again. "John Barleycorn."

"Who is to say you didn't find the note in some drunken stupor? Or perhaps drafted it yourself in some drunken stupor?" said Mr. Goldman. "The truth is, Mr. Bracegirdle, you've grown *dissolute* this past year. You have lost control of your practice and maybe even your life. You are, what's the word, *unfurling*, and it shows in the numbers."

"You have been slipping," Frank Smith said.

"You are falling apart," Mr. Goldman added for good measure.

"For the record," Marianne Doogins interjected, "I disagree with these gentlemen, and I

believe you are an asset to this firm, especially when one considers what you've been through."

"Good for you!" Mr. Goldman sneered. "Now, listen, this meeting is adjourned."

A thick, silent odium settled over the Grand Conference Room yet again. I was thinking many things at once—cold room, the managerial class, Marianne Doogins's nose, even violence, Detective Mann, I should admit. I was thinking too many things at once.

"You're free to go now, Llewelyn," Mr. Goldman said condescendingly.

To this day, I don't recall rushing Mr. Goldman, or the crack of my knuckles against that thick, thick skull, or Frank Smith hollering, "Security! Security!" or the crimson rivulets of thick, thick blood, or Marianne Doogins's subtle smile. But these things did happen, Detective Mann. The record is indisputably clear on these points.

———◆———

Some nights later, for who's to say how many, the old colonial home creaked in the cold and steady wind. I had not left home since the assault on Mr. Goldman, but I had learned through a visit from Marianne Doogins that Mr. Goldman was magnanimously refusing to pursue criminal charges against me. "Your name of course would not be added to the partnership, obviously," she said from the porch, where she stood because I would not invite her inside, on account of the mess and what have you. "And you won't be fired, either. Out of pity, they've placed you on a sort of leave, until you can prove you've reformed, or something. Would you like to grab dinner and talk things over?" She had, the same year as me, become widowed.

"No," I said.

And so, Marianne Doogins left me. I never saw her again, I'm sad to say. I spent several hours on the sofa, consuming huge draughts of Woodford bourbon whiskey and watching nature documentaries on the Chesterfield sofa Julia had insisted we purchase. After some time, I began to feel uncomfortably warm. I rose from the sofa and opened four of my living-room windows. Winter drifted inside wraithlike and curling. Yet, despite this cold, my temperature continued to rise. I turned off the gas fireplace, and the living room became opaquely dark. Still, in the cold and dark, I grew warmer and began to sweat buckets. I patted my bloated, clammy face. I removed my bathrobe too and walked to the open window where I stood nude, looking out at Cranberry Street, where I lived, the parked cars clogging the street in front of the Andersons, who were throwing a party,

to which I was surprisingly invited (it is rumored Mr. Anderson suspected me all along), but declined. Abruptly, I recall, as I stood nude at the window, there came a sound like scratching in the walls. Had mice finally come? I wondered. Of course, they could've come, for I never picked up after myself.

The scratching sound was faint, at first, but as the moments passed, it grew louder and more intense, and then it became a fierce scratching, and the heat—well, I was boiling! The scratching was truly deafening, and the house, creaking, and I, plugging my ears with my thumbs, hot in the cold dark, collapsed back into the Chesterfield. And as suddenly as it started, it stopped, the scratching did. Hush. Humming silence. It had passed like the wind.

Cold again. The strange bodily warmth had disappeared with the sound. The old colonial was quietly creaking. The night was at peace, and a cold wind waltzed through the window. I put my robe back on and flicked the fireplace on again and stood trembling. Tremblingly, down the hall, toward the dining room. Tremblingly, into the dark dining room, the long mahogany table, the bay window facing the backyard, the bony trees swaying in the wind, tapping against the window, outside all lunar blue. Shadows. Specters. I turned on a light because I was very afraid. And there, beneath the mirror, on the face of the cupboard, a sort of antique pewter pen dripping red ink and another, yes, another pale white visiting card, its corner folded skyward:

IT WASN'T NICE WHAT YOU DID

– J

Needless to say, at that point I grabbed the butcher's knife and began to search the premises for intruders. Yes, I had searched the house liked I'd searched it before—this card's author had been characteristically meticulous. As you know, I found nothing, nobody. And suddenly I remembered Katherine's words—could it be a ghost? Could the colonial be haunted?

Returning to the sofa, I lie on my back, gazing at the stucco ceiling, clutching a butcher knife. Could it be? I observed the ceiling for forty-five minutes, ruminating on the visiting card, the suspects, the events of the week, the plausability of haunting.

And then suddenly there came a knock at my front door, three forceful and familiar knocks. I peeled myself from the sofa—this took everything!—and answered it. Detective Mann, I must confess I was very afraid.

It was only Wendell, smiling eagerly, gripping a bottle of pinot noir in his black-gloved hand.

"My friend," Wendell said. "I only wanted to stop by and check on you. I haven't seen you in two weeks now. You know I worry. Here," he said at last and handed me the bottle of pinot noir, which I accepted. The wind surged and smacked violently against our pale skin. "May I come in?" Wendell said, looking past me into the austere foyer.

"You know I haven't seen you," Wendell said, pushing himself inside, removing his jacket and hanging it up himself. "Haven't heard from you. Forgive me just showing up here unannounced. But you've become a ghost."

"It's fine," I said. "Come in."

"You don't reply to me," Wendell continued. He'd always had the insufferable habit of belaboring obvious points. "I've texted, I've called, I've emailed," he continued, fussing with his greatcoat, which would not stay on the burnished hook.

"Someone is stalking me," I informed him curtly. "Is it you?"

Wendell gave me a look.

We sat in two leather recliners and faced the fireplace. We sipped red wine from stemmed glasses and remained mostly quiet for a good portion of the evening. I watched him closely. Why had he come here? A bitterness had infected me. Wendell's teeth tapped against the rim of the glass, and the bitterness grew worse because of that irritating sound. His every gesture was an outrage. Across the street at the Andersons' party, a drunk woman was laughing.

"Do you remember that night of the HeartMart merger . . ." Wendell ventured.

I grunted.

"How Smith fell asleep in the supply closet, and we couldn't find him for three hours. And when Katherine finally found him, he had his hands down his pants! That was a moment. He was itching his balls. He claimed it was intertrigo. . . . You were essential in that merger," Wendell continued. "Without Lew, there's no merger, that's my god's honest assessment. We made a lot of money, a lot of money. Gah, we were young. You know you're a fantastic attorney, Lew. You know it, I know it, everyone in this profession knows it. Even scrotum-scratching Smith. You're just—you haven't been yourself," he said. "And nobody blames you, you know, what with what happened."

"Were you fucking my wife?" I said suddenly. He only smiled, Detective Mann. That stupid, content little smile. The outrage!

"Now, now, old friend. You know some of us, not me, of course, but some of them, thought, no, *suspect*, in the present, that it was *you* who killed her."

Wendell's bulging eyes shined in the firelight. Crazed eyes. The wine had gone to his striking head. He leaned toward me, unblinking and smiling. I sat quietly, twisting the glass between my finger and thumb.

"Now, Comandante, my oldest friend, I wanted you to hear this from me." Wendell gently placed a hand on my knee and took a deep breath. "I'll be the next named partner," he said. "It will be *my* name on the building. It becomes official in a few days. Berger in big golden letters. Can you believe it?"

I would never recall switching off the fireplace or reaching for the butcher knife, which I'd stashed beneath the Chesterfield, or how it glimmered in the moonlight, no, I remember none of it.

———————◆———————

In any event, Wendell is buried beneath the birch tree, beside the dregs of Julia. After it was done, I soaked in a scalding bath. I drank black, black coffee until dawn.

And for the days and weeks after, I sat in the kitchen for a long while, in the creaky wooden chair for who's to say how long. It was often morning and cold. I'd fall asleep with the windows open because I liked the sound of the wind gliding over the snow and the slush. But when I'd wake, I'd regret having left the windows open because the night had been very cold, and the morning, too, so cold my hands felt on fire, if you can believe it. I spent those days there in the creaky wooden chair of the kitchen with an old box labeled *Julia,* where I kept her postcards and photographs and the trinkets and sentiments and symbols she left me upon her untimely departure from this stinking dunghill of an earth. As for those mysterious visiting cards, I left them on the cupboard beneath the mirror. I must admit they were similar to my Julia's handwriting. *You're finished, old man*, one of them said, I do recall it quite clearly.

One day, the coldest day in the region's recorded history, I awoke at the kitchen table yet again. The kitchen was blue. The chickadees were twittering nonsensically. The light funneling through the windows was blue, and the brown wooden table was blue, and the creaky chair and my white hands were blue, and the world was blue, all of it. What shade of blue? I didn't know. I didn't know anything. I hadn't been paying attention. So I poured whiskey in my favorite coffee mug, the one Julia had bought me: World's Best

Dog Dad. The dog! Yes, the dog, little Ethan. Ethan had died too, I regret to inform you. He simply had to go, for he was there when it happened, and he'd stayed away from me after that, and he even tried to starve himself. I'd liked to be charged for his death, to the fullest extent of the law, though I know he was only chattel.

It was for the remainder of my days in that old colonial that the notes piled up on the cupboard in the dining room, underneath the dirty mirror, and many nights I would hear the scratching and find another note, taunting me, reminding me of what I had done. The very last note read: *There is a light, but not for you.*

But where did they come from, Detective Mann? Have you solved this mystery? And do they still pile up there on the cupboard, beneath the dirty mirror?

———◆———

Detective Mann, I am guilty. I killed my wife because she was against me and my oldest friend because he was against me, perhaps against me together, or so I suspected. Something I have learned: the guilty are irrevocably doomed, and there is no forgiveness on earth, or in heaven, and when you take a life, all life that remains turns against you, it's true. Even the black-capped chickadees. Their songs are threats and warnings and forebodings. And by the very end amid the threats of the chickadees in the blue morning, I would sometimes glimpse her reflection in the dining-room mirror—her red bow, her blue dress, finger on her pulse—and I would scurry over, to apologize, or something else, but she would fade away. Sometimes Wendell would call out to me from the hereafter, and then one day Wendell stopped calling, he had gone on, and it was finished.

Because one afternoon you came to my door, Detective Mann. I do not know the day or the month even. My beard was a great rain cloud, and my eyes were a great rain cloud. I had aged one thousand years, you said. You remembered me from the first investigation, you said. You were very young and optimistic, with a very red nose. "Yes, sit down," you said. You were not against me.

"I will tell you everything," I said. ❀

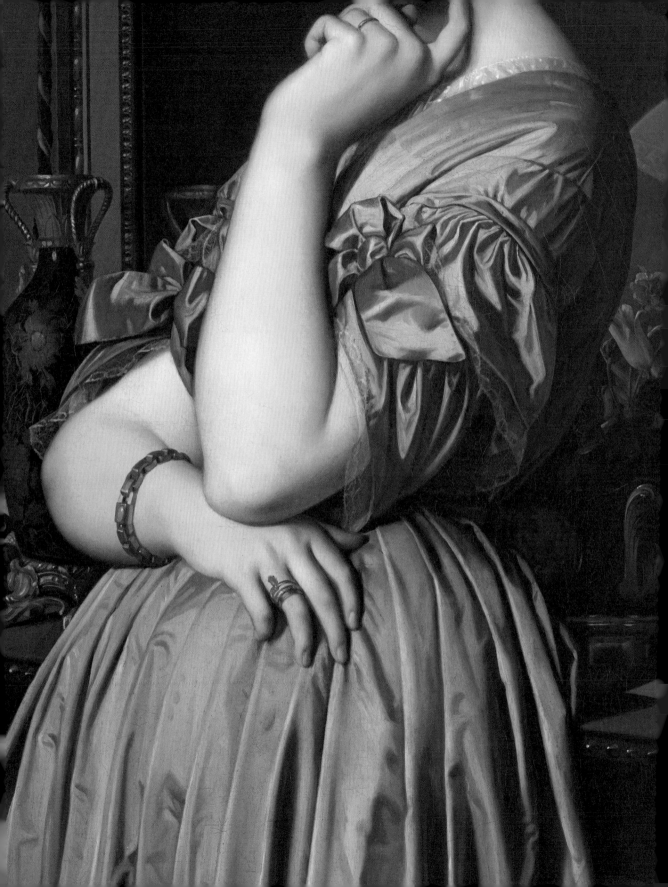

A Place for Us Both

ISABELLE PHILIPPE

Basile Raymond arrived on a Thursday afternoon in the heat of early May. Adalee watched from the window of her father's study as Basile descended from his carriage in a genteel and cautious manner, as if the stone walkway were a bed of clams swept from the sea that required careful preservation. She found herself touching the pins that held together the neat chignon adorning the back of her head, then smoothing down the fabric around her waist. He had aged handsomely since childhood. Her father, who had been waiting at the head of the stairs, came down to greet Basile, the son of his business partner, Silas Raymond, and the heir to both families' shared museum.

Adalee took to the stairs in a modest haste that wouldn't betray her eagerness if one of the housekeepers rounded the corner. She walked past the separate dining and tea rooms, through the kitchen, and finally into the parlor where Serafine sat at the piano.

"Serafine, Basile has arrived."

The melody coming from her cousin's spiderlike fingers stopped. "Oh, he's early. Shall we?" She stood up, entwining her arm with Adalee's.

"You'll leave your hair like that?" Adalee asked. She regarded the loose, golden tresses that hung down Serafine's back.

"Well, yes, I didn't realize he'd be arriving so soon. We were expecting—"

"It's a bit unpresentable, don't you think?"

If she was offended, Serafine's face revealed nothing. "I'm sure he won't mind, seeing as we were expecting him—"

"Fine, hurry then," Adalee said, quickening her steps and pulling Serafine forward. "We can't keep him waiting."

They passed through the back archway and went down the steps, emerging from the shaded dome of the tunnel-like passageway into pervasive light. Their path split in two, the left fork leading to the edge of the sea, which surrounded the back half of the

Bourdons' coastal estate, the right fork opening to the trail that wound through the gardens. The two took the latter.

"You're very eager to see him again," Serafine said.

"Well, it's been years since they moved. I don't know if you'd remember him well. You never did want to play our games." In Adalee's memory, the sweet boyish face adorned with budding curls smiled from beside her as they ran barefoot across the sand, treasure-hunting and building makeshift shelters from branches of pine. To think he would soon be director of the museum and working so closely with her papa. A boy of aspiration now a man of stature.

"Are you aware of what's taking place?" she asked Serafine.

"Why wouldn't I be?"

"Well, you don't seem to take much interest in Papa's work, sweet cousin, so I'm never sure what you are and aren't aware of."

"I take plenty of interest. The new collection for the museum will be a great success, I'm sure."

"Did I tell you how Basile's father let me choose the stone tiles and Basile the wall colors?" As if they had built it together. The first private museum in France. She felt a great sort of pride when thinking of Silas's and her father's creation, how Papa traveled across seas from Asia to the Americas to source riveting art pieces, how well she would do in his place with Basile at her side.

"I wonder how he's taken to Paris," she continued excitedly. "And the plans! Oh, I have such big plans for future exhibitions."

Serafine gave her an inquisitive look.

"It's only natural that when Papa retires, I'll take on his role as curator, just as Basile will succeed his father as director."

"That would be lovely!" Serafine replied.

Adalee squeezed her arm in response. They continued down the line of hedge-rows, around the circular garden beds, the air balmy and dense, laced with an occasional breeze. Adalee's father and Basile came into view, both perched along the fountain's wide edge. Adalee took in the neat, gray suit their visitor wore, the polished boots, the waves of brown that brushed across his forehead. Both men stood as the young women approached.

Adalee spoke first.

"Papa . . . Monsieur Raymond. It's wonderful to see you again."

Basile's lips fell on her hand. "And you, Adalee. You're lovely in womanhood."

Warmth spread across her face. At nineteen, she felt womanly too. "I hope that your father is well after his fall. We're all very excited about your plans for the museum."

"Yes." Serafine stepped forward. "Uncle has expressed nothing but praise for your work and vision for the museum." Basile took in Serafine's face, his eyes widening slightly. Heat rose in Adalee's abdomen as she imagined what his gaze discerned—green eyes set against an alabaster face. An elegant curve to the bridge of her nose. Cheeks flushed from constant communal endearment and that loose, wild hair. But beyond that, was it still the pitiable face of an orphan, whose parents died in the Bazar de la Charité fire, of the miracle baby who had survived the flames at the cost of her father's life, of the girl who grew unscathed and beautiful as a full moon in autumn? Did her now-mature face resemble that of her mother or her mother's sister, Adalee's own mother, who died of tuberculosis four years later? Perhaps he thought Serafine uncouth. Perhaps he thought her anything but desirable.

Adalee ran her tongue across the back of her lower teeth until the flesh became tender with pain. She was used to the looks her cousin received—from visitors who frequented the estate, their numerous trips into town—but this she was not prepared for. These eyes were meant to be cast on her alone.

"My beautiful girls," her father said, his voice hoarse from cigars. "Basile is here, no doubt to see you."

"Us!" Adalee exclaimed.

"A visit that's been long overdue, and on account of a favor." Basile looked slightly abashed. To Adalee, his liquid brown eyes resembled the color of her father's purest brandy.

"We're looking for a signature piece for your father's exhibition, *Faces of France*. My father and I hope that you, Serafine, would agree to be painted for the exhibition, if you are so inclined. Your story is so dear to the people of France. And your aunt, may she rest peacefully, and your uncle's benevolence in raising you . . . It would be a wonderful addition to the collection, to see such beauty so well and alive."

If her bones hadn't locked in place, forcing her to remain upright, Adalee could have collapsed from shock.

"Monsieur, I'm . . . what a kind thing to offer," Serafine stammered out. "I don't, I don't know what to say—"

In the periphery of her vision, Adalee saw her father move to embrace Serafine before kissing the top of her forehead.

"Nothing at all, my love," her father said. "Your acceptance will be enough."

"And Adalee," Basile continued. "Your father tells me that you have an extraordinary sense of design and eye for detail. You could style Serafine, her dress, her pose—you would be akin to the artist. It's a grand role."

"Oh, that would be lovely, a place for us both!" Serafine said, unable to conceal her excitement. "Adalee was just saying how eager she is to learn the trade of curation."

Adalee wanted to recoil from the grip that'd been placed on her arm. Styling Serafine had no similarity to curating in any form. She fought off the feeling of being dismissed.

"Then you accept?" Basile asked.

She could sense her cousin's eyes on her, and when she turned to meet her gaze, she found the flecked green orbs as deceitful as the scales of a reptile, the pupils dilated and pitiless. And then there were those of her father, which narrowed infinitesimally at her hesitation.

"What a wonderful idea, Basile," she said flatly. "It would be my privilege."

His mouth fell open slightly as if in question. If her curt response had come across as ungrateful or resentful, so much the better. Let their joy be tainted with her disappointment. Did he think she was too dull to draw in the people of France, too bland to prompt contemplation, too unremarkable for viewers to form an opinion about her looks, her reputation, her character? At the base of her eyes came a sudden sting. She curled her tongue in on itself and looked at the parasol pine trees above, willing the small pools of salted tears not to betray her.

"Serafine, why don't you give Basile a tour of the grounds," Adalee's father broke in. "I've only shown him the garden trails."

"Yes, Uncle. Thank you." Serafine's cheeks turned the warmest shade of rouge, a coral-pink azalea in bloom, as Basile held out his arm and looped hers within it.

Adalee and her father watched them depart in silence.

"Papa, what is this?" she asked, when the figures had receded from her view.

"A wonderful opportunity for you both."

"For us both? You plan on making her a celebrity while leaving me to—" Words eluded her, so she waved her hands about, feeling small and petulant.

Her father stood up and took her arm, leading her in the opposite direction of Basile and Serafine, closer to where the gardens opened to the edge of the Mediterranean. "Be

reasonable, Adalee. You know exactly what position we're in. The debt that our Argentine Museum owes is considerable, and with the Coltier Museum opening in September—the challenges will be even greater. If this collection and future ones do not attract . . . I don't have to tell you the rest, do I, sweet girl? For Silas, this isn't a problem. His money is endless. If it fails, at least there might be the prospect of a union between Basile and—"

The sound of the crashing waves, the birds in the trees, the wind against her ear—all suddenly felt deafening. Adalee stopped walking.

"A union, Papa. Serafine and Basile." The saliva in her mouth was bitter.

"She would be taken care of, and we would be taken care of, Adalee. I've invested everything in this museum. The assets, they may not be returned to me if it were to fail. But this way . . ."

"It's returned to her."

"Of course you would have your share."

"Of what?" She looked around her. "The estate? All my life, you've known I only wanted the one thing. I watched it be built, I watched as the art was collected, I—"

"Oh Adalee, don't be irrational—the museum was never yours alone to inherit."

"Alone, no! But in partnership—with this you've given everything to her, a niece!"

"A daughter all the same. Don't you have any regard for your mother?"

Adalee straightened her back, keeping her face void of emotion. When she thought of her mother, it was never in health as she had been too young to know her in her prime. The face that came to her, sickly and worn, was always turned away in her memory, fixated on the golden angel, two years Adalee's junior, who was petted and soothed, frequently reminded of how loved and wanted she was. Her father's words to her now were callous. If she were to return the sentiment, she would ask if Basile's affection would also be lost to Serafine.

"I was the one who accompanied you to meet with the artists. I am the one who arranges your affairs!"

"Adalee," he said calmly. "You are creating a world for yourself that does not yet exist."

Her breath was short. "How long is the painting scheduled to last?" They had rounded the gardens and were approaching Serafine and Basile.

"That's up to the artist, Sébastien Larose. He'll arrive in about two weeks. You've met him before, my love."

"I've met them all."

"Come then," he said, kissing her head. Then loudly to the two, "Shall we sit for tea?"

Adalee's stomach tightened as Serafine approached, her eyes dancing with sunlight. They walked slowly to put distance between themselves and the men.

"I hadn't remembered that he was so kind, so sensible."

"What did you two discuss?" Adalee asked with attempted indifference.

"The museum, of course, but he also asked about my own plans and desires, my thoughts on the portrait."

"Well, and how do you feel?" Perhaps Serafine didn't want to do it after all. Hope made her voice eager.

"I would've never predicted the opportunity for something like this, but Basile—he thinks it will be a way to honor my parents and the others who died that night. I want to do exactly that." There was a pause before she said, "As grateful as I am to you and Uncle, it would be nice." Timidly, she continued, "To have a way forward for myself, a reputation that's separate—it would mean something." When Adalee failed to respond, she said, "I think he thinks that I'm brave. I don't see myself that way, but I would like to—I would like to see myself as meaning something to the people of France, if that's how they feel. I want to see what he seems to see. I know it sounds silly, but I had such a feeling come over me. No one has ever . . ."

Adalee stiffened beside her. "What an impression, in such a short amount of time."

Serafine laughed, a grating sound against Adalee's ears. For a moment, she saw Basile, the tender brown eyes that had regarded her reverently in childhood. She heard the memory of his laughter mixed with her own as they fenced and climbed trees, activities Serafine had refused to partake in because they were too rough, too boyish. What had changed in their familiarity? Did the boy who tilted up her chin delicately as if she were the finest piece of porcelain no longer exist in the man who stood before her today?

No, he was blinded by beauty. Involuntarily, she thought again of her mother, young and iridescent, a jewel among other women who visited the chateau. Adalee herself was marred by too many of her father's features. The brown eyes that appeared birdlike, the nose too large for the rest of her delicate features, the jaw too square for the small chin. But her mother, her face had been lovely, unique in its beauty. The memory of her face was quickly overtaken by the tuberculosis that weathered her, making her pallid and gray. Her mother's eyes grew too big for the sunken face. Her plump, firm body became feeble.

Beauty, Adalee knew, faded so easily. But career, legacy . . . things that rested in the hands of men, these endured. Perhaps Serafine had figured it out too.

———◆———

Adalee watched Sébastien Larose and Basile as one watched a fight between peafowls in mating season, for when Sébastien arrived, each man had his own vision for how to pose Serafine— how to bring the luminous girl to life on canvas. Adalee, for all the supposed value of her skill in direction and theme, was not consulted once. Instead, the morning after his arrival, she found herself consumed by the shadow of midday, Serafine centered in golden light. With her hair braided in two parts and pinned up, a red ribbon encircling the web of hair like an ordained halo, and the rippled fabric of her blue gown, Serafine looked like a porcelain doll, leaving nothing of the wild appearance she'd carried the day before.

When Basile entered the room, Adalee moved from her place beside the curtains, smoothing down her silk brocade dress. She wore her hair down, the middle section pinned into a makeshift bun, while the cut of her dress highlighted the barely visible top of her breasts. With confidence, she could say that she was much more womanly than Serafine, but was that what he desired?

"Serafine," Basile said. "You look extraordinary." His hands reached outward toward her waist and came to rest lightly on barely formed curves. "This gown must have been made for you."

"It's Adalee's, actually," Serafine said, her voice breathless. "She thought it would be nice for me to wear."

"Well, I thought I would contribute something," Adalee responded rigidly. "You and I haven't had any time to talk, Basile."

He turned to look at her. "Time is infinite in the country. There's too much of it. In the city, everything moves like a lightning storm."

"I do remember how attached you two were," Serafine chimed in. Adalee almost felt appreciative. She noticed Sebastien's eyes moving between them.

"Childish endearment," Basile said, looking first at Serafine, then briefly regarding Adalee with a wide smile. "We were foolish, don't you think?"

"Foolish? I wouldn't say . . ." Adalee's voice trailed off as embarrassment rushed over her. There was a moment of silence between them. She looked directly at Serafine, who kept her

eyes lowered toward the flounce of the gown. *He is mocking me,* she thought. The whole thing to him was a game, with his peacock feathers ruffled up, deciding who was worthy of time and attention. Had time warped his memory? When he gazed at Adalee's face, took in the rose of her lips, were they not the same that had touched his in their first embrace?

She clenched at her skirt and watched as artist and director stood around Serafine, angling her arms this way and that, nearly bumping into each other to tip up her chin. Serafine wore a mask of pleasure and contained her excitement as her eyes moved from Basile to Sébastien. At that moment, Adalee hated her.

"Here, why don't we place some articles around the armoire," Adalee said loudly. "I can pick some fresh peonies and get the binoculars. You'll look like you've just come from the opera. Also, your calling cards—you've been missed," she said in a forced attempt to sound conspiratorial.

"Yes, those would add great character to the portrait. You have a good eye, Miss Adalee," Sébastien said, turning to regard her.

"It's the least I can do," she replied, moving the golden vase from the sitting table to the armoire. Behind her, Serafine and Basile continued their courtship. She wasn't sure if any of her words had been received. And though Sébastien had paid her more mind in this moment than Basile had since his arrival, she still saw him cloaked in bright, jarring feathers—his tail never once angled toward her. "I'll fetch the flowers."

Over the course of ten weeks, Larose worked from sketch to oil with precision, every stroke, detail, and ruffle immaculately depicted. Throughout the process, he offered Serafine cooing encouragement, which never failed to make her giggle or blush.

"The loveliest of France," he would call her, his voice sticky like honey.

Adalee—on call should Serafine require a glass of water or need the ruffles of her dress smoothed out—watched the proceedings each day, not only to be present for Basile's rare appearances but to monitor the interaction between Serafine and Sébastien. Sébastien, a well-known artist, was also known to amalgamate his talent with lust. All of the French Riviera was interested in his work—and who his latest infatuation was. As the weeks passed, Adalee, from her corner of the room, watched as Sébastien smoothed Serafine's hair into place or corrected the angle of her head, just so, with no real difference made, just to lay his hands on her. She didn't comment on the affronts, mild enough in their nature, only watched with veiled indifference, all the while making careful note of the indiscretions. Some days, Adalee found herself imagining what would happen if she

were not in the room. Would Serafine's dress gradually be slipped off, revealing first her collarbones but then her small breasts? Would Sébastien smooth the creases over with his thumbs as though he were smoothing charcoal on paper before pressing his lips to the tender skin and taking the dress, Adalee's dress, further down Serafine's body in the process? She imagined Basile catching the two in the act, his betrayal and anger, his need for carnal relief and Adalee's presence to provide it. Her body was sexually overdriven in these moments, and she found that time passed quicker if she gave in to these thoughts.

The opening of the rival museum, the Coltier, and other business affairs required Basile's presence in Paris for most of the time during which the portrait was painted. When he returned to the coast in mid-August, Adalee stood at the stairs with her papa waiting for his return, but it was Serafine who ran down the length of the stairs to greet him like a wild foal ravaged with obsession.

"You're back early," Serafine said, hesitating slightly at the base of the stairs. Basile grasped her hands, pulling her toward him.

Adalee staggered backward at the sight of the gesture, cutting the skin of her ankle on the edge of the step.

"I hope you don't think of me as weak," Basile said. "But I—I wanted to return to you as soon as I could."

Serafine looked down. "We're all glad that you're here, monsieur."

"Very glad, very glad," Adalee's father said from beside her. "We're sure you have news about the Coltier. Let's walk by the shore."

Basile continued regarding Serafine with doting eyes that Adalee wanted to claw at. She had never been prone to violent thoughts, but now they were relentless. Poor Basile, entirely blind to Serafine and Sébastien's incessant flirting. Her vision didn't take in the bloom of summer around her or the song of the sparrows. As she made her way through the manicured hedgerows, she could only feel the pain of her feet as she stepped on cobblestones and the dizzying rush of the ocean at the back gates of the house. She gripped her stomach, the corset feeling too tight all at once, every lace up against her back palpable.

"Papa," she panted, the sun filling her eyes with a blank, white light. "Papa!" she called out again.

"Yes, yes, Adalee, what is it?" Her father spun around to wrap a hand around her waist. Ahead, Serafine and Basile did not falter in their steps.

"I can't—I don't think I feel like myself. There's something I have to tell you. Something I've seen."

"Seen what, silly girl. You're overwhelmed by the heat. Come, there'll be water for your face."

"No, Papa. Serafine and Sébastien, they're familiar with each other. Too familiar, Sébastien—he looks, and he lingers."

"That is the way of a painter, Adalee. How do you expect him to remember the details?"

"But the way he touches her to adjust her pose."

"Enough! You'll see soon enough that your worries are gratuitous." He pulled her across the length of the sand and deposited her onto an edge of rocky shoreline. She could feel water sinking into the fabric of her gown.

Basile regarded her with an amused expression. "Are you alright, Adalee?"

She imagined announcing it here, Serafine's behavior, imagined that smirk stunned off his face. That damned face she knew so well.

"Fine!" she snapped.

"Oh, cousin," Serafine said, rushing over with fluttering hands.

"Leave me, I'm fine!"

"Please, don't mind her. It's only the heat," her father said, applying salt water to her cheeks despite her protests. "Your news, Basile?"

"Oh, yes, the Coltier—my father was also in attendance. We saw, well, they had landscapes, portraits, pieces from Japan. It was—"

"Well," her father nearly barked, rising from beside her. "What did your father say?"

"He said—he doesn't think that the portrait will be enough to revive the Argentine."

There was a long break of silence, during which the heat mounting in Adalee's stomach felt pleasurable, as though someone had ignited a dead furnace.

"The work will not be enough."

"Inanity," her father declared. "He hasn't even seen it. I've never seen a more beautiful portrait. It will be the star of the exhibition."

Basile spoke now only to Serafine, whose eyes glistened wetly, her face that of a sparrow's mournful song in winter. "Never mind my father. We'll face the day when it comes, my brave girl. I wrote a letter to your uncle when I was away because my only thought was not the museum but returning to you. You've become so dear to me in such a short time, Serafine."

If the feeling at the base of her stomach hadn't transformed into anger, Adalee thought she might have been made sick, by the words, the false confession—false because it was premature—by her cousin's face and that of her father's, whose eyes now grew twice their regular size as Basile kneeled.

Adalee cursed the world for the cruelty of its unspoken legalities and unwritten judgments, for a fate worse than death, the rejection without consideration more painful than any shame. And Serafine—it was as if Adalee had grown a garden for them both, but only her fruit had been poisoned.

Basile rose from his knee and kissed Serafine's hand modestly. In the minutes after, Adalee was passed around in a dizzying motion, only she was in the wrong role. From Serafine to Basile, she stated words that felt impermanent as they came from her mouth in tenors and vocabulary she wouldn't recall later on. And finally, she landed in the arms of her father whose body trembled, his eyes shining with tears. "Adalee," he said, looking into her unblinking eyes. Two blurred hands rose up to cup her face. He leaned in, so his lips grazed the curve of her ear, and whispered, "We are saved, my love. In either case, we are saved."

———————◆———————

The end of August brought heavy rains and a general glum feeling over Adalee's days, which was caused in part by the official announcement of the wedding. It was already declared to be one of the biggest events of the next summer season by *Le Matin*. Serafine had made a name for herself—Serafine soon-to-be Raymond. The estate, the social prestige, the claim to the museum—she would have it all. Adalee stood in front of the finished portrait now wrapped in glassine and resting against the wall of her father's study. It was nearly as tall as she. Sébastien had finished it only earlier that evening and kept in her items—the fresh flowers, the vase, and the cards. He had made her dress look elegant, and naturally, Serafine shone like a radiant gem, her pondering gaze accentuated by one hand perched delicately on the nape of her neck. Her green eyes carried a dark turbulence not reflected in person. Had he meant to cast her as the troubled orphan? Adalee's throat felt thick with frustration and tears that she would not allow to be shed.

The sun began to set, barely visible through the dark storm clouds that pervaded the sky and negligible to the ocean that brewed in torrents of blue. She could hear laughter, that of Serafine and Sébastien, which rang through the floorboards in the cadence of

derision and deceit. Her father and Basile had ventured to Paris to continue the installation work begun earlier in the week, leaving the two to their devices. The sound was like a migrant creature come to haunt her in her own house, but not for long. Sébastien was leaving. From the window, she watched as he and Serafine came outside, then slowly descended the front walkway stairs, pausing to say their goodbyes. She thought then about Silas Raymond and whether he approved of Serafine, if the portrait had been his idea, and now his gravest mistake. Because his words were correct. The portrait was not extraordinary, and it would not be enough. How would it commemorate the victims of the Bazar de la Charité fire? This gave tribute to Serafine alone. She gripped the back of her father's chair. Though she had lost the battle for his son, the war for her spot—as curator, as someone essential to the affairs of the museum, that was yet to be won. How quickly things could turn depending on the reception of the piece. She smoothed her dress and headed down the stairs toward Serafine and Sébastien, her blood coursing with renewed vigor.

As she walked through the front door and into the blustery evening air, the first echoes of thunder roving around her, she jolted to a stop at the sight of Sébastien's fingertip edging along the base of Serafine's lip.

"What are you doing!" she cried. The feeling that she experienced, the feeling that threatened to undo her, was not shock. It was horror and envy, rage and exultation coalesced into one.

"Mademoiselle," Sébastien said, his voice loud with what could only be guilt. Serafine stepped back, swatting away the hand.

"Adalee, please. It's not what you think." She crossed the length of the walkway to grasp Adalee by the top of her arms. "I wouldn't dare—"

"I saw what I saw. When Papa returns with Basile tonight, I will have to tell him. I will have to tell them both!" Adalee said, her voice trembling with excitement.

"Adalee!" Serafine yelled.

"You stupid girl, you are mistaken," Sébastien yelled, drawing the attention of the maids in the nearby hall. Thunder resounded, closer.

"Sébastien, please. You have to go now," Serafine said, tears bedding in the rims of her eyes. Then to Adalee, "He was only telling me—"

"I don't care what you say he was doing. You're a spoiled, selfish girl." The rush of adrenaline had left her, and in its place was only pain, anger, and triumph. "You don't

care about the museum or Basile—you only want to preserve yourself! I've always known." She watched the long lashes blink, saw the water fall from the ends of her lashes, blending with the first droplets of rain that arrowed down from the sky. "You knew how I felt about him."

"What?"

"The plans we had, for the museum, his work, my planning." In the corner of her eye, Adalee could just make out Sébastien's retreating figure.

Serafine's tears seemed frozen in place as her expression transfixed into one of bewilderment. "Are you insane? Oh, Adalee, I love you. You are a sister, a beloved sister, but you're so awfully blind when you're envious." Her voice grew small. "Can this not be mine? Only mine. You've had everything growing up. All of this," she said, motioning to the chateau, "is yours, but my future, it was never mine. It was stolen from me. This . . . Papa arranged this for us, for him and me. He was always meant to be mine, Adalee. He and all that he—"

Thunder cracked against what sounded like a mountainous boulder being split in two, a cane striking metal. It was the sound of a skull striking stone, a mind no longer intact. And then the rain, rain that came down torrentially, pattering into the stream of red, running over the ground like a river of sin. In tumultuous drops, it fell on the guilty hands attached to the guilty arms that were outstretched and unmoving, for the intent of those arms hadn't been to push with such force, such hatred, only for their victim to feel the same kind of crippling, blinding pain that had compelled the action. But here was an unexpected pain, one that could not be undone.

Adalee looked at the scene before her, feeling the force of her push reverberate through her arms. She was convinced that should she look down at her hands, she would see that they were coated in the same watery crimson that covered the ground. Wildly, she turned to the doorway, where thankfully, no maids were found, but they would be here again, to call her and Serafine in from the rain. *What have I done?* It was the trembling of her core that forced her to move, as it was the only way she could get the unnatural feeling to stop.

Her feet took to the stairs, her voice called out a name, the only name in the world. "Serafine, Serafine," silk on the tongue. "Serafine, really!" Bile and remorse mixed into the bloodied water as her body heaved, and the other remained unmoving. Adalee gasped for breath, drowning in the deluge from above. She found herself rising, uncertain that the

hands that were now locked beneath Serafine's weighted underarms were her own, that the same hands connected to the same arms were dragging the insentient body attached to the golden, dented head around the drive to the left-most pathway, through the back gate and onto the sand that felt grotesque as it slipped over the tops of her exposed feet. She was huffing and grunting in a tongue unfamiliar to her as sweat and rain matted her hair causing it to cling to the nape of her neck. She stopped to switch positions, grabbing the turned-out feet, then tugging roughly across the length of the sand. Farther and farther she pulled, the golden head collecting crystalline particles. The blood-caked body was dampened by the violent storm, imbued with an aura, that of a fallen angel. Adalee blinked at the sight of water rushing at the feet, her feet—at the beautiful white and rose gown that clothed the delicate face that lay below her. Then the rise of the current, a wave that collapsed onto the body, and Adalee was plunged under. She struggled to the top, coughing, gasping, yelling out little screams smothered by the hand, her hand. The current was sucking her back, but the sand was still beneath her feet, clenched in the palms of her hands, and with a push, she rose from the water panting and sputtering still. The waves continued, in and out against the backs of her feet, against her calves and buttocks, but she stood motionless, watching the limbs, the golden hair, the billowy gown be pulled farther and farther into the depths of the sea.

———◆———

She reached the split of the trail, rain pelting down on her. Just outside the hedgerows, she could hear her maid, Margot, calling from the kitchen window, "Adalee! Serafine!" When the calling stopped, she quickened her pace, walking in a large circle around the spot at the front of the house where red still snaked in the crevices of the stone, then went directly to its center, falling on her hands and knees, scrubbing at the slick cobblestone with her hands, until any rivulets of blood that the rain had not already washed away were gone entirely. She rose and quickly entered the house, rushing past the kitchen, from which the smell of supper had already migrated throughout the halls. Clambering up the stairs—in the same undignified way for which she had chided Serafine—she entered her father's study, closing the door behind her. The silence transfixed her, like entering another world. Yet, the window appeared the same, the stairs outside, that ocean bed. Her sight was blurred, but in her peripheral vision, she could still see it, the portrait, that face. She inched toward it, slowed by the renewed quivers that now overtook her body.

"This," she whispered, grasping the sides of the wrapped canvas. Her voice came to her as a shock, an unwelcome noise in the haven that had been silence. What would happen to the portrait now, the museum? What would they become in Serafine's absence? In her mind came an image of Sébastien, the retreat, the insolent tone of his voice when he insulted her. The advances, the gall. And then there came the possibility of a way forward. The war, she thought, it could still be won. Moving quietly, she took the canvas, surprisingly light for its size, and exited the study, descending the back stairs, which led directly to her mother's garden. She paused at the last step, listening intently for any movement. No housekeeper would be out in the rain. She entered the garden through a wrought-iron gate and started to search desperately for a spade—deeper and deeper, through the hedgerows, past the lines of rosebushes, in the place that was not tended. And there, along the roots of a great oak, a spade, its metal rusted but still intact. She discarded the canvas on the wet earth, then traced its outline. Moving the painting aside, she rooted up the soil, which, though dense, gave little resistance with the excess moisture. The dug-up rectangular bed was shallow but sufficient, and she packed the painting in place before covering the exposed top with soil. Her mind, unable to move quickly, could only fixate on Sébastien's face. There was a way. In the ten years since her mother's death, she hadn't once returned to the garden. Her only thought now was to pray to her mother—for what God would hear her—to keep the portrait hidden to buy her time to do the only thing left that was possible. Would her mother scorn her from the afterlife, or would she be mollified by the return of her precious Serafine? Both now were beneath her. Adalee reached for the stems of weeds, the closed tulips, branches and stones, anything to place on top. Once covered, she looked around, then walked as quickly as her legs would allow toward the front of the house, gaining speed until she was running, flying, calling out the name desperately, "Serafine! Serafine? Oh Serafine—I couldn't stop her!" Her steps took her into the house, a bewildered, drenched bundle of fabric, in and out of rooms searching until all the maids were gathered around her. "She's gone!" she cried out. "Can someone please call for my father?" Adalee backed into the arms of one of the older women, then sunk to the ground. "Sébastien," she sobbed heavily. "Serafine has gone after him—I've searched everywhere. What if she runs off with him? What if he hurts her? And the portrait! Both of them are gone—he's planned this, I know it. Oh, I've looked everywhere—please, won't you call for my father! We can't wait for his return. Margot, Lucille, send for a carriage, quickly!"

She had never been to town without Serafine or her father, but in the cover of darkness, Adalee rode in with one of the maids by her side. The storm had lightened to a minimal patter that allowed the horses to move quickly. Finding Sébastien's residence proved simple, as she'd gone there with her father once, on business for one of his earlier collections. The house was modest, small, and red-bricked with smoke billowing from the chimney. He was home.

"Wait here," she said to Lucille, shutting the door of the carriage as her maid protested.

After several sharp rasps, the door opened. Adalee didn't wait for acknowledgment but barged in.

"Close it immediately. I come here as a favor to you because I know the relationship you've had with my father. Serafine—where is she?"

"What? What are you asking me—she was with you!"

"No." Adalee forced her legs to move, and she walked around the place in a tight circle. "Tell the truth. Is she not here? She said she—after you left, during the storm, she took off after you."

Adalee looked around the small house. There was a lit fire, a small brass table littered with books and journals, magazines strewn on the floor. The one couch at the back of the room had a fur throw. She caught sight of herself in the mirror—a sickly pale and splotched waif—then spun back around to face him.

"I don't know what impression you gave her—that you would renounce the painting, that you didn't want it shown anymore, or that your feelings for her were too great!" It was too hot in the room—she wanted to scream at him to put out the fire.

"Feelings! Don't be ridiculous, and I would never—but where is she?"

"You're telling me the truth? She hasn't been here?"

"Of course not, I told you I—"

"It doesn't matter. The maids saw what transpired between you two earlier. They've called for my father. If she isn't found, the portrait with her . . ."

"The portrait? The portrait is gone? Adalee, what are you telling me?"

"I have to go—I've stayed too long as it is. I've only come to warn you, Sébastien. If the officials appear, I'm afraid you might be a person of interest. And Basile, even when she is found. Once he learns . . . I pray for your safety."

With that, Adalee opened the door, leaving Sébastien standing in the entryway.

"Let's continue," she told the driver. "We'll search for her on the opposite road."

———◆———

Le Petit Journal, the same newspaper that reported the death of Serafine's parents and others in the Bazar de la Charité fire, would state that by the time officials reached the home of Sébastien Larose, he had already fled. The subsequent search for him was detailed in every paper and magazine across France. Among the loudest voices to detail the events leading up to Serafine's disappearance was Adalee herself. She had been possessed with a restless energy, calling for the capture of Sébastien and the rescue of her cousin. She recounted to the newspaper the indecencies she had witnessed, her father's regret at not listening to her because if he had perhaps he would have been spared the loss of his niece and the portrait. The missing painting— the last idol of the disgraced beauty—was more talked about than Serafine herself, fueling a scandal that only grew as the days went by. Who had taken it—Serafine or Sébastien? And why? What was the nature of their relationship? And what did poor Basile make of it all?

"Is it true?" Basile asked Adalee on the second day of Serafine's disappearance. He was staying at the chateau while the search was underway, his presence welcomed. "What you've been telling the reporters?"

"Where are they, Basile? Why has neither been caught?" Though she met his eyes, a cold moisture spread along the nape of her neck. She didn't like questions from him or her father— the journalists took every word she said and reprinted it without hesitation. But Basile was not so easily pacified.

"Was I that blind? Why didn't you come to me sooner?"

"You were so enamored with her; I didn't want to—I wasn't even sure of it myself. I had only spoken of it to Papa, and he told me not to bring it up." She regarded him closely for any indication of an incurable grief and was pleased to find minimal signs of it. Only anger marred his brows.

"How could he have kept something like that from me?"

"I'm sure he had his reasons, but Basile . . . the museum—the collection? What are you going to do about it?"

"To hell with it."

"You don't mean that."

"It's incredible really. If the painting was not lost—everybody is searching for it. Hell, Armand Fallières is searching for it. The Argentine would be saved."

Adalee fought to control her expression. "They would come to see it."

"Of course—the town flirt and the—" He stopped himself. "I won't stop until I find her. But Adalee, you're telling me the truth?" In that moment, the anger in his eyes vanished entirely, and the concern she saw there became so grave, it twisted her stomach.

"What reason would I have to lie?" When he nodded and his eyes released her, she found herself saying, "Let's hope for a quick return—Serafine and the portrait."

<hr />

The news, a body washed ashore, reached her the next day while she was sitting at her vanity. She walked alongside Basile and her father, who'd been called to identify it, through the gardens, past the gateway and onto the sand. The beach had become a foreign territory to her, something that stopped existing in her memory. Adalee raised one arm to shield her gaze, though there was little sun on the pleasant September evening, and her steps were small so that sand did not slip into the openings of her shoes. In the distance, the ocean glimmered, shiny rays bouncing off the surface that reflected in her eyes despite her best efforts. She shuddered lightly, then rubbed at both arms in case either Basile or her father should comment. They met two officials stationed in uniform at the edge of the shore. At their feet was a bloated, hideously disfigured mass placed on top of sheet paper or a tarp of some sort. Fleshy skin, blistered and greenish black, appeared bitten off, making the surface of the torso and limbs appear both hollow and bumpy. What remained of the flaxen hair lay in straggling tendrils that were pushed away from the face, that once beautiful face that now looked half eaten apart. The lips were mottled and uneven, the eyes peeled back in disfigured white and expansive red veins. Parts of the iris had been picked at, but there was just enough color left to make out a pale green. Acid overfilled Adalee's stomach, burning her throat, and she turned away as it splattered along the sand.

"Adalee, go back to the house," her father said when she had stopped heaving.

"I'll stay."

"Don't be brave," Basile replied.

She didn't stir, and nobody sought to physically move her.

After a moment, one of the officials said, "We believe it to be her, your niece, Monsieur Bourdon. Serafine."

"Oh. Yes, yes," her father said and staggered back. Basile grabbed his hand before he fell to the sand. A low moaning sound escaped from his lips.

"Serafine," Basile said, his voice defeated.

Ephemeral, Adalee thought, looking at the distended, monstrous figure with horror-seeped pleasure. *How quickly beauty was taken from her.* Her gaze remained fixed on the corpse, wind and salt beating against unblinking eyes.

Basile turned her around to look at him. His hands cupped the side of her face, stroking at the wetness on her cheeks with both thumbs.

"You're trembling, love," Basile said. "Please, take your father to the house. Make your way to the gardens, I'll soon be close behind. This is too much for you, for anyone."

Adalee couldn't formulate any words, unsure that the sound of her voice wouldn't be that of a demon, but she nodded once, not quite looking into his eyes, and reached for her father's arm. Side by side, the embodiments of depravity and grief, they hobbled back to the gates. Adalee slowed when she walked through, conscious of the awful, gasping noises her father was making. Her ears were already filled with a distant ringing noise, her eyes filled with dazzling white light. She stepped forward and darkness consumed her.

"Adalee, Adalee." She woke with her back pressed against the cool of the marble fountain. "Adalee, it's all right." Basile's voice coaxed her gently. "You've fainted. Your father went searching the maids, for ice, but—" He trickled fountain water along her forehead. As it ran down the length of her nose and down her neck, she opened her eyes.

"The news continues. They think the portrait may be in the ocean as well. They're sending a search party in the morning." For a moment, her heart lurched. She waited for it to calm before answering him.

"Searching the ocean?" she asked. "How does anyone—?"

"If—if Serafine was so close, they believe—I don't want to upset you again." One arm fixed itself around her waist and pulled gently. She clutched one hand to his chest, looking at the soft brown eyes, those treacherous eyes. If only they had seen her first! "They believe it might not be far out. It's a long shot, but it's all that's left of her. When they catch that monstrous—"

His words faded away. *This is okay*, she told herself. The inevitable unearthing would just have to come sooner than planned. "Your father—does he agree? We would be saved."

His brows furrowed, and then, understanding, he nodded once. "I'm not sure what the papers will say about this. It will be hysteria, surely." The rims of his eyes were shiny.

In his anger, his hand had clenched around her waist. She relished the feeling. "But if it were found, we would be saved."

———————◆———————

Adalee was sent to bed early and had a dreamless, anxious sleep, where she was uncertain of time's passing but conscious of her dormant state. In the early hours of the morning, she woke up to moonlight casting an unearthly glow in the room. The temperature felt chilled, and she planted both feet on the wood floor, unsure if she were caught in some sort of a nightmarish purgatory or if she were still asleep. As she walked out of the bedroom and down the stairs, her body felt light and airy as if she were soulless, her body afloat without it. She went through the conservatory door and out into the gardens, picking up the spade on her way. The night air was cool on her damp skin. She hadn't realized how hot the house or her bedding had been, how the heat had made her hair stick to her neck. She panted with the exertion of unearthing the painting, though it hadn't been buried deep at all. And when it was finally in her hands, she gripped the two sides and rose, following the path to the beach. She thought of his hand, Basile's, against her face, the way the thumbs had soothed her and gripped her midsection. As the cobblestone gave way to sand, she thought of her father and the museum, and then Basile's words: "We would be saved." It would be enough after all. Everybody would come to see the relic.

"The missing cost," she whispered out loud. Her words dissolved into the night, blending in with the hum of the sea.

Further and further she walked, the sand becoming wet, water edging to meet the tips of her feet. The portrait was still wrapped in glassine, the contents beneath, she was sure, protected and unmarred. If she looked, which she did not, she was certain that perfection would gaze back at her. Instead, she continued holding the portrait pressed against her belly and ribs, the waves rising, rushing against her shins and hips. She was struck, submerged, resurfaced, over and over, but she held on still. If she pressed the portrait below her, she could float. With her eyes closed, Adalee did just that, letting the waves pull her under and resurface, over and over, her legs not once touching the bottom of the sea.

———————◆———————

And what a sight it was, when dawn rose, for the men who filtered in from the shore with their black and gray suits, their lazy, unexpectant mien, to see the girl and the portrait

floating in the sea, close to shore. Among them, Basile, who instantly recognized the muddied brown hair, the pale visage, even from so far away.

"Adalee! Adalee!"

In her dazed consciousness, she felt like she was being pulled apart, like parts of herself were being swept away with the tide. She was unsure if she could speak, but for the voice that called her, all things had to be possible.

"What is this?" he asked, holding her tight against the length of his body and pulling her to the water's edge. The painting was unfastened from her grip.

"Basile," she rasped. Her mouth tasted of minerals and brine, of victory and remorse. "I searched all night, and I prayed and prayed and searched and searched. And here it is." One hand stretched out to touch the edge of his lips with the tips of her fingers. "I found it, Basile. For us, our future. Our salvation." ❧

Paranormal Patterns

ERIC RUBEO

A ndrew, pulling up the gravel road in his compact rental, thought he had never seen a home look so insane. Then again, in his near-thirty years, he'd never seen a real-live mansion—three stories, broad Corinthian columns, and an honest-to-God fountain with mermaids spitting into a pool. Driving up, he'd been so enchanted by how the vertical symmetry appeared like an illusion of mirrors, he almost drifted off the gravel into the lawn. Except it wasn't quite an illusion. The manor was just huge. Gate security had mentioned an east-side lot, which he found just before a ramp leading down to a garage. He parked the rental there.

His girlfriend, Sophia, heaved forward to look up through the windshield, gawking. "Holy shit, Andrew."

"Come on," Andrew said. "Duty calls."

From the trunk, he lifted the single frayed strap of his ghost-hunting bag, the one full of his father's tools, and tossed it over his shoulder. He offered Sophia his hand. As she stood, she groaned.

"Babe, you're pregnant, not dying."

Sophia released his hand. "What's the difference?"

On the stoop before the double front doors, which were high and painted black, Andrew couldn't find a doorbell. A small camera surveilled from up high, but, so far as Andrew could tell, that was it.

He took back her hand and squeezed. "You didn't have to come."

"What, and miss this?"

There wasn't even a door knocker, which seemed odd. Beneath a stained-glass transom window, he might have expected a metal lion or eagle or some family crest. "Maybe they'll send someone," Andrew said, pointing up at the camera. Though who *they* were was still vague to him. He only knew one name: Louise, the woman who had contacted him. Or rather, who had contacted his father. His father had succumbed to cancer two months earlier, but that Contact Us form had been forwarded to Andrew, his father not being one for computers. And Louise's message had been intriguing: a dead father's visage returns distorted in a mirror.

"If nothing else," Sophia said, "you'll have an article to sell."

Though Andrew had long since quit believing in ghosts and hadn't joined his father on a job since high school, he felt now a calling from the void, his father's deep, rumbling voice coaxing him out of that cramped Brooklyn studio. Not to mention they needed the money.

Sophia perched on the concrete stoop and rested her forearms on her abdomen. "So what's the play?" she said. "We get paid more if we talk to it, right?"

Andrew rapped the door again. "You know," he said, "almost half of Americans believe in ghosts."

"Half of Americans believe a lot of things."

The left door creaked inward, and a short, round woman in a black-and-white-striped blouse stood just shy of the sun. Dark glasses shielded her eyes. "Mr. Mallory," she said, "I thought you'd be older." Then, looking down at Sophia. "And you are?"

"The brains," Sophia said, pushing down on her knees to rise. But noticing Andrew, she said, "Kidding. I'm just here to help."

"You're Louise?" Andrew said.

"Indeed."

The foyer opened into a living room, high-ceilinged, with auburn tones in the carpet that matched the oak paneling. Flanking a fireplace were four velvet wingback chairs, two on each side, askew beneath a second-floor hall and balcony running perpendicular to the front door. A bearskin dangled like a cape from the banister.

"Some place you got here," Sophia said, head cocked back.

Andrew, too, was looking up at that bearskin, when Louise said, "It's my husband's family home," and then, a little louder, "I'm sure you're anxious to hear the details."

"Of course," Andrew said, setting down the bag. He helped Sophia sit down first, then said, "So your father's been visiting you?"

Louise nodded. "It's strange," she said, "because he never saw this place. Not even to visit. He died back home in London."

"You're not American," Sophia said.

"It's been twenty-six years since Martin and I eloped." Louise shifted in her seat. "And then, the night my mother called with the news—oh you'll think me mad—I was at the vanity readying for bed and I felt him in there. That's how it came to me, a feeling of being watched. And then one night I saw him in the mirror."

"Your dad?" Sophia said.

"Just for a moment. His arm was drooping in the mirror, like his shoulder was detached, but when I turned around, he was gone."

"How often do you see him?"

"Just the once," she said, "but I feel him there most nights. Watching."

"What about your husband?" Sophia said. "Does he sense him?"

"He wouldn't," Louise said. "Martin sleeps down the hall."

As she spoke, Andrew had been scribbling in a notebook. Slowly, his father's process was returning to him, how he'd let the client lead. How he'd taught Andrew to resist assumptions and leading questions. *Keep an open mind*, his father would say, usually in the parked car just before a job. Andrew said, "I've heard of spiritual immigration," remembering something his father had said, or written about, "like when a spirit travels long distances quickly." His leg bobbed against his father's bag.

Sophia gave him a look like, *Really?*

"Well," Louise said, "that's why I called you. You're the expert. You know things."

He felt pretty good when she said that, as if maybe he wasn't a fraud. He had, after all, a secret weapon: *Paranormal Patterns*, his father's handwritten composition journal describing dozens of ghost varieties he'd encountered and classified. Andrew remembered how excited his father got when adding new entries. Though he didn't think he believed in ghosts, Andrew thought maybe he could keep an open mind.

"So about our rates," Sophia said. "Andrew, what are our rates?"

"Oh," Andrew said, "Yeah." And then, "We appreciate the flat fee bringing us here. If we find proof of spectral activity, that'll double. Then if we establish communication, that's the third and highest tier. Just remember we won't try to capture or otherwise dismiss the specter, though. That's how you get hurt."

"Yes, yes," Louise said. "See Martin about the money before you go."

"Well," Sophia said, hoisting herself upright and brimming with excitement, "Care to show us your bedroom?"

———◆———

The master bedroom was massive. Sophia, holding Andrew's hand, squeezed tightly as they entered.

"Ow," Andrew said.

But he understood her point. The master bedroom was larger, he supposed, than their entire Brooklyn studio.

"Is this floorcloth handmade?" Sophia said, eyeing the rug.

"So this is where you feel him?" Andrew said, releasing Sophia's hand. "And you saw him once there?" He pointed to a corner alcove, where a cloth-draped vanity was tucked away. On its blue surface, two ornate vases flanked a center cluttered by potted flowers and a pile of business cards. Up against the wall, a tall mirror was set in a gold frame.

"A rare piece," Louise said. "Imported from a countess's estate in France."

"Can you feel him now?"

"He only comes out after sundown."

Sophia sat in the reading chair beside the vanity alcove and ran an index finger up and down the armrest. "What do you think, Andrew? Think we can help?"

"Do you mind?" Andrew asked Louise, setting down his bag on the bed. Louise said nothing so Andrew began unzipping. "Still a few hours until sundown," he said. "We can scan for trace activity, but mostly it's about being ready for tonight."

"I'll send for Martin," Louise said. "When you're ready, he'll show you the guestroom."

"You don't want to stick around?" Sophia said, but Louise was already halfway out the door.

Once alone, Sophia looked at Andrew, eyebrows raised. "Trace activities?"

Andrew smiled. "That's how my dad would say it." He had begun laying out items on the bed—white taper candles, matching holders, incense sticks bundled in a bamboo box—each item igniting new memories. Of weekend trips to city apartments and cabins in the woods, wherever duty called, but also of his father, bearded and tall. As an adult, he never knew his father. Halfway through high school, his mother had moved him across the country. But as Andrew laid out his father's tool belt, he remembered how, on the job, he'd clip that belt so the leather would rest below his gut, how he'd slide through the loops his many flashlights, each emitting a different color of light. In Andrew's memory, there were more flashlights than the two on the bed now. For some of the items, though, he could not recall their purpose: a bodiless crucifix made of dull and welded nails, a handheld radio, a third power cord beyond those belonging to the camera and accompanying laptop. He laid them out beside the tripod.

He saved *Paranormal Patterns* for last. How fragile it was, just two sheets of crinkled cardboard protecting the wispy lined paper inside. He set the duct-taped spine on the bed and skimmed the pages. The main text was loaded with annotations, scribbled-out corrections, and occasional sketches in the margins. Behind the cardboard cover, his father had included a table of contents, though the section titles grew increasingly illegible as they shrank approaching the page's end. Andrew was skimming for anything about ghosts migrating or appearing in mirrors when Sophia, from behind, wrapped her arms around him. She said, "So tell me, Dr. Venkman. How will you use all these toys?"

He closed the book, then took her hand and kissed it. "Take this thermometer," he said, lifting a cumbersome instrument off the bed. "And check for cold spots."

"Cold spots?"

"Anywhere the temperature drops."

"You're so hot to me right now." Sophia released him to take the device. "What about those?" She was pointing at the five taper candles on the bed.

Andrew took the first and nestled it in a holder. "You're gonna think this is dumb."

"Honey, no," Sophia said. "I always wanted the father of my child to be a ghost hunter."

"Dad would say specters don't exist materially," Andrew said. "They're like empty space, a vacuum. So flames will point toward any small void." He set the candle gently on the bed and picked up another. "It's just detection."

"Hmmm," Sophia said, looking over his shoulder. "You got a light?"

"Shit."

"And the incense?"

"They say it attracts the ghost."

"I'll attract your ghost," Sophia said.

He slid another candle into its holder and dropped it on the bed. It split from the holder.

"And this is?" Sophia said, lifting the nail crucifix.

"Would you please just check for cold spots?"

Once all five candles were set, Andrew placed one on the windowsill. "It's getting cloudy," he said, looking out beyond the lawn. "Might make the ghost mad."

"Wow, I thought I was just running hot," Sophia said, sitting at the vanity reading the temperature. "But no, Louise lives in a furnace."

"But any change?" Andrew said.

"Nope."

"Makes sense," Andrew said. He approached her holding another candle. "Louise saw the ghost in the mirror, but that would be a reflection from elsewhere."

Sophia paused to look at him. She set down the candle beside the mirror and said, "Oh my God. You think we might find a ghost."

Andrew looked past her in the mirror. "I'm just keeping an open mind."

"Is this about your dad?" she said. And then, "Oh no. I didn't mean that."

Andrew closed his eyes. She didn't understand, but how could she? After the divorce, his father went a little manic, buying a mobile home to take his business on the road. He'd asked Andrew to join once, back when he was in college. Instead, Andrew made the website. That way, he had reason to call every so often with a new job, though his father never mentioned the cancer. Maybe he wasn't worried. But Andrew wished now that Sophia had met him. Maybe then she'd understand. These tools, his memories, they were all Andrew had in the way of inheritance. He opened his eyes. "You didn't have to come."

"Neither did you," she said. And then, "Kidding."

———◆———

In the guestroom, which was less impressive than the master bedroom but still roomy, Andrew was sunk into yet another velvet wingback chair, half-monitoring the laptop open on the end table, half-reading *Paranormal Patterns*. Displayed on the screen was an infrared projection of the master bedroom: the five candles, the vanity alcove, and the bed all framed in view. In *Paranormal Patterns*, he was reading about the Sensory Ghoul, an archetype known to manipulate the senses of the living. Though the more Andrew read, the more his hunch—could the sensation of being watched be connected to other senses?—seemed to fall short. The Sensory Ghoul was among many that were attracted to incense and that come out after sundown. So far, on the screen the candles flickered unperturbed.

Sophia reclined on the bed, clicking on and off the Zippo lighter Martin had located in the master bedroom closet. She watched the light and yawned.

"Babe," Andrew said. "We got a real chance here."

She set down the Zippo on the end table. "For?"

"I've been reading about these spectral archetypes," Andrew said. "None of them are like what Louise described."

"Okay."

"So maybe we have a new one on our hands."

"Don't forget there also might be nothing."

There was a knock on the door, then Martin reappeared. "Did you miss me?" he said, grinning and holding a silver tray covered by a cloche.

"God bless," Sophia said, rolling upright with great effort.

Martin was a mammoth of a man. Even indoors, he wore a wide-brimmed outback hat with the chinstrap drawn taut beneath his beard. Louise had mentioned he'd come to show them the guestroom, but she'd said nothing of his infectious hospitality, the way his smile had the gravity of a small planet. When he first saw Sophia back in the master bedroom, he exploded with enthusiasm, asking her how far along she was, what she planned on naming the baby, if this was her first. And Sophia, Andrew thought, was loving the attention. "From the moment I met you, I knew you were one of the good ones," she said. As Andrew finished setting up the camera, and as they walked to the guestroom, Sophia had asked all about his business ventures, the family mansion, and his own adult kids. When she asked how he met Louise, he mentioned one summer holiday, back when he studied at Oxford, when they found each other in London and quickly fell in love. "Sounds like us," Sophia said, side-eyeing Andrew to rope him in, as if they hadn't broken up twice before she conceived. The whole conversation made Andrew feel small.

Martin now set the silver platter on the coffee table near Andrew. "Hope you like sirloin," he said, and winked.

But Andrew wasn't hungry. He returned to *Paranormal Patterns*.

"By the way," Sophia said. "We never asked you about the ghost."

Martin stood up and shrugged. "What's to tell?"

"Just your experience," Sophia said. "It's good to hear all sides."

"Hard to say." Martin lifted his hat and scratched the back of his head. "I sleep down the hall, so I never felt or saw him."

Sophia hummed. "Louise wasn't close to her father, was she?" She covered her mouth. "I didn't mean that."

Martin grimaced. "I shouldn't say."

"Oh, please," Sophia said. And with great effort she stood, slowly approaching the coffee table, resting her hands on her abdomen as she went. "It would really help."

Martin sighed. He waited for her to sit, then said, "No. They weren't close." His eyes glazed over. "For years, I wanted Louise to make amends, but she wouldn't go back. And he never came either. I'm sure he hated me for stealing her, or he hated her for leaving. We

say she's from London, but really she's from a farming town to the north. I got lost on my way to the city for some conference or interview, I don't remember. I just remember her on the side of the road walking and crying. I couldn't leave her."

"That's awful," Sophia said.

"Sounds like there's unfinished business," Andrew said. "Good thing she contacted us."

"To be honest," Martin said. "Louise hasn't been all right since he passed. She's often awake at odd hours, asking him questions, saying she's sorry. I got my doc to up her sleep meds, but now she's a bit zombie-like." He sighed. "Losing a parent is tough. I mean, I lost both of mine too young, too. So, ghost or no ghost, I hope you can help her." With that he stepped back. "Enjoy," he said and left.

"Andrew," Sophia said. "I think we're in a little deep here."

Andrew lifted the cloche revealing two plates of steak and steaming asparagus.

"I feel bad," Sophia said. "Taking advantage of a woman in mourning."

Andrew took his plate in his lap. "So tonight," he said. "I need to go alone."

"What?"

"When Gerald arrives," Andrew said, "I need you to stay here."

Sophia watched him.

"I'm concerned Gerald is angry," Andrew said, chewing. "And if he's angry, he's dangerous."

"What are you talking about?"

"You heard the man," Andrew said. "He hates Louise for leaving. And he's come all this way, and it might rain?" He set the plate on the table. "I need to keep you safe."

"I'll sleep in the car, then?" Sophia said. "Would that be safest?"

"Maybe."

"I can't believe you."

He turned back to the monitor and nearly fell out of his seat. A colored blob, vaguely humanoid, appeared on screen. A floating head with two glowing arms and feet. "Babe," he said, "something's there."

"What?"

"Oh. It's just Louise."

Sophia grunted. "Will you pass me that plate?"

Andrew stared at the screen. The five candles flickered.

Sophia heaved forward and gripped the underside of the coffee table, then pulled it close. She picked up her fork.

"She's getting ready for bed," Andrew said. "Gerald could come at any moment."

Sophia lifted the whole cut to her lips. Eyeing it, she said, "I'll have yours too if you're done."

———————— ♦ ————————

A crash, not on camera but down the hall, shook Andrew awake. He was unsure when he had dozed off; last he remembered he was watching the master bedroom, Louise a dull green light in the bed, all five candles flickering, waiting for Gerald. Andrew sat up straight. It was dark outside. Only a small lamp beside him cast a dim orange hue around the guestroom. Sophia was under the covers—she hadn't slept in the car after all. To his right, the laptop screen was blank.

"Babe," he said.

Sophia was still.

He nudged her, gently at first and then more forcefully. "Babe. It's time."

Sophia's eyes fluttered, then shut.

"I need you to watch the screen."

Sophia grunted.

Andrew helped her up, then guided her to his chair. "Something's wrong with the camera," he said, buckling the tool belt around his waist. "When it comes back, click Record."

Sophia yawned, gave a thumbs up, and Andrew took off for the master bedroom.

Dashing down the hall, he wondered, briefly, if he was overreacting. He'd been watching all night, and so far he'd observed no paranormal evidence to speak of. But then the crash and the camera? This could be his chance. Or maybe it was too late. He was just beginning to wonder which it was when he ran into Martin.

"This way," Martin said, pointing back the way Andrew came.

Outside the master bedroom, Andrew said, "Careful. He might be angry."

The incense inside was overwhelming. The five candles illuminated the room just enough for them to discern Louise on the bed. Andrew looked for his camera and found it in the corner on the tripod where he had left it, but as he took a step, he found hundreds of sharp mirror fragments scattered about the floor. In the alcove, the vanity mirror's gold frame clung to the wall, hollow. Amid the wreckage were blue porcelain fragments, flower petals, and potting soil. The taper candle, half as tall as before, flickered near the table's edge.

"Dearie," Martin said. "Louise, dear, wake up." He was stepping carefully around the fragments toward her. "Oh no, the meds."

Thunder crashed. Andrew thought, what would his father do? The camera, he noticed, was not blinking red as it should. On closer inspection, he found the power cable on the ground. "Dammit." He reinserted the plug, but the battery was dead and would need time to recharge.

Martin was struggling to wake Louise. He dragged her upright against the head-board practically sobbing, "My dear. Please get up."

From the loops of his tool belt, Andrew pulled out two bulky Maglites: one emitted a purple UV ray, the other a sinister red. "Come out, Gerald," he said. "We know you're here."

Scanning the room, he saw the candles dancing with only a normal degree of chaotic movement. Andrew looked to the red light. "We just want to talk."

Martin, coughing, drew up a window. Immediately, the nearby candle was extinguished. "Andrew."

Behind him was Sophia, leaning around the door. "Your bag," she said. Then, noticing the fragments, "Holy shit."

Andrew held up a hand and approached her. "Don't come in."

She set down the bag inside. "You're welcome."

Just then, the vanity candle flickered, extinguished.

"That's odd," Sophia said.

Louise, groggy, was beginning to stir. Martin hoisted her up on the side of the bed.

"Dad?" Louise said. "Daddy, are you here?"

Andrew hoisted the bag over his shoulder. "Back to the guestroom."

"God, what's that?" Sophia took Andrew's hand and pressed it up against her abdomen. "Do you feel that?"

"Gerald," Andrew said. "Are you in there?"

"Jesus Christ," Sophia muttered, then glanced to Martin and Louise across the room. Loudly, she said, "Gerald, don't hurt my baby."

"Daddy," Louise moaned. "I'm sorry."

"It's okay, dearie. It's okay."

"Sophia," Andrew said. "It's not safe."

"Oh no," Louise said. "He's here."

Andrew took Sophia by the arm. "I'm not joking."

Sophia looked at him, then to Martin holding Louise in his arms, then back to Andrew. Wind howled through the cracked-open window.

When they came close, Andrew said, "Is this proof enough?"

"Make him go away," Louise moaned.

Martin said, "I'll pay you triple to put an end to this," then disappeared into the hall. Andrew knelt and ripped open the bag. Only two items remained: the nail crucifix and the handheld radio. Picking up the radio, he said, "I'm going to try to communicate."

"Andrew," Sophia said. "We did it."

"Maybe we can help him find peace."

"We just tell them we got through, and they pay us the max."

Andrew rotated the tuning knob, and with a click it powered on, emitting a low, static crackle. "Please," he said. "Back to the guestroom."

"Are we really doing this?" Sophia said, and then she crumpled over. "Oh wow. Little one's got a mean hook."

"Gerald," Andrew said, slowly turning the knob, listening. "Give us a sign." Then to Sophia, "Please."

Under her breath, Sophia said, "Oh right. They might be listening outside."

"At least take this," Andrew said and handed her the nail crucifix. "It'll keep you safe."

Sophia took it. "Take your time."

Slowly, Andrew turned the radio knob, listening. Outside the wind was calming down. Gliding from one frequency to the next, he said, "Gerald, give us a sign. Give us a sign." When he reached the highest channel, he lingered there a moment, before shifting back down. "Give us a sign."

They stood that way a long while, Andrew twisting the knob, begging the ghost to speak, Sophia behind him, limply holding the crucifix, watching. Eventually, the wind passed, and only the low static hum remained. The incense, still strong, had faded somewhat. Three remaining candles danced in the night. Just the window and vanity candles extinguished.

Sophia, from behind, wrapped her arms around him. "Is it time we call it?"

"No," Andrew said, weakly. "He's here. He has to be."

"That candle?" Louise said, gesturing toward the vanity. "Could it be a draft from the hall?"

"But the mirror," Andrew said.

Sophia nudged a small fragment with her shoe. "They believe we got proof," she said. "We'll just tell them we convinced Gerald to leave. Wasn't that the plan all along?"

"I need to know what he is," Andrew said. "I need to add him to the book."

"Is that what this is about?"

At his feet, his tool bag was empty. Everything was spent, he had no way forward. No memories to fall back on. Even *Paranormal Patterns*, perched on the end table back in the guestroom, had no more guidance to offer. Andrew clicked off the radio.

"We'll tell them he's gone," Andrew said. "We got through to him and he's gone."

———◆———

The next morning, back in the foyer, Martin stood beneath the bearskin hanging from the hall balcony and handed Andrew three stacks of twenty-dollar bills still bound by bank straps.

Sophia held his hand and squeezed.

"We can't thank you enough," Martin said. "For making this old trailer home safe again."

Andrew nodded. "He shouldn't, but if he comes back, give us a call."

"May our paths never again cross," Louise said behind her sunglasses.

Andrew slung his bag over his shoulder. "Thanks for the hospitality," he said. "You have a beautiful home."

"Let me walk you out," Martin said.

On the stoop, Andrew said, "We're parked just around the corner. We can find our way."

"Aren't you going to ask?" Martin said.

Andrew and Sophia turned around. Andrew said, "Ask what?"

"About the mirror."

They stood there frozen, until Sophia said, "You rigged it to fall?"

"And unplugged your camera so you wouldn't see." Martin raised his eyebrows. "Don't worry. I'm not mad." He lifted his hat and held it to his chest. "Really, I should be thanking you."

"You shattered it just to spook your wife?" Sophia said.

"A mirror like that?" Martin said. "I've got dozens." He returned the hat to the top of his head. "What's more important is that Louise can sleep."

Andrew clutched the bills in his coat pocket. "How did you know?" Andrew said.

"That you're grifters?" Martin said. "Well, for one, you're obviously no ghost expert, Mr. Mallory. I saw your website. You drove up in a compact, for Christ's sake." Then he pointed up to the security camera. "But, also, that picks up audio. Got 'em all throughout the house."

"Look," Sophia said, "he's not his father, but he's still the best you got."

"No, you look," Martin said, holding a finger up between them. "You got your payday. I got my wife. I'm only telling you this so if it happens again, we're on the same page." He turned to Andrew. "Not saying it'll happen again, but when I got a guy, I like to keep him."

Andrew took Sophia's hand. "Let's go."

"You're my guy now," Martin said, smiling.

In the driver's seat, shaded by the manor, Andrew closed his eyes.

"I kinda like him," Sophia said.

"Babe," Andrew said. "I think I'm done ghost hunting."

"Kiss me," Sophia said. And when he did, she said, "Never say never."

"How about the Mirror Specter," he said. "For our new entry."

"Awful," Sophia said. "I love it."

"You think the book would sell?" Andrew said. "I hear raising kids is expensive."

"'Kids' plural now?" Sophia said. "And those are my family secrets, too, you know."

Andrew ignited the engine. He wanted to drive far, and fast, to be anywhere else in the world but there.

Sophia stopped him. "Andrew."

He leaned over and pressed his ear to her abdomen, her warm breaths heaving up and down. "Hello there," he said. "Are you there? Give us a sign." ❧

[NEGATIVE SPACE]

ERIN TOWNSEND

I

The voicemail, in all its elaborative glory, is this:
"It's happening again. Can—ah. Please, call me?"
It doesn't matter. I know what she means.

II

The students tack up their sketches, four one-minute poses crammed onto a single sheet, at the front of the room. Grids of humanoid scrapes and blotches. The professor, a shaggy man sporting some sort of chinless beard situation, moves through the images one by one, fingers following variations of my charcoaled hips, using phrases like *confident strokes* and *negative space* and something he calls *disjunctivitis*. He likes this term and thinks he coined it. He tends toward the minimalist; fewer lines, more conviction, he says. Practice, practice, practice. Flow, flow, flow.

At the far back, draped in a dark-plaid bathrobe, I feel like a spurned housewife. Twist the phone around in my fingers. Watch the professor smudge a section of my shoulder blade, comment on its severity.

"Another round?" he says. I realize he is talking to me. I slip my phone back into my satchel. "Ten minutes this time. Dealer's choice."

I disrobe and take the stand. New pose: seated and leaning back, legs open, one foot farther out than the other. Real power-top shit. One hand grips the chair in between my legs, the other arm slung over the back. This time, I face the front, toward the professor and his kingdom of nudes. Someone spent most of their drawing time on my ass. Two or three sketches seem to be more movement than person, and in one of them, I have wings.

The arm behind the chair turns out to be a mistake. I spend the next break pounding the flesh of my bicep back to life.

III

Finally, two hours later, back in my clothes and sucking down a cigarette outside the researcher's entrance of the Fine Arts building, I call back.

"Hi, Ma. Yeah, sorry, I couldn't take it, I was—" Naked. "At work. What's . . . ? Okay. Yeah, okay. Wait. Mom—Mom, we talked about this."

She is insistent. The background is motion and ambient din, closing and opening cabinets, crinkled bags, the staccato of a sink faucet, on off, on off. Restless sounds. Every now and then, her voice drops to a whisper, as though her own apartment is eavesdropping. I bundle up my robe and toss it into the trunk of my car, take a final drag of smoke before crushing the butt underneath my shoe.

"No. I told you I quit. Listen. Did you stop going, I mean, are you still seeing that Whitmore guy? Well. Yes, Ma, of course I think it's related. I—all right. No, okay, fine. Yeah. I'll come by."

IV

The power pose, it seems, has worked some magic. Professor Chinless Beard wants to recommend me to an artist friend. That's the phrase he uses—"artist friend." I wonder which of the two terms is the truest. Says he can put me in touch, nail down some details, a possible contract, if I'm interested. I am. Artists always pay more.

V

I hate my mom's apartment for all the obvious reasons: cramped, not enough windows, my sister died in it.

The winter months are the hardest. All those rattling pipes and hissing radiators, the whole building shivers, and Mom takes every sound personally. "I heard her in the sink," she says to me. She is seated at the kitchen table now, having worn herself out a bit on my drive here. She twists a ring around her finger.

You have to tread lightly with this kind of shit. Can't just tell her, the sink, of all places, she's going to spend the afterlife down a fucking garbage disposal? You have to say, okay, sure, tell me more. How can I help. Where does it hurt. But really, if she's going to do any haunting, there are way better places. I've heard great things about attics, for instance. Basements are very popular.

Instead, I get Mom a glass of water. Check the faucet handles while I'm at it, the water temperature, the pipes underneath. I don't know what I'm looking for.

"You know, it got cold quick," I tell her.

She says, "Yeah." She nicks a drop of condensation off her water glass.

"This building is old, the pipes make all sorts of noise."

This is the wrong thing to say, and I know it before it comes out of my mouth. It feels like that scene where the crazed hero tries to convince his friends or the cops or the mayor or whatever that aliens are attacking. Except I'm the mayor. Calmly and politely telling the hero to fuck off, right before everyone starts dying.

Mom wants me to stay, of course. She always wants me to stay this time of year.

VI

Dani's bedroom and my bedroom are connected by a closet-sized bathroom. Just a sink and a toilet and an awkwardly narrow cabinet Mom fills with pillowcases and enough BOGO Crest toothpaste to ride out a nuclear war. You'd think we would've used the shared space for sisterly stuff, sneaking into each other's rooms at night or sharing secrets or pulling pranks or something, but we didn't. We weren't that kind of sisters. For the most part, it was spitefully locking each other out of the bathroom, accusing the other of not flushing, and Dani leaving the cabinet door open so that when I went into the bathroom at night with the light off, I'd walk right into it.

The night Dani died, I walked into that cabinet so hard and so audibly that she laughed from her bedroom. But I think, technically, she must have already been dead by then. I guess I don't really remember what time it was.

Nowadays, the bathroom feels like that rickety walkway that leads out to an airplane. A loading area for the underworld. Mom keeps all of her old sketches and paintings and unfinished portraits in Dani's room, lined up little soldiers leaning against the walls. For a while, they faced forward, bunched-up charcoal noses, tongues sticking out, Dani smushing her face to the center. It creeped me out. Eventually, I turned all of them around.

Memory is weird. It convinces you of a lot of things that can't possibly exist in the same reality. Like, I can picture the shape of Dani's body on the floor of her room, face up, one leg crushed underneath her, arms out in L's to either side. A human goalpost. Her face was slack, and I think she had been drooling and one of her slippers had fallen off.

But then, I also remember standing in the bathroom that morning, in front of Dani's closed door, Mom yelling at me not to come in. I was trying to tell her that I had missed the bus. The door was locked.

I don't know which one is true. Maybe both.

The only thing I remember about the wake is the casket. Some mud-yellow wooden thing. Dani was propped up on pillows wearing a blazer I had never seen before, looking like a business-casual store mannequin. They had glued her mouth shut. She was holding her stuffed bear, a pink-and-white monstrosity with a crisp lab coat and plastic stethoscope sewn into his neck. His name was Dr. Cotton. I don't remember where he came from. He had been around since we were kids. He definitely lost his clothes years earlier, but that's the image in my head, every time I look. His beady golden eyes, his shag fur bright and clean.

Maybe it wasn't even an open casket. How could Mom have handled that?

And anyway, Dr. Cotton couldn't have been there at all because I wake up the next morning, in my old room, in Mom's apartment, holding him to my chest. Just as ratty as I remember.

VII

The "artist friend" is not what I expect. She buzzes me up to a seventh-floor room overlooking the pathway into Edgewood Park, a woman not much older than me, climber's hands, strawberry hair plastered away from her forehead the way men do in mafia movies. A gold and turquoise snake wraps around her ring finger. Her name is Marika.

"Truth be told," she says, rattling her curtains closed, "I've never done this before. How do you normally start?"

Once, I did a few sessions with a lady who wanted to borrow my face and chest to make papier-mâché busts. Another guy zoomed in on my pores with a for-real handheld magnifying glass, Sherlock Holmes–style, to make hyperrealistic sketches of my whiteheads. More recently, I worked with a sculptor who needed some hands-on time with my legs in order to get his textures right. It was strictly professional, of course. Professionally weird.

I don't tell her any of this. I say, "I'm here to do whatever you need me to."

So she starts with what she calls preliminary sketches. An easy pose: lying flatbacked on a jute mat, staring at a center-ceiling titty light and wondering about

symmetry. Marika sets herself up above my head first, then spends some time to my left, and then finally, by my feet. She asks me about modeling. If I enjoy the work. How the group classes are. The drawings.

"Some of them are a lot prettier than I am," I joke.

She makes a disagreeing click with her tongue. "Pretty is so much about the viewer and so little about the subject," she says. "There are artists who eschew anatomy entirely just for the sake of some . . . *romantic* notion of what makes a person beautiful."

I can't tell if this is meant to make me feel better or not. It's not like I haven't seen students cinch in my waist or slap on some anti-gravity breasts, though, so I get what she means. But I'm not used to talking on the job, so I let her go on.

"Besides, I've always thought: if you paint a woman, right?" She balances her pencil on her knee so she can talk more with her hands. "And you include her wrinkles, eye bags, you don't de-age her or smooth her out. Just drawing her the way she looks in front of you. People always—there's the implication that you're making a statement. Because you've deviated from some default state of beauty. Like beauty is the expectation."

"Would I be more beautiful with an arm coming out of my stomach?"

She laughs, a surprised, breathy sound. "Part of me just thinks beautiful is one of the worst things you can call another person," she says.

"I don't know," I say. "I'd like to be beautiful."

She glances down at me, picks up her charcoal pencil, makes a few more scrapes with it. "You don't have to worry about that," she says.

VIII

"Listen—you hear it, right? You hear that."

I do. Some whispery, bubbling sounds of protest. I say, "Yeah, Ma, it's like, the pipes. There's water in them, they gurgle."

"It's—" Her hands make frustrated fists. "No. I'm telling you, you're not listening."

"I really think it's time to call Dr. Whitmore."

"No. Can you just? I don't want to talk to him."

"Okay. Ma. Mom? Either we're calling the therapist, or we're calling the plumber."

"No, no, no." She leans heavily over the sink, fingers white with effort. "Just forget it. Leave it. I'll deal with it. Okay?"

Upstairs, I stand at the far side of the toilet with Dr. Cotton and stare into Dani's bedroom. It's the same as I remember, except muted. The colors in my memory are all brighter: baby-blue comforter, plush eggshell wall-to-wall carpeting, a deep mahogany headboard. Everything pops in my head. But in person, now, the saturation is dialed all the way down.

It takes me a few minutes to gather the courage to cross the threshold, off the bathroom tile and onto the carpet. The bare backs of canvases watching me the whole way. I nestle Dr. Cotton against Dani's pillows, try not to look at anything, and close the door behind me when I leave.

A kind of peace offering. Like, please stop clogging the sink. Or, let Mom go already, would you?

IX

Dani wasn't pretty. Not exactly. I don't know why people always insist that their dead mothers or dead aunts or dead sisters were so damn pretty, but it can't always be true, and in this case, it isn't. We looked alike when we were kids, but the middle school years did us dirty; she grew tall and gangly and flat-chested in a way I longed to be, and I stayed a little shorter and a little stumpier and eventually had tits and hips enough for both of us.

So we needled each other's insecurities. She called me Bilbo, and I called her Treebeard. She would rest her elbows on my head, and I'd kick at her shins. Mom didn't put any of that in her paintings. Instead, she focused on the expressive eyes, the wide, toothy mouth. Dani had a lot of Mom in her in that way; a kind of dynamism, an impossibility of stillness. Maybe that's why she was the favorite.

 But anyway, at the end of the day, we both had the same big ol' Greek noses, the same stubby chin, and eyebrows that needed to be weed-whacked into submission. We probably looked more alike than either of us wanted to admit. But I guess, out of the two of us, I'm not dead. So I have that going for me.

It was an aneurysm. Short and to the point—it ruptured, she died on the floor. So medical, it's almost boring. A total fluke.

"You're ugly," I say, to the sink.

I lean closer with my ear, listening for a response, a gurgle, anything, but nothing happens. I turn on the faucet. The water pools in the sink and doesn't drain.

X

On break, I ask Marika if I can peek at the canvas. See what I look like. I'm eager to know what she sees in me, in a way I'm usually not. Maybe she gave me wings or floating tits or laser eyes or something. She just says, "You know, if you see the process, the end result loses all its magic."

We lean out her open window and blow smoke into the breeze. I've put on a shirt so I'm not flashing all of Edgewood Park, but I'm still naked from the waist down. I crinkle my nose. "You really believe that?"

She shrugs.

"Okay," I say. "Okay, fine. Tell me . . . tell me what it's about."

She sucks through her cigarette and lets the breath out through her nose, snake ring glinting in the sunlight. "It's—I'm representing a physical body, but I'm most interested in . . . an *underneath*. So to speak. The stuff below. Bodies as representative of the individual human experience. I mean, I should say, it's not just that. There's a lot of—how the body views itself, impression versus reality. Questioning that reality. Experimenting with visibility, the malleability of flesh. It's all very pompous, to be honest. I'm annoying myself just talking about it."

I'm not annoyed. I might be too dumb to get it, but it sounds nice. "How the body views itself."

"I'm not sure how to explain it. The feelings of the body or the experiences of the body, represented in the physical. Marrying the body with the individual by way of separating them out and smashing them back together in a different way. Like a kind of disassociation. Am I rambling? I feel like I'm rambling."

"No," I say, "I like it."

Her eyes flick over to me, then back out to the street. "I talk a lot when I'm working, I'm sure you've figured out. To myself, mainly. To whoever. Maybe in some way it occupies this logical, conscious part of my brain and makes it easier for my subconscious to get the fuck on with the work."

I decide I'm in love with her. Her mafia hair. The way she studies me with her head tilted back, like she's wearing reading glasses. How the words *aestheticism* and *fuck* have the same marbly weight in her mouth.

"Hey," I say, after a minute, "have you ever taken apart a garbage disposal?"

XI

I buy two gallon-sized containers of Drano Max on the way home. The blue stagnates around the drain. I listen a while for bubbling, or gurgling, or whispering, but nothing happens, so I turn on the garbage disposal and splatter Drano all over the kitchen curtains.

"Fuck it," I tell the sink, "fuck it, I'm getting a plumber. Fuck."

I don't call a plumber. Instead, I sit on the bathroom tile and press my ear to Dani's door. I whisper into the wood, "How come you talk to Mom, but you won't talk to me?"

She doesn't answer. So I open the door a crack and peer through, and I can't see Dr. Cotton on her bed anymore, and something about it makes me feel like I'm intruding, so I slam it shut again.

Dani wouldn't have wanted me in there, anyway.

XII

I can remember three times that Dani invited me into her room willingly:

—Once when we switched beds because my room is farther from Mom's room, and Dani wanted to stay up talking to some boy who dumped her the next day anyway.

—Another time when she was trying to hang a sketch that Mom had drawn over her bed, presumably so she could sleep under a giant picture of her own face, like any sensible person would do.

—The week she had the flu and she wanted someone to bring her chicken and rice soup and Powerade and also because she was trying to give me the flu.

There must have been more times than that. But if there are, I don't remember them.

XIII

"I can't believe I haven't asked you this yet. Do you paint?"

We're working with lighting today. Marika has a number of lamps set up at varying distances; first she tries the overhead boob lamp, then she turns that off and turns on a tall one standing at my right shoulder, then points a shorter one up toward my chin. I have no idea what part of the process this is.

"Oh, no," I answer. "My mother used to paint and sketch some stuff. I modeled for her

sometimes. With my clothes on, obviously," I add, rather quickly. "I don't know. It never called to me the way—well, it just never really called to me, I guess."

"Maybe you heard whispers," she says.

Something pings in the back of my brain. Suddenly, I'm thinking about the sink, about Mom, and feel a weird swell of panic. "What? What did you say?"

"It didn't call to you, necessarily, but it whispered at you," she clarifies. She turns off both lights and plunges us into afternoon dim, then flips on a small table lamp by my right side. "You're a performance artist now, of sorts."

"Oh," I say. "Right." I look down at the lamp, which is searing a yellow circle into my left boob. "Is that what this is?"

XIV

Really, I only modeled for Mom one time. That was usually Dani's gig—she had a real flair for the dramatic. Say what you will about beauty, but that girl knew her angles. At one point, the kitchen table was reserved entirely for sketches and feature work, just different positions of Dani's head. Side profiles, looking up, looking down, baring her teeth, sticking her tongue out. I remember eating cereal next to one where she had pushed her nose up into a pig snout. I don't remember what happened to it. I haven't seen it since.

The only time Mom ever drew me was after. She wanted a very specific position: on my back, hair bunching up against the wood floor. From there, my mother was upside down, dangling from her chair, hand suspended, fingers smudged black, charcoal pointed down at the ceiling.

"Left arm out," she said. "Yes—there. Good."

The sun from the window warmed my stomach through my shirt. She ordered my left arm above my head, knees splayed in opposite directions, one leg twisted up underneath the other. It was only when she told me to take off one of my shoes I realized the part that I was supposed to be playing. I know I should've been angry. But it might've been the closest I ever got to being her favorite daughter.

I stayed very still.

XV

When we finally fuck, the reality of it is jarring. Marika's mafia hair, it turns out, is glued in place and when she arches her back against the wood, her hair pushes up toward her forehead as a single unit, like a helmet. Someone's errant elbow sends a paint can skittering along the floor. She eats me out with a corset of oil crayons digging into my spine; afterward, she brushes hair away from my face the way they do in movies, but it turns out she is trying to get blue paint out of it and she accidentally drags some into my eye instead. I spend the next ten minutes trying to rinse it out in her kitchen sink.

"Wait," she says. "Oh, my god. Wait. Stay right there."

I am holding a dish rag over one eye. Through the other, I watch her disappear and moments later drag an easel into view.

I say, "Really?" We look ridiculous, I imagine. Me, face drenched in tap water, red and squinting, spit crusting on the inside of my thighs. Her helmet hair still pushed a little ways upward, she is curved over an easel set too low for standing, taking up the whole hallway. "Really."

"Here—hold on—" She pats her hips a couple times as though she is searching for something hidden away in pockets, even though she's still naked. She disappears again. I can hear her rummaging in the living room, opening and closing drawers. Sounds of feverish movement.

When she finally returns, she places a black capsule in my free hand. "Just chew," she instructs, "don't swallow."

I am still maintaining some sort of face that requests an explanation, I think, but Marika is lost in the moment, fumbling for supplies in front of her canvas, whispering, "Just give me one minute," starting with pencils and reconsidering and picking up a charcoal stub instead, "This is the most *you* that you've ever been."

The capsule tastes of salt and ash. I let saliva build up and mix with the sink water drooling down my face and run over my lips and around my chin. It seems to satisfy her. She spends the next excruciating minutes flitting between me and her canvas. I want to ask her what part of the painting this is, slobbering charcoal on myself like an extra from *The Walking Dead*. I want to know what's most *me*. The drowned-rat aesthetic? The implication of pain?

By the time she is finished, my left eye is soaked and blurry and doesn't see right for a half hour. I rinse out my mouth in the sink, but the taste lingers. Marika angles the easel in toward me, bumping the wooden feet against both sides of the doorframe, and gleams.

"This is it," she says. "This is what I want to paint."

I remember the face. Distinctly—slack, open, wet, I can see it against the bedroom carpet, eggshell, sharpened with sunlight. A dead face. Instinctively, I peel the first page of the sketchpad up to reveal more sketches underneath, a face angled to the left, and to the right, her wide, dynamic mouth. Toothy smile. And the next, another, pressing her nose up into a snout. And—

I flip through them, kind of rabidly, like coming up for air after someone pushes you into a pool. I say, "Where did you get these," and a drop of my spit hits the tile, still stained with black.

"What do you mean?" She moves behind me and reaches past my arm to smudge a section of Dani's hair, blend it into shadow. "I hadn't quite worked out the right angle yet, but I don't think they're that bad."

I must look a mess, staring blankly, leaking charcoal and sink water out of my mouth.

"It's just you," she says.

XVI

It looks easy enough on YouTube. Get a bucket, check. Bright yellow cleaning gloves, check. Unscrew the connectors on either side of the P-trap, dump out any clogs, rinse it out. Remove the pipe leading into the wall and cram a drain snake in there.

All the while, Mom weaves in and out of the kitchen, pretending not to watch me. I don't have a drain snake, so I unfold a wire coat hanger and bend a loop into one end. It takes a few minutes of finagling. Eventually, things start catching: a mangled ribbon, some sopping wads of food, paper, who knows. And then I pull out this mass, a shredded spine of fabric knots, flashes of pink, and one of Dr. Cotton's amber eye beads chipped and clinging on for dear life. I squish it between my hands. It bleeds brown water back into the bucket.

"Mom," I say, as calmly as I can, "what the fuck is this?"

Behind me, she is quiet and still. "I didn't want her to be lonely," she says.

XVII

So—again—I idle at the threshold of tile and rug. Wet hands gripping the sides of a cardboard box, staring into the darkness of Dani's bedroom.

"We ruined your bear," I say.

I'm not expecting a response, but some part of me is disappointed in the stillness. I want her to be angry. Or sad, frustrated, anything. I want her unsettled ghost to hurl pillows at my head, I want poltergeist shit, broken windows and moving furniture and paintings leaping between the walls. I want the bathroom apocalypse cabinet door to slam open. I want to walk into it, have it leave a bruise.

Nothing happens. Just me and an empty room.

I turn on the lights. March past the skeletal backs of canvases and set the cardboard box on the tightly wrapped present of Dani's bed, take off the lid. Dr. Cotton's mangled body crammed inside. Open casket.

"Do you want to see?" I ask.

I don't wait for an answer. Instead, I pick up the closest canvas and turn it around to face me. The sketch of a head and shoulders, chin propped up and nestled into a palm, pursed lips. I turn around another one, this time a full-body drawing, bent over at the waist, tying a shoe. And another, zoomed in on a scrunched nose and a twisted mouth. One by one, I face all the soldiers to the front. Happy faces, disgusted faces, bare shoulders, squinting eyes.

I used to know the background for each of them. I used to be able to hear her laugh through the pictures, the pseudo-complaints she would make, telling Mom she was taking too long, her cheeks hurt, her arms are cramping. I don't remember any of them now. The canvases look nothing like Marika's sketches, and it dawns on me that I don't remember what Dani looks like anymore. I don't recognize this person at all.

"Flush your shit, loser," I tell her.

I close the door behind me. ❧

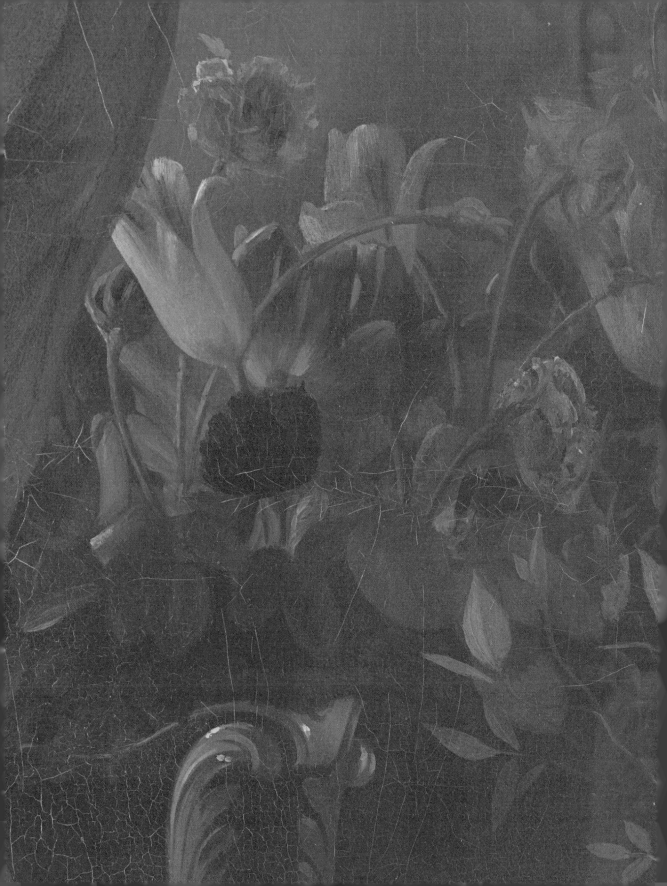

Details

DEVON WALKER-FIGUEROA

Tuesdays at Sturgill Hoffman Funeral Home were often quiet but rarely *so* quiet that Lola—the home's "first mate," in the director's words; "receptionist," in everyone else's—could devote an entire morning to cleaning the display caskets in the Vessel Gallery. But the phone had only chimed once in the hour since opening and merely to bring her the voice of their local florist: "Apologies, ma'am, but we're running behind; noon's probably the earliest we can make that delivery," to which Lola had replied in a tone of weary amenability, "Very well."

Without having to look, she knew her image—kneeling, scrubbing, hunched—shifted in fetal inversion over the black plastic dome attached to the ceiling. She could just picture Mr. Hoffman scanning the security footage from his office, tweeded elbows poised on polished rolltop, an apostrophe of blood browning under his freshly shaved chin, fingers tapping as he *re*wound-*re*wound-*re*wound right past her to the little girl, sorry creature caught in a sorry act. Zooming in, he'd squint his gray-blue eyes at the fingers traveling from mouth to casket, and in that moment, pulse rapid in his wrists, the looking-for-the-error would confirm and immortalize it. He would press Pause and lean in close. Yes. That is how it would go.

Because surely it *was* that little girl, who'd crawled, despite near adolescence, on all fours around the Vessel Gallery last Sunday, who'd failed to realize reverence was required of her, who defaced the Shores Ahead: after all, hadn't the ragamuffin dragged her marker-splotched fingers all over the newly linen-skinned walls, rapped at the casket lids ("Knock, knock, who's there! Who's there!"), plucked at the cremation necklaces as though they were harp strings?

Not only was the Shores Ahead the *only* display vessel that she, Lola, dusted twice daily with a bouquet of synthetic yellow feathers, but the room favored it as well, a lone skylight pulling the morning down in pale parallelograms over the beveled mahogany lid. She ran a washcloth lovingly over the length of it and was pleased.

Carved in the vessel's central niche was a modest relief with a lighthouse the height of a man's pointer finger. Or perhaps a woman's. This lone detail pleased her: each brick

in the tiny lighthouse seemed an actual brick you could knock free from the structure of which it was part and not just some line carved in resin with a toothpick. Slanted bands of black lent the whole column an odd sense of rotation, like a barber's pole, climbing up and up into a perpetual disappearance.

When Lola touched the detail, as she often did for luck, she swore it touched her back, casting an aura of impregnability over the hours ahead, and she would whisper, face angled down so no camera caught her mouth, "Here, there is no place that does not see you."

There were certain days, today being one of them, that demanded this ritual exchange. Days that, if offended, might rob Lola of a whole sense—leaving her a world shed of music, perfume, or the texture of grass; a world fallen tasteless or, worse, invisible at the feet of some god she'd only passingly accused of existence.

The entrance doors rang softly as they slid open, and Lola turned, half expecting to see Hoffman bouncing in with a stack of programs he'd no doubt expect her to fold, restack, and, in time, disseminate to forlorn clusters of mourners. But no one was there, and beyond the doors, only the near-empty parking lot with its puddles of sky and the green, granite-pocked meadow beyond looked back at her. And just as quickly, the doors slid shut and left her alone with the Shores Ahead.

Though Hoffman told Lola the Shores Ahead didn't "move" as well as the Mother, or even the Monarch Black, if the home were closer to the ocean, perhaps it *would*; perhaps if they were any closer, though, their clients would waltz out the door and, returning the Pacific's blank gray gaze, spread their ashes right there in the parking lot—so many dull gray dunes waiting for the wind to make off with them. (Lola couldn't help it. She pictured the harsh, immolating glow in which even the sturdiest stones of the teeth turned to sand. A whole smile, a whole person, you could lift with a sneeze . . .) It was for the best, then, the home's distance from the froth-lipped surf and the imitation calm beyond it.

She would try. Again. To scrub the bubble gum from the detail, though she wasn't feeling particularly hopeful: over the past three days, she'd applied numerous cleaning agents to no effect; today, however, she'd employ the nail polish remover she'd borrowed from the basement without telling anyone because, really, the crypto-staff, as they called themselves, were apparently so shaken by any exchange with the living that they almost never spoke to anyone until it was time for "the final bath." ("Why, how are you?" she'd once made the mistake of asking. "Me?" the crypto-man had whispered, as though

scandalized that she should address herself to him rather than the only other body in the room, the one he was draining of blood.) She spit into her cloth and resumed rubbing at a patch of yellow paint meant to be light.

God, how she hated walking in on it, that grim ceremony Hoffman *pretended* to revere but that no one actually wanted to see, likely not even those who made their living performing it. A consummately private enterprise, more so even than the sealing-of-the-mouth or the fastening-of-the-eyelids, it brought to mind, quite out of the blue, the image of her father, bloated, nude, drifting through her kitchen in the middle of the night, his own name lost to him, tracking his feces all over the tulip-stamped linoleum . . . and calling out for someone named Claire to pour him a glass of milk!

To rid herself of this uninvited scene, one she knew would lodge itself in her mind's eye if she let it, she summoned the image of an immense blue gown to envelop her father and dissolve his nakedness. As the folds of the skirt devoured the vacant and etiolated eyes of her father, the gown's bodice, more architecture than garment, took on greater life, filling up with the flesh of a young woman Lola recognized but couldn't name. The woman's face was wealthy with confidence and vaguely seductive, a coral bloom of ribbon pinned to her honey-haired head, and a pale plump arm bent in a *V* so that it framed a pile of azure pleats—a sleeve of sorts. The other arm sat propped impossibly on the woman's hip and culminated in a rather boneless hand that seemed to be joyfully petting one of the deeper folds of satin. Lola shuddered and pulled her hands from the Shores Ahead.

The lighthouse's bold black bands had dimmed to gray under the assaults of yesterday's scrubbing. She would be gentler today. She spit into the cloth once more.

But what was the woman's *name*? And why did Lola *know* that the woman, beyond the shadow of a doubt, had hoped to be embalmed? To have her body outlive itself—that numb and sapless flesh, at last unencumbered of beauty, taught to disobey time by the embalming fluid its own veins. And wasn't such a hope forbidden by the woman's time and place . . . but what *was* her time and place?

A name here, a date there, not lost in the beginning, but just very far away . . . *A quiet conversation as heard through a wall,* her father had said, not angry but disappointed in the frail reach of his recollections. The detail would come home to her if she merely set it aside for a moment. Set it aside like an over-examined crossword.

"Our clients don't want detail," Hoffman was fond of saying. "They want simplicity at a time of complexity." Lola would nod, though more out of instinct than agreement.

"Yes," it seemed, was the word she spoke most often in his company. She glanced up at the camera, half expecting sympathy, but all she saw was her own waist, horribly distorted, stretched over the curve of the camera's plastic hood, and her head receding, a worthless, shriveled bead dangling floorward.

Hoffman had installed it, as well as seven others, in the lobby and hallways of the home, and though likely no one had time to view all the footage, its presence alone had a way of flooding her with guilt, as though by being caught on film coming and going—replenishing the pamphlets, offering tissues and shoulder pats to the bereaved, answering the phone, Windex-ing the handprints from the glass doors, receiving the endless floral deliveries, even contributing lines to the occasional obituary—she were caught doing something *else*, something untoward.

But who would ever steal nail polish remover? Of all things. The whole to-do was over a wedding ring that came up missing. The customer, a balding widower who made eyes at Hoffman's pregnant wife, had made an awful stink about the ring, and Hoffman had planted "surveillance apparatuses" in "choice spots."

How could anyone think of such earthly things as jewels and laws after having lost someone they supposedly loved? With whom they exchanged *vows*? All *she* was able to think about in the wake of her father's death was whether he had a soul and, if so, if this translated into the possibility of reunion (or not). And then of heaven . . . the infinite boredom it was doomed to become. Though, of course, she never married anyone, was never widowed. Nor did she have any children to her name, not that she particularly craved them. *Still*, the years behind her felt crowded by the very silence that had kept them in motion: the not-sound of a child not-crying for milk in the predawn hours, the not-whisper of a husband not-crawling into her ear as she lay on the brink of sleep.

The scent of the remover! So caustic it brought tears to her eyes as she soaked the cloth. Perhaps she should have snagged a surgical mask while down there, what with the air circulation being so poor in the gallery. Just removing the lid had made the whole space rank as a nail salon.

Last time she'd set foot in a salon, the woman assigned her wore one of those paper masks even when she was just peeling away bits of dead cuticle. The woman, who referred to herself as an aesthetician, who had the unnerving habit of lifting the mask to blow on Lola's nail beds, told Lola that she would have "gone for to get a degree" if she'd been able.

When Lola asked what the aesthetician wanted to study, the woman said "counting." "Oh, accounting," Lola replied, attempting to sound generous.

Lola herself would have said "art history," had the woman bothered to ask. But, then, would Lola's face have contradicted her words? *Too old for ambition*, its deep lines might have lied, *too old for art*. Didn't she go to that salon to feel *younger* on any account? To buff away the signs of having lived—what?—this too-long, too-short life?

And hadn't that once been her *job*? To *be* the eyes of her state's best art museum, to be *better* than the eyes of any camera? She had shepherded thousands, surely, over the years, from gallery to gallery, had rescued the innocent lives of many oil paintings, had warned children and couples and old men against standing too close to those precious, visiting artworks. Once, she caught a woman with manicure scissors approaching a mummy on loan from Egypt, one of the rare ones with the face still legibly painted over the wrapping. Another time, she caught a teenage boy kissing the pointed bronze foot of a Degas.

A foghorn hummed its dirge through the walls, through Lola. Her head, impossibly light, felt barely fastened to the rest of her. She lifted her eyes from the detail and scanned the neat tercet of corner cuts lining the main wall. A not-so-thin layer of dust sat evenly over the Monarch Black, her least favorite vessel in the gallery. "If it were a flavor," Hoffman had once said, "it would certainly be licorice." "Certainly," Lola had said. "Yes."

She closed her eyes and tried to see herself as the painter had seen the blue-gowned woman, all alabaster glow and voluptuous curve, visible from two angles at once, a mirror behind her offering up the immaculate drape and coil of her hair. Lola always marveled at hair, how alluring you could make the deadest parts of yourself, if only you knew how.

Lola did not know how.

And yet, she suspected she was built more for *that* world than her own. To have threaded gilded hallways with her going. To have taken in great tragedies from the velvet-skinned balconies of Europe, to have felt her eyes and ears flooded with the raptures of sopranists. To have to hold still for many hours over the course of years, so her soft throat and blonde eyelashes, her floral purse and floral vases could be envisioned and re-envisioned and served up to the ages on a platter of blue satin less a dress than a waterfall some god had put on pause, so that the years themselves could be distilled into a single instant that would live and live and live. To have held the room and won, yes, the affections of—a diplomat? A count? To have been unable to leave the house without missing a caller, the proof a stack of dog-eared cards littering her bureau.

However homely in comparison with the painted woman, though, Lola had never had to wonder if her beauty was an artist's fabrication. And in her youth, as now in her maturity, though she'd never seen *Don Giovanni* in Prague or donned a gown that conferred on her its bright immortality, she had a few friends and her "excursions," as she called them. She had lived—continued to live—within her means, which were her *own*. And her body, though unsure of its shape these days, had never been marred with motherhood. No purple veins webbed across her thighs, at least. No stretch marks smiled across her belly.

Her father had made *his* living mostly by helping farmers around the state manage their local insect populations—keep what was beneficial; erase what was not. He'd discovered the effects of releasing a particular synthetic pheromone into the air—"The moths will never find each other!" he'd cried. But then, two months later, he read a research article delineating the approach he thought he'd authored—fill the fields with the scent of longing and the moths will think the air through which they fly is their only mate— and he fell into a quiet depression, one from which he would never quite recover.

Back then, Lola only ever used the remover to suffocate Lepidoptera sufficiently rare to warrant a spot on her bedroom walls. She would soak a paper towel and cover the mouth of the jar with it, just as her father had taught her. Not wanting to breathe the fumes herself, she'd then screw the lid back on over the towel, two turns, to hold the fluttering animal secure in the vessel, which it shared with several drenched cotton swabs.

There was something unbearable about it. This damp, pink putty collecting filth. A new layer each day. She would fix it and Hoffman would praise her ingenuity—when all was said and done. A penny saved and so forth. He smiled so rarely these days. It was as though he had only a finite amount of comfort to offer the world, and he reserved it for those who merited the title of "client," of "family of the deceased." Lola did not resent this fact but rather regarded it as she might a secret unwittingly shared.

She herself preferred the term "customer" to "client," the latter resolving in a sharp sound that lingered on the tongue like the aftertaste of salt. "Customer" held "custom" inside it, and this pleased her. The child had been neither customer *nor* client. The child, for she had no doubt it was that child, had also drawn on several of the leaflets out front in the waiting room. Had defaced them—crossed out the word "dedicated" and written "deadicated," drawn mustaches on all the women in their promotional materials and traced a penis spraying the top of a tulip arrangement.

Lola couldn't prove anything, of course, so hadn't mentioned it to Hoffman, who was inclined to say things like, "Go easy on them; they're in mourning," and in any case was more taxed than usual, what with his wife's troubled pregnancy. Rumors of bed rest lingered like camphor in the air, rumors of blood and tearing and the cruel promise of prematurity. Though if he took any more time off, she would not feel bad asking for some time herself. Ever since visiting Istanbul two years ago, on a whim, she had wanted to get away for a longer and more orchestrated spell, something that would require her to cross a different ocean and walk barefoot on a finer sand. Would invite her into waters so salty her body would rise to the surface as though it weighed nothing at all. To not feel the weight of the body. To not feel weight.

One, two, three, four, five, six, seven, eight, nine, ten, eleven . . .

Having quit the rubbing technique, she now held the remover against the defaced lighthouse. She could see it clear as day: the girl wandering through the front lobby, chewing and chewing, blowing bubbles and popping them loudly. You could have kept time by it.

Lola's least favorite part of the trip to Istanbul had been the bath house—an ancient affair, steeped in mildew, whose name was lost on her and whose marble dome held within it like a stale breath the memory of glamorous guests.

And that horrible wash woman, her doughy breasts hanging down so far they obscured her belly button, her purplish brown nipples pointing to the floor as if to say, "Look." The woman laughing at her, at Lola, upon seeing her perched on the warming stone, her legs crossed, her towel wrapped tightly over her unassuming chest. "Amereekan!" the woman scoffed, her derision unimpeded by her accent, her derision scaling the walls and crashing down over the two of them, causing a terrible heat to travel from the bridge of Lola's nose all the way to her earlobes. She quickly removed the towel from her body and threw it on the wet floor, her off-white bra and underwear soon to follow. The woman observed this frantic and unceremonious disrobing without remark before setting about scrubbing all of Lola, including her breasts, which no one had had occasion to touch in years, save for those gloved assistants who, in the mammography room, occasionally arranged her pale flesh between cold plates of glass.

The woman handled Lola as if she were a chore, and before the end of it all, the two of them stood briefly covered in tiny brown peelings, much like those an eraser leaves on a sheet of paper. Dirt and skin. Skin and dirt. One substance as unfeeling as the other. There was nothing erotic about the experience, though Lola felt now as if perhaps there

should have been. It all seemed in preparation for something she could not put her finger on. Like a dress rehearsal, Lola mused, for a performance no one would see, no one would *want* to see.

She pulled her hand away from the detail as if from a stove burner: she had lost count. The paper towel fluttered to the floor. Squinting her eyes, she brought her nose close to where the tower had stood. Her eyes stung. The lighthouse was gone. Or half gone. Not the gum trapped in its textures, but the *paint*. Gone. You would hardly even know the detail had been a lighthouse relief except for the gum, which, defiantly pink, outlined the bricks composing the now-illegible, now-absent tower.

He would have her hide.

He would have it on the wall.

Perhaps he would even have her paycheck.

There would be no finer sand beneath her feet, no saltier sea to make her light, not for many months.

Or was it covered by some policy? She wasn't sure—how to bring it up. She would have to confess the part she'd played. No, she would detail all the correct steps she'd taken and which had, only through her determination and will to fix the situation, culminated in the lighthouse's destruction, which, of course, the child—and not she—had started.

She walked slowly, deliberately down the hall, the maroon carpet swallowing the sound of each footfall. The hallway longer than usual. A gamut. The sepia photographs of the coastline eyed her at even, soldierly intervals. It struck her that the woman had held a title, not a name—the title of *countess*? "Countess," she whispered, and the syllables soothed her. She was not like her father, to whom such details would never return.

Mr. Hoffman's office door was closed, an occurrence rather unusual given the early hour, an hour she'd come to associate with the older crowd, who tended neither to sleep in nor put off the less comfortable duties of life. She knocked but did not have to wait long to determine Mr. Hoffman's absence. Later might be a better time. Perhaps this was meant to be. Perhaps it would be best to return the remover to the basement as quickly as possible and even polish the Monarch Black without having to be asked. The cameras kept on, though, capturing their footage. And Lola kept on going, down the hall, which seemed to go on forever.

The conference room was empty.

The twin sanctuaries, empty.

The side reception. Empty. Empty. Empty.

She opened the door labeled "Audio" cautiously, as she always did, for there was no need of swift movement in a funeral home (save in the basement), as Mr. Hoffman was always quick to adjure.

Music playing. Was it choral? Oh, he was so kind, Mr. Hoffman, so generous, after her father's death. Gave her such time. Such generous leave. It was he who'd arranged for the fruit basket with the pomelo in it. She had eaten it slowly, over the course of an hour, charting the movement of sunlight over the gingham grid of her kitchen table.

Surely, she had nothing to worry about. The detail might not even be missed.

Or perhaps it was time for a new model . . . Everyone knew Hoffman was a reasonable man, and she'd catch him, at just the right moment, when he was between appointments and nearing the lunch hour, and all seemed vaguely manageable.

But his eyes did not meet hers when she opened the door. They were tightly closed, and his mouth was open, declaring his crowded, gray teeth; his blond head tilted back unnaturally on the spindle of his flushed neck. And she thought for an instant she was perceiving not a man but the corpse of a man. He was dead, yes, dead—save for a quivering motion that shot through his body in peristaltic bursts. Lola closed her eyes a second and reopened them.

The image remained, bright and wrong, a new detail materializing within her frame of sight: a mass of brown curls bobbing in his lap. That most private part of him appearing and disappearing into the face of whom she couldn't tell. The tangled mass, so many curls hooking into the air as they rearranged themselves, a narrow and besuited frame kneeling down, reverent and greedy. Fingers, the director's, buried in the rising and falling swarm of curls. It could be anyone in front of her, swallowing and unswallowing her employer. The director. The man who would have her hide, her wages, her—his name, what was his name? Its syllables lost to her, as his eyes shifted frenetically beneath sweat-slicked lids.

He seemed deep in a childish dream, the kind in which you fall but never land. Or rise but never—a sound like a foot slipping in and out of a wet boot. She stepped away, leaving the door ajar.

She had not been seen.

Lola paced back and forth in the lobby like a nervous bride, clutching a bag of mixed hard candies, the kind that bloodied the tongue if enjoyed too vigorously, to her

chest, dipping down here and there to fill already full dishes she had long ago placed strategically around the room.

Still holding the translucent, now empty bag to her chest, she walked through the automatic doors out into the parking lot, its pale puddles looking up at her, and surveyed the grounds beyond, the tender green folds of earth, the fir trees flinging down their stout and wind-stirred shadows; the crosses geometrizing the entire plot as with dormant grapevines. The sky was blind with mist. A green beer bottle caught the late-morning sun in its neck. She knew it was not yet noon because she could see her breath mingling with the mist, and the groundkeeper, who was gathering the graves' spent trappings—arrangements, real and synthetic, of blooms and leaves; tiny flags so sun-bleached they could only mean surrender; rain-drenched ribbons and moldy cakes still nestled in their cardboard boxes; candleholders the coastal winds had caressed out of use; origami cranes deliquescing in yesterday's rain—into a wheelbarrow. The ground-keeper was hunched over, one hand on a headstone to brace himself, one hand reaching toward the groomed earth.

She had not been seen.

No. No one in the world had ever looked at her, she was certain, as carefully and lovingly as that painter had looked at his countess, keeping each successive version of her alive in that single image, the blanched lashes near luminous, the dress spilling into the space around her, warning all emptiness away. A gaze so loving it could invent you—

And no one had tended to her as carefully as this keeper tended to his dead, lifting each expired gift from its grave as though it were a creature in need of safer ground.

Who would do such a thing for Lola? "Of passion they say burning, of bridges burned," she said quietly, fastening her gaze to a distant and lightless tower, impotent, quit of the duty to illuminate, unable to warn any sailor of what lay ahead in the cold and rocking dark.

So much energy lavished on the dead. What good? What good had they ever done her? The artist numb and irrelevant. The subject too. Her father, her father. And all those moths, whose flight she'd traded for ornament. She knew then that she would neither quit nor make mention of the detail, and that nothing, so much nothing, would surely happen to her. ❧

These Useless Hands: A Polyptych

ALANNA WEISSMAN

I

These are the things Louise keeps on her vanity: a pair of opera glasses, for when she can't see far enough; two tall and shapely urns, widest at their hips, navy with gold leaf and gilded feet; flowers she displays in a squat floral-painted vase, a wedding present from her mother.

Flowers are her sister's favorite, especially pinks and reds. As Louise applies her makeup, in the mirror she can see Elise at her elbow, standing on tiptoe to smell the bouquet. Elise fingers the bent edges of the calling cards that have formed a precarious tower, Louise lately having turned away visitors, and by some miracle Elise doesn't send them flying.

"Your bow is a tiny bit crooked," Elise says. She's always had a sharp eye for detail. Louise squats so her sister can reach the top of her head. With small fingers, Elise adjusts the red ribbon cascading from Louise's hair, then, laughing, pinches the apples of Louise's cheeks for rouge. "Remember how I used to have a hair ribbon just like this? Look, your dress is the same color as our eyes."

"That's why I wore it," Louise says. "It hasn't been fashionable for years, but it's my favorite. It reminds me of you, and the sky, and the sea, and how blue they were that summer in Italy. Plus, with the crinoline removed, it still fits."

The man who comes to paint Louise's portrait doesn't acknowledge Elise. He positions Louise in front of the mirror, turns her this way and that, tilts her jewelry so the turquoise accents face outward, smooths the front of her dress, crosses and uncrosses her arms over her belly. Under the hem of her gown, Louise taps her bare toes on the carpet. She drums a finger against her face. Her sister sits silently on the floor, petting the soft yellow shawl Louise left slung over the side of one of her accent chairs, braiding and unbraiding the fringe.

Louise knows her husband is spending a lot of money on this portrait. The artist has come to make sketches before, has traced the lines of her dress and shoulders and hands. But today is the day he finally applies paint to canvas and captures this moment, Louise and the small thing growing inside her, the two of them still one.

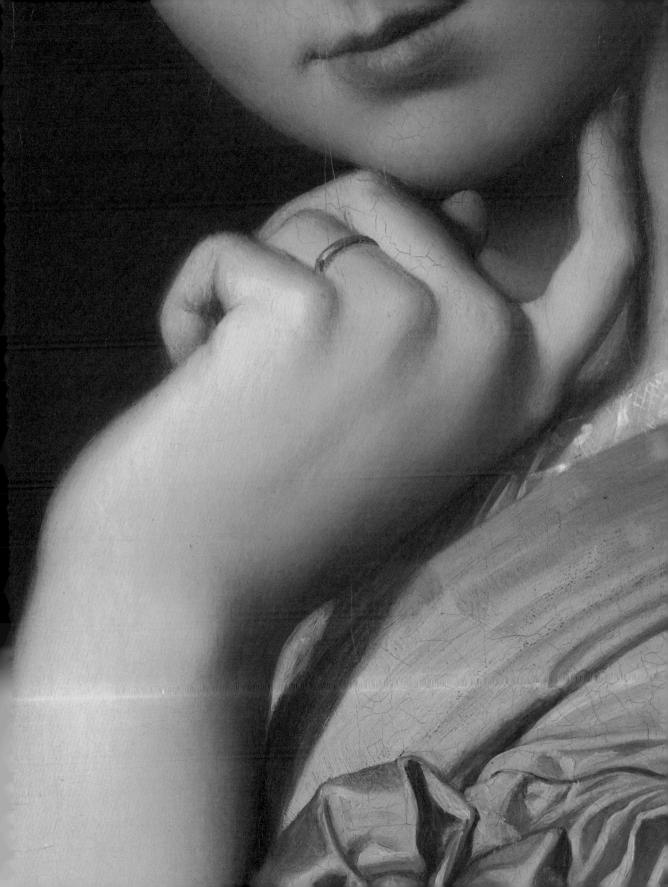

II

Louise has always liked children, her little sister especially. Even as an adult, she feels she can relate to them better than most. Still, the thought of having one of her own frightens her.

When Louise was a child, her parents' neighbor gave birth and it had been snowing so hard the midwife didn't arrive in time. Elise was still too small to help, but Louise and her mother boiled rags, held the woman's clenching hand as she screamed screams that now return to Louise's ears from time to time. How much blood there was, how red, the way it seeped into the cracks in the wooden floorboards and later had to be covered up by an imported rug. She also remembers how when the baby came out he was blue and stiff, the cord wrapped around his neck like *boudin noir*. As they waited for a cry that never came, her neighbor's wails echoed off the walls, filling the quiet of the snowfall outside.

"What happened to the baby?" Louise had asked her mother when they returned home that night. Elise was curled on the floor by the fireplace, asleep; Louise was half out of her dress at the wash bucket, trying to scrub the neighbor's blood from her sleeves, stubborn soap bubbles clinging to her hands. They could still hear the woman's wailing muffled through the walls. "Is he in heaven?"

Their mother stared through the window. Snow was collecting on the bare flower bushes outside, bending the twigs under its weight. "Sometimes, when someone dies too soon, or suddenly, their soul doesn't know where to go and lingers between worlds."

"So he's still here, with us?" Louise asked.

"Yes," her mother said. "We might not be able to see him, but he's still here."

III

As a child, Louise liked to spend time with Elise in her father's vast library. They loved the leather-bound volumes, the smell of the paper, the ink on the pages. Some of the words were still too difficult for them, so their favorite books were the ones with pictures. One subject in particular captivated them: mermaids. They would snuggle into a corner, and Louise would read to Elise what words she could, and together they would run their fingers over the illustrations, woodcut prints of women with fish tails.

"If we were mermaids, what colors would our tails be?" Elise asked Louise one morning as they were getting dressed. The night before, they had reread one of their

favorite fairy tales, about sirens luring sailors into the sea. "Silver like the fish at the market, orange like a goldfish? Or green like an eel?"

"You've never seen an eel."

Elise scrunched up her face. "They probably look like snakes."

"You've never seen one of those in real life either." Louise smiled. "Something colorful. Like the decorative fish Papa's business associate keeps in a tank. He has blue and purple and yellow fish, remember? Here, come help me with my hair."

Louise kneeled, and Elise climbed onto a chair so she could reach Louise's crown. Louise had never been good at doing her hair; she always ended up working the strands into knots. Elise's fingers were small and pliable, proficient at things Louise's had never been.

"I'm going to draw a picture of us as mermaids," Elise said. "I'll give us colorful tails—pink for me and blue for you."

"I hope we get to see the sea for real someday," Louise said. From the walls, portraits of their ancestors stared down at them, unaging, unblinking.

IV

This was the first time Louise felt she couldn't see far enough: that summer on the Amalfi Coast. The sky and the sea seemed to stretch on forever; she thought if she could just see better, she might catch a glimpse of water nymphs emerging from the waves, or cherubs descending from the clouds.

Louise and Elise greeted the sun from the beach each morning. After a hurried breakfast of fresh fruit and eggs, they pulled on their most lightweight dresses, tied their hair up in red ribbons, and walked along the jutting cliffs toward the water. While their parents conducted business, the girls sat all day on the rocks, practicing their Italian, stacking the white-striped pebbles, and eating picnic lunches. The girls didn't know how to swim, but each day they waded a bit farther into the waves, lifting the hems of their skirts higher and higher to keep them dry.

On the last day before they were to return home to France, the water was exceptionally warm. Elise had a red rose on her head, plucked from the bushes they passed on their way to the beach and tied with her hair ribbon into her hasty chignon. She had admired the roses every day they were there, wished she could pick one and adorn herself with it,

but it was only as they were preparing to leave that she finally did so. Elise went into the water up to her knees, waves lapping against her thighs.

Gulls slashed through the air and down near the girls' heads, whipping their flyaway hairs into tangles stiff with salt spray. Elise looked out into the distance.

"Do you see that?" Elise pointed to a spot far out on the water.

"See what?" Louise's eyes followed Elise's finger. Little flashes of silver glinted off the crests of faraway waves.

Elise dove. She had never done such a thing before, but she moved through the air with such grace and precision, her body arcing the way Louise imagined, based on the illustrations she'd seen in her father's books, a dolphin's might. As she entered the water, the surface barely broke, and faster than Louise could comprehend it, Elise was in the sea.

Louise tried to follow her sister, but her feet refused to move. Her hand dropped the hem of her skirt, and her dress grew heavy with water.

As Louise watched silent and open-mouthed with her left arm uselessly outstretched and her right arm hanging limply at her side, her sister went farther and farther into the distance until Louise could only see the red ribbon in Elise's hair. Eventually, she couldn't see anything at all.

V

Louise wanted to learn how to swim, to dive into the sea and find her sister, but since that day at the beach, her parents wouldn't allow her near water deeper than that in a bathtub. Instead, she sat in her father's library and read: mythologies of sirens and mermaids, ontologies of sea creatures, guides to sailors' knotwork. She kept Elise's drawing hidden in one of the books and every day took it out, unfolded it, and ran her hands over the image before refolding it and putting it back in its hiding place.

Sometimes her parents cried; other times they shouted at each other. At night, when they thought Louise was asleep, she could hear their hushed tones—saying she's always been young for her age or that she just couldn't cope with her grief. While they whispered, Louise stuffed a blanket under the crack of her bedroom door and lit a candle. She was keeping a journal for Elise, a daily accounting of everything that happened while she was gone to read to her.

. . .

18 août – Dear Elise, You missed the most beautiful sunrise today! The flower bushes outside are in full bloom, covered in pink and red blossoms that draw honey-bees with their sweet scent. You would love it.

. . .

30 septembre – Dear Elise, Today I went with Maman and Papa to an art museum. Maman liked the still lifes and Papa liked the history paintings, but my favorite were the fabulous creatures: mermaids, manticores, hippogriffs, satyrs . . .

. . .

11 novembre – Dear Elise, Joyeux anniversaire! I baked you a cake just how you like, vanilla with strawberry jam in between each layer and pink frosting roses on top. Je t'aime, ma petite sœur.

. . .

02 janvier – Dear Elise, I'm afraid my coxcombing isn't coming along very well. You know I've never been good at things like braids and knots—these useless hands!— but you'd be great at it. Maybe one day you can teach me.

. . .

27 février – Dear Elise, Papa's business associate visited today, and he brought me a present—a big conch shell! It's so magical. If you put your ear to it, you can hear the sound of the sea. It makes me feel like I'm with you.

. . .

14 avril – Dear Elise, Today I tried again to tell Maman and Papa about the mer-maid, but they wouldn't listen. They don't like it when I talk about you. They say I am living in a fantasy world.

. . .

Eventually, Louise's parents found the journal where she had been hiding it, tucked into a novel she kept by the side of her bed. Her father tossed the journal into the fire. He was shouting about how if only Louise had held on to her sister this wouldn't have happened. Louise sobbed and clung to her mother's skirt.

"Remember what you told me about the neighbor's baby? How we can't see him but he's still here?"

"Oh, Louise. You were so young. I was just trying to console you."

"But what if Elise is still waiting for us on the beach in Italy and just doesn't know where to go, like you said?" Tears welled up in Louise's eyes. "What if she's living by herself on a little island somewhere? Or what if she's become a mermaid? You don't think she is still here in the world with us, even though we can't see her right now?"

"Oh, Louise," her mother sighed. "Oh, Louise."

VI

This is the first time Louise has returned to that beach: a decade later, after she married a wealthy man—a count from Haussonville, in the northeast—of whom her parents approved. He was the son of her father's business associate and had admired her from afar since they were young. The count wrote odes to Louise's beauty, lavished her with gifts, built an extravagant new house on his estate for them to live in. She liked him well enough, but mostly she just wanted to escape. At her childhood home, memories lingered, clinging to the walls, and the air was thick with unspoken thoughts.

Louise's new husband proposed a trip to celebrate their marriage. He told her she could choose the destination, anywhere she pleased, and she chose the Amalfi Coast. The count rented a cottage overlooking the beach, where Louise again ate picnic lunches and sat on the pebbly beach. In her new imported dresses, she didn't go near the water, only stared out at the waves from her spot on the shore. Sometimes, the count sat next to her on the rocks and reached for her hand, but she never returned his touch.

On their last night in Italy, they went to the opera, where the count presented Louise with a pair of binoculars. Louise wrapped herself in her shawl the color of sunflowers—also a gift from her husband, from when he was wooing her—and through the lenses stared absently at the performers, who sang in a language of which she only recalled snatches.

"What did you think of the opera?" her husband asked. "Is that why you wanted to come here to Italy? For the opera?" Louise didn't answer.

"Ah, you were daydreaming again, weren't you?" He smiled and plucked an unruly strand of hair from Louise's collarbone. "I've always loved the way you do that."

That night, their child was conceived. Louise didn't feel anything, but still she knew; she recognized that something was brewing inside her, a singular sense of something beginning, the seismic ache of new life.

Louise didn't sleep. She peered out the window through her opera glasses, inspecting each break in the surface of the waves. Faintly, she could hear children's laughter, carried on the air from a great distance away.

In the pink of the sunrise, Louise crept out of the cottage and went alone down to the water's edge, still in her nightclothes, the rocks cool and damp against the soles of her bare feet. It was one of those sunrises where you could still see the moon before it fully receded and the light was bouncing off the salt spray, giving everything an aura of haze. The water was cold that morning. Her arms felt heavy with emptiness. Louise fell to her knees and grabbed at the pebbles, traced the white lines the water had etched into the black stones, buried her arms up to her elbows. She folded her skirt into a pouch and tied a handful of them into the linen.

Louise pressed her forehead onto the ground. The rocks smelled moist and earthy, borne of water and fire, both land and sea at once. While in this position, curled up with her head to the earth, she felt a tap on her shoulder—gentle as a breeze, yet familiar as the sun.

"Why did you leave me here?"

Louise turned and saw Elise standing behind her. She looked exactly the same as the last time Louise had seen her, wearing the same dress, the same red rose tied by the same hair ribbon into the same chignon. Her small hands were balled into trembling fists. Her ruddy skin glistened with saltwater, and her bare feet were gray with the dust of the earth.

"Maman and Papa said you were gone." On shaking legs, Louise stood and reached out toward Elise, but she backed away. "They said I was a fool for believing you were still here." Elise's face crumpled.

"I'm still here. I've always been here." Elise rubbed at her eyes with her knuckles.

Louise again reached out, and this time Elise let her sister clasp her hands. "No matter what anyone says, I promise I'll never leave you again."

Elise and Louise embraced. "You'll take me home?" Elise whispered in Louise's ear.

"Yes. Of course."

Elise squeezed her sister tighter, then laughed. She released Louise and bounded down to the water's edge, stopping just before the waves lapped her toes. She reached up, and in one smooth motion untied her hair bow and pitched the red ribbon into the air. Like an eel or a snake, it swam gracefully through the air, gliding, arcing, and weaving, and the wind carried it for a distance before it landed in the sea, a tiny blot of red against a backdrop of infinite blue. The red rose that had been tied into Elise's chignon fluttered

from her loose hair to the ground. Then she returned to Louise, and they walked hand in hand along the beach back to the cottage.

VII

Elise has been gone for a decade, swept out to sea, her remains never found.

VIII

Louise hasn't been to the opera since the time she went with her husband in Italy; the flowers on the vanity are long dead, remnants of the bouquet from her wedding; the blue-and-gold urns hold the black pebbles with the white stripes that she took with her from the beach on the Amalfi Coast.

The artist will arrive soon.

Louise has the housemaid comb and plait her hair and tie the braids up in a red ribbon. She forces gold rings onto her swollen fingers. She doesn't bother with shoes; her feet are sore, and based on the artist's sketches she doesn't think the portrait will include them anyway. She wraps her yellow shawl around her shoulders, then changes her mind and tosses it over the back of one of the white chairs. In the time she's been pregnant, a constellation of small pink papules has spread across the nape of her neck. She wonders what the artist will choose to show.

The artist politely says nothing about the stack of neglected calling cards, the cashmere shawl thrown haphazardly over the chair, the thin layer of dust that's settled on the vanity. Louise won't allow the housemaid to touch anything on her vanity.

With his fat wrinkled hands, the artist sets up his paints and easel. Louise stands with her back to the vanity mirror. She tries and fails to smile. He gestures behind her, toward the desiccated remains of the flowers sticking up from the vase Louise's mother gave her. "Those flowers. How should I paint them?"

Louise presses her hands to her belly. For the first time, she feels movement.

"Make them alive," she says. ✤

Contributors

FACULTY ADVISOR

DARIN STRAUSS is the author of the novels *Chang and Eng, The Real McCoy, More than It Hurts You,* the memoir *Half a Life,* and, most recently, *The Queen of Tuesday,* a finalist for the Joyce Carol Oates Prize in Fiction. He has also written a comic book series, *Olivia Twist,* and screenplays for Disney, Gary Oldman, and others. A recipient of a Guggenheim Fellowship and a winner of the American Library Association's Alix Award and the National Book Critics Circle Award, Strauss is also a Clinical Professor in the Creative Writing Program at New York University (NYU). His work has been translated into fourteen languages.

STUDENTS

MATHIS CLÉMENT was born in London and studied English at Oxford University. He is in his first year of the MFA programme and has yet to adapt his spelling to "program," although he prefers bagels to an English breakfast.

NAJEE FAREED is a southern poet from Atlanta, Georgia. He has been published in literary journals such as *The Arden* for his poetry, prose, and fiction. He won first place at the 2019 Southern Literary Festival in the One-Act Play category and was published in the subsequent anthology.

NINA FERRAZ is a Brazilian writer based in New York, a mother of two, and a medical doctor, who also holds an MA in literature. She is currently a Goldwater Fellow in Fiction at NYU, where she is Assistant Web Editor for the *Washington Square Review* and teaches creative writing to undergraduates. Her short story "The Hot Pitch Under" was nominated for Sonder Press's 2022 *Best Small Fictions* anthology.

OMER FRIEDLANDER grew up in Tel Aviv. He is the author of the short story collection *The Man Who Sold Air in the Holy Land.*

AMIR HALL plays at the intersection of body, word, and spirit to describe the divinity and beauty of their people: the poor, the Black, the queer, the Creole, and the free. Their work has been seen in the United States, Nigeria, Switzerland, and their home country, Trinidad and Tobago.

ANUSHKA JOSHI is from Ahmedabad, India. She recently graduated from Sarah Lawrence College, where she studied history and literature.

CHRISTOPHER LINNIX is a Brooklyn resident who is currently working on his first novel. Every night, he reads drafts of his manuscript to his young son, who clamors for more.

MADELINE McFARLAND is a writer living in Brooklyn, New York. She is from Philadelphia and graduated from Williams College in 2018.

JONATHAN PERRY is a writer living in Beacon, New York. His work has been published in *Hobart After Dark*, *Vol. 1 Brooklyn*, the *Underground*, *Great Ape*, and elsewhere.

ISABELLE PHILIPPE is a writer whose work has appeared in the *Washington Square Review*, ABC News, and the *Ithaca Times*. She is currently working on her first novel.

ERIC RUBEO is an Assistant Fiction Editor with the *Washington Square Review*. His work has appeared in *Fiction Southeast*, *Tupelo Quartely*, *(parenthetical): the zine*, and other publications.

ERIN TOWNSEND is a graduate of the Creative Writing MFA program at NYU and a recipient of the 2022 Writer-in-Residence Axinn Fellowship, as well as the Jennie Hackman Memorial Award for Short Fiction. Their work has been featured at Long River Live and in the *Long River Review*, *Arkana*, and other publications. They are currently at work on their first novel.

DEVON WALKER-FIGUEROA is the author of *Philomath*, selected for the 2020 National Poetry Series by Sally Keith. Her writing has appeared in the *Nation*, the *Iowa Review*, *Tin House*, *Ploughshares*, the *Harvard Advocate*, and elsewhere.

ALANNA WEISSMAN is a writer and editor from New York. Her work has appeared in the *New York Times*, the *Guardian*, the *Bellevue Literary Review*, the *Rumpus*, the *San Francisco Chronicle*, and other publications. She holds an MFA from NYU, an MS from Columbia Journalism School, and a BA from Colgate University.

First published in the United States of America in 2023 by

RIZZOLI ELECTA
A division of Rizzoli International Publications, Inc.
300 Park Avenue South
New York, New York 10010
rizzoliusa.com

Publisher: Charles Miers
Associate Publisher: Margaret Chace
Senior Editor: Philip Reeser
Production Manager: Kaija Markoe
Design Coordinator: Olivia Russin
Copy Editor: Elizabeth Smith
Proofreader: Adele Kudish
Managing Editor: Lynn Scrabis

in association with

THE FRICK COLLECTION
1 East 70th Street
New York, New York 10021
frick.org

Editor in Chief: Michaelyn Mitchell
Assistant Editor: Christopher Snow Hopkins

Designer: Marlos Campos

Full portrait (*page 8*) and details:
Jean-Auguste-Dominique Ingres (1780–1867)
Louise, Princesse de Broglie, Later the Comtesse d'Haussonville, 1845
Oil on canvas, 51 ⅞ × 36 ¼ in.
The Frick Collection

ISBN: 978-0-8478-9912-8
Library of Congress Control Number: 2022941822
A CIP catalogue record for this book is available from the Library of Congress.

2023 2024 2025 2026 / 10 9 8 7 6 5 4 3 2 1

Printed in China